industrial interiors

BARS &
RESTAURANTS

RotoVision

© 2005 Page One Publishing Private Limited

First Published in Singapore by
Page One Publishing Private Limited
20 Kaki Bukit View, Kaki Bukit Techpark II
Singapore 415956
Tel: +65 6742 2088
Fax: +65 6744 2088

ISBN 2-940361-02-9

First Published in the UK by
RotoVision SA
Route Suisse 9
CH-1295 Mies
Switzerland

RotoVision SA
Sales & Editorial Office
Sheridan House
114 Western Road
Hove BN3 1DD, UK
Tel: +44 (0)1723 727268
Fax: +44 (0)1273 727269
Email: sales@rotovision.com
Web: www.rotovision.com

10 9 8 7 6 5 4 3 2 1

Editorial/Creative Director: Kelley Cheng

Art Director: Jacinta Neoh

Sub-Editors/Writers: Hwee-Chuin Ang, Narelle Yabuka, Ethel Ong

Designers: Chai-Yen Wong, Sharn Selina Lim, Soo-Shya Seow

Editorial Coordination & Text
(in alphabetical order):
Anna Koor (Hong Kong, China)
Masataka Baba (Tokyo, Japan)
Meng-Ching Kwah (Tokyo, Japan)
Reiko Kasai (Tokyo, Japan)
Richard Se (Kuala Lumpur, Malaysia)
Savinee Buranasilapin (Bangkok, Thailand)
Thomas Dannecker (Bangkok, Thailand)

industrial interiors

BARS & RESTAURANTS

contents

contents

introduction

Wining and dining are two of the greatest pleasures of life; they are also a quintessential part of urban living. As Asia quickens its pace of urbanisation, its bars and restaurants have diverged from the noisy and crowded bourgeois establishments that have typically sprung up rather chaotically throughout cities over time. Asia, it seems, has undergone a radical makeover, and is now producing stunning designs that have catapulted its bars and restaurants into the standard of the international arena.

In the past, many bar and restaurant designs in Asia have focused chiefly upon spatial planning and packing in as many seats as possible. However, things have changed in recent times. Increasingly, interior design and its complementing elements are being recognised for their importance as well, as they are essential contributions that make up an extraordinary wining and dining experience. Responding to this newly shaped sophistication, *Within Bars & Restaurants* gathers some of the most outstanding bar and restaurant designs in the region. This book is bound to delight and inspire architects, designers, bar and restaurant operators, as well as the design-savvy public. Filled with page after page of hip and stylish ideas that combine contemporary design language with new Asian aesthetics, it introduces the hallmarks of contemporary Asian design in a refreshing manner. The rich showcase of photographic images, taken from attractive angles - both conventional and creative - tells the story behind each and every bar and restaurant in a vivid manner.

From cafes, wine bars and eateries, to fine dining restaurants, *Within Bars & Restaurants* covers just about every genre of cuisine and establishment. Underlying this myriad of types, is simply good, appetising design that is delectable to all of the senses. These exciting interiors offer more than merely a venue to eat and drink. Design is on the house tonight.

AT ANOTHER PLACE

alibi

Lush, chic, sophisticated - this is Alibi, Hong Kong's answer to a stylish wine-and-dine hangout to see and to be seen at.

NAME OF ESTABLISHMENT **ALIBI**
OWNER/CLIENT **KEEN CITY INTERNATIONAL LTD**
ARCHITECT/DESIGNER **DARRYL GOVEAS/PURE CREATIVE ASIA LTD**
PHOTOGRAPHER **ELAINE KHOO**
TEXT **ANNA KOOR**
LOCATION **73 WYNDHAM STREET, CENTRAL, HONG KONG**
TEL OF ESTABLISHMENT **(852) 2167 8989**

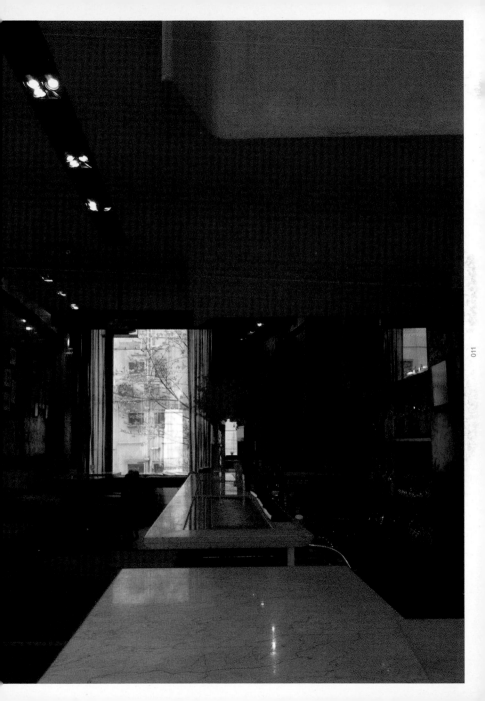

Although distinctively a bar and restaurant, Alibi more prominently carries with it the ambience of a lounge. Designer Darryl Goveas' expertise in luxury brand retail design has given Alibi a strong sense of street presence. Much attention has been paid to the design of tactile detail and circulation, helping Alibi establish its identity as a chic establishment.

The skills of the designer were put to test with this difficult site, split into two levels and encompassing 3,500 square feet, divided by a deep, narrow well of steps. The bar takes up a narrow front-to-back space on ground level. By deliberately locating the washrooms upstairs, patrons are given an excuse to wander up to the dining area. In any case, the designer has made sure that this is a journey worth making.

The journey up the steps is much like walking through a forested path. MDF board, carved with bark-like patterns, lines the stairs. Upon reaching the brasserie on the second level, a kinetic sculpture created from curves of Brazilian Zebrano wood acts as a focal point for the space. A red fiberglass bar is a visually vibrant counterpoint to the earthy notes of the surrounding interior theme.

Colours and materials play a great role in defining the sophisticated and lush atmosphere of Alibi. Monolithic elements are dressed in a restricted palette of pearly beige, mud and russet reds - the last being a common link between both floors. Chocolate walls are smeared in sanded stucco that captures light gently on its surface, and finely woven drapes are layered over the top to warm things up.

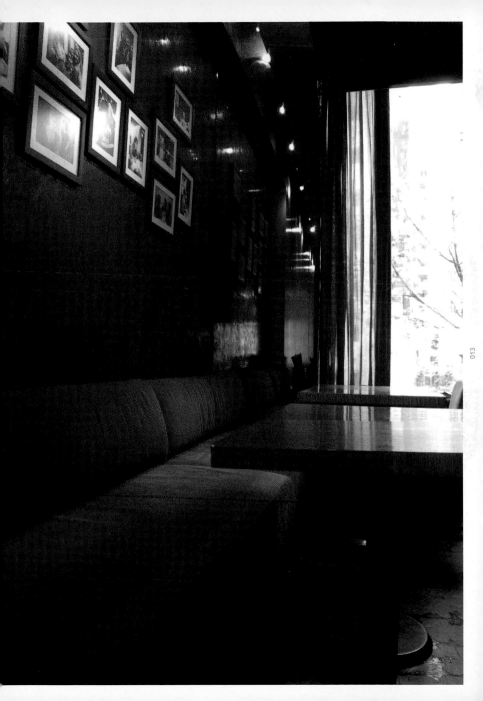

CULINARY EXTRAVAGANZA

café too

Discarded into the ranks of things passe, the banal hotel coffee shop sees a new take in Café TOO - which is touted as a "theatre of food".

NAME OF ESTABLISHMENT **CAFE TOO**
OWNER/CLIENT **ISLAND SHANGRI-LA**
ARCHITECT/DESIGNER **SUPER POTATO**
PHOTOGRAPHER **ELAINE KHOO**
TEXT **ANNA KOOR**
LOCATION **LEVEL 7, ISLAND SHANGRI-LA, HONG KONG**
TEL OF ESTABLISHMENT **(852) 2820 8571**

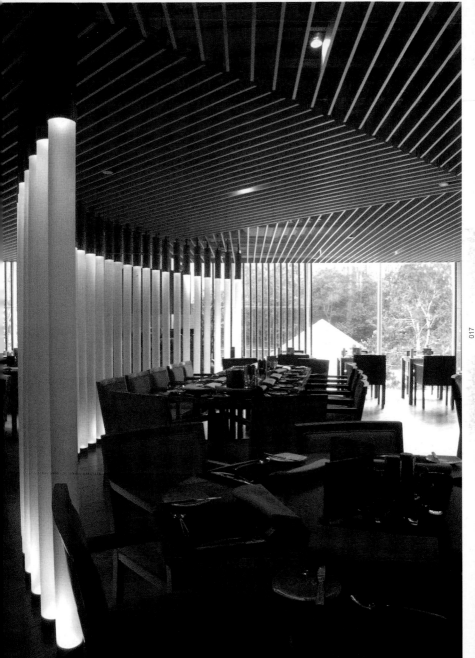

The banal hotel coffee shop is fast becoming a thing of the past and Café TOO is a dynamic illustration of this fact. Applying their trademark contemporary Asian Minimalist flair to the décor, designers Super Potato have resurrected the restaurant into a vibrant and attractive "theatre of food".

Seven "cooking theatres" replace the typical buffet counters, and each "theatre" features a different genre of cuisine. At each "theatre", chefs are present to put up a culinary performance to the guests. Diners can choose to get up-close to the buzz of activities by the "theatres", or seat themselves in one of the restaurant's many intimate corners on the fringe, that are semi-enclosed by dramatic curtains of columnar lights and vertical timber battens.

A warm, textured colour palette inspired by what is being featured on the menu dominates the restaurant. Walls of glass are filled with varieties of coffee beans and tealeaves, while perspex funnels are crammed with pasta and spices - all in gradations of earthy hues. The design invests highly in lighting effects, eliminating the excessive bright lights that frazzle many hotel coffee shop interiors. Pre-programmed lighting systems are instead employed to capitalise on exterior views and natural light by day, while illuminating the theatres as stunning islands of frosted glass by night.

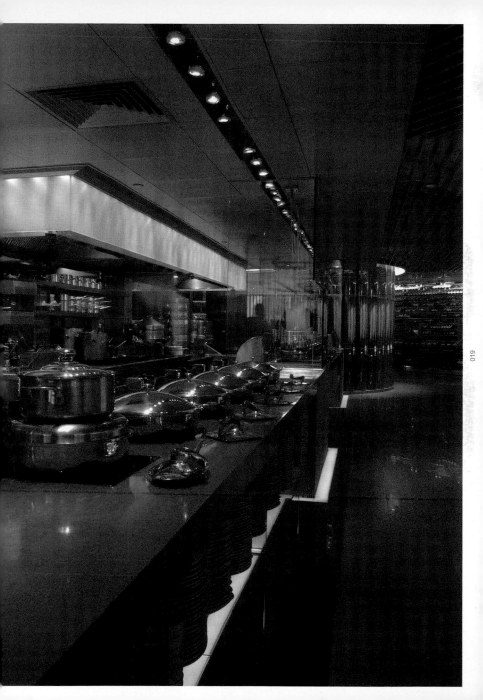

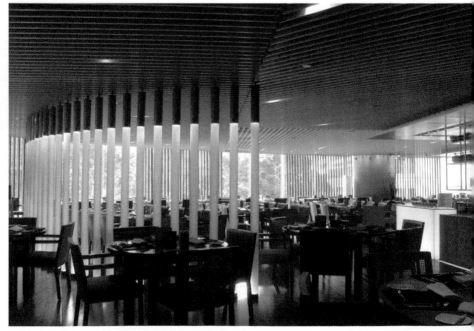

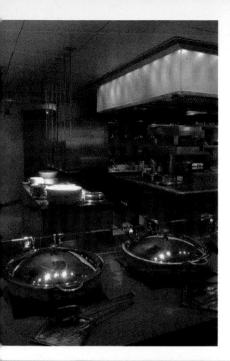

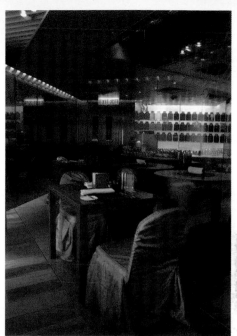

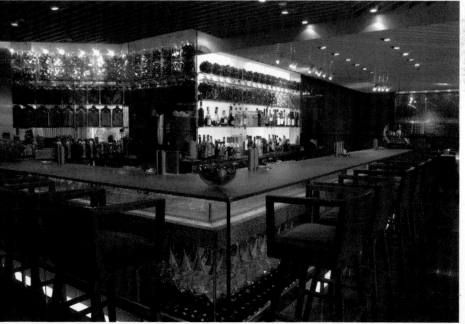

UNDERGROUND GLAMOUR

drop

The incongruity of a dank back alley being home to such a highly polished club with no apparent exterior identity proves to be too enticing.

NAME OF ESTABLISHMENT **DROP**
OWNER/CLIENT **NEWARD LTD**
ARCHITECT/DESIGNER **DAN EVANS, TRACEY STOUTE**
PHOTOGRAPHER **KELLEY CHENG**
TEXT **ANNA KOOR**
LOCATION **BASEMENT, ON LOK MANSION, 38-43 HOLLYWOOD ROAD, CENTRAL, HONG KONG**
TEL OF ESTABLISHMENT **(852) 2543 8856**

To the uninformed, trying to locate Drop is certainly no easy task. Tucked at the end of a dank back alley, it is not immediately apparent that the site is in fact a huge disused storage warehouse.

The design of the bar begins with a minimalist and monochromatic theme, but gradually veers towards something plusher. An air of exclusivity is enforced by the members-only door policy and its underground location - a concept that draws on the success of similar venues in London. More so, the incongruity of a dank back alley being home to such a highly polished interior with no apparent exterior identity proves to be too enticing.

Transiting down the alley, the search terminates with a red door that opens to a seductive staircase, which subsequently projects right onto the dance floor. The large square basement has 5 metre high ceilings carved up into bold slabs of components and materials. The DJ platform has a real presence; the convenient solution of tucking the platform at the end of the bar is deliberately avoided. It is outlined in black leatherette and mirrored glass. The panelling on the walls shift from mirrored glass, cream cushioned leatherette, then tuna coloured paintwork, to frosted mirror panels. Finally, red polycarbonate screens identify the washrooms. The unusual colour combinations do not end there. The elevated seating section along one side of the bar is decked in a mixture of burgundy upholstery and mint green finishes.

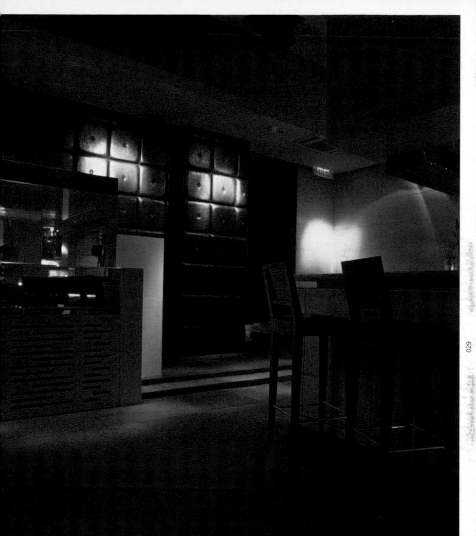

ORBIT IN SPACE

elements

Elements is pure stimulation for those who thrive on life's social pleasures.

NAME OF ESTABLISHMENT **ELEMENTS**
ARCHITECT/DESIGNER **HEAD**
PHOTOGRAPHER **GRAHAM UDEN & ELAINE KHOO**
TEXT **ANNA KOOR**
LOCATION **55 ELGIN STREET, CENTRAL, HONG KONG**
TEL OF ESTABLISHMENT **(852) 8105 0155**

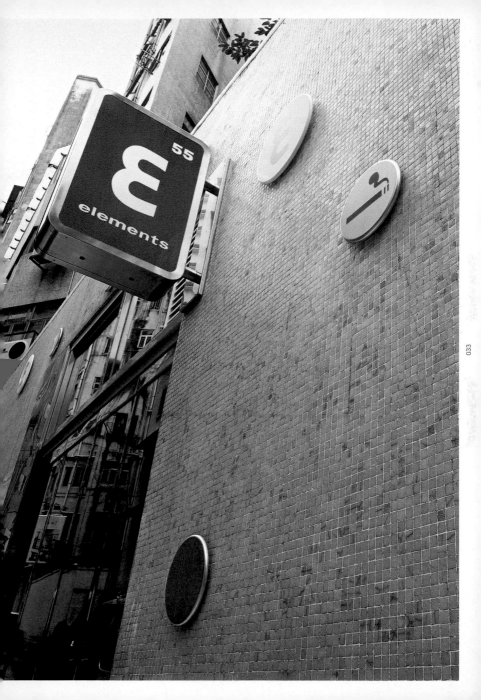

The designer's concept hinges on the venue's name, which, in a whimsical move, has prompted him to look at the periodic table and the chemical laboratory for inspiration.

The only trace of its previous life as a printing shop exists as a spiral staircase that leads up to a mezzanine level above the ground floor. The bar has been conceived as the "nucleus" of the space, with all activities orbiting around it. These radiate outwards, reducing in intensity - from the hyper buzz at the bar, to the more relaxed pace of the fringe areas. The designer has cleverly disguised the difficult triangular floor plan by situating the kitchen at the apex of the triangular space.

To further soften the sharp edges, the curves of the horseshoe-shaped bar and horizontal bands of veneer running along the walls lend useful effects. Two datum levels circumnavigate the perimeter of the bar, executed physically in the form of fabric panels. An intervening recess, coinciding with the level of the bar and backed by a sheet of frosted glass, serves as a drinks shelf as well. Three-dimensional molecular structures constructed from spray-painted steel tubes - abstracted from the molecular structures of (a suggestive combination of) alcohol and aspirin - are suspended at the entrance to form visual cues to signify the presence of the bar.

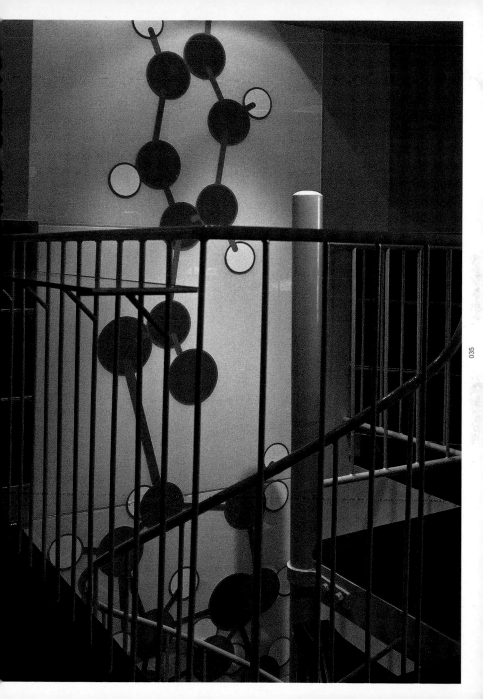

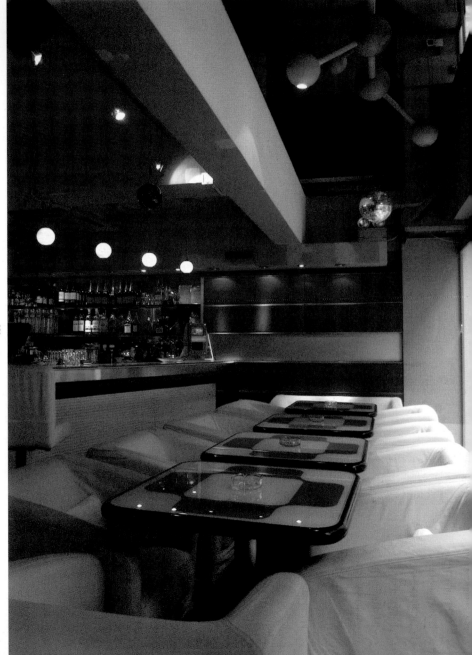

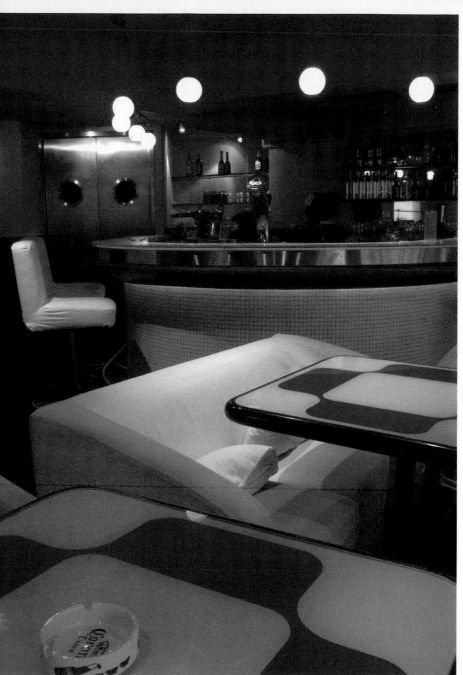

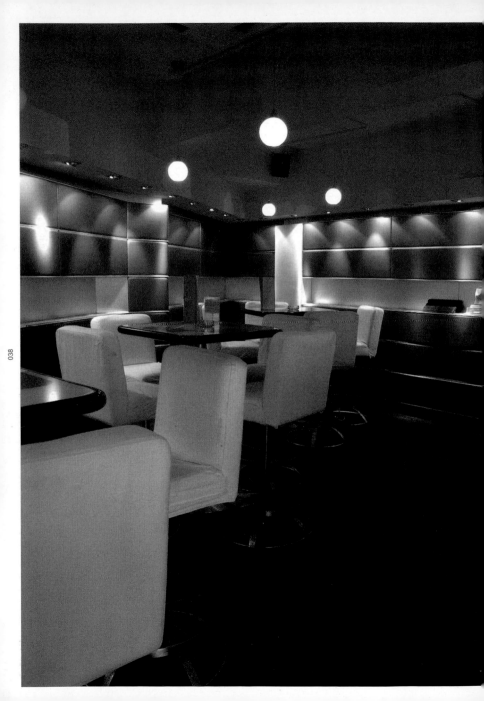

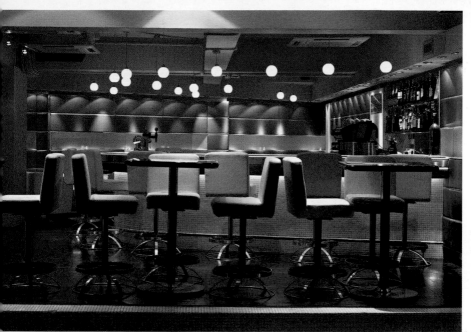

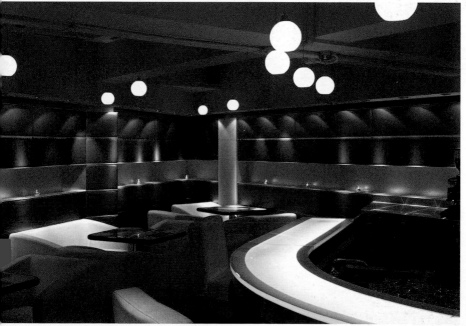

ARTFUL ASSEMBLAGE

gaia restaurant

Throughout the restaurant, dramatic gestures in the design concoct a heady mixture of styles and eras.

NAME OF ESTABLISHMENT **GAIA RESTAURANT**
OWNER/CLIENT **FINEMAX LTD**
ARCHITECT/DESIGNER **L & O LTD**
PHOTOGRAPHER **ELAINE KHOO**
TEXT **ANNA KOOR**
LOCATION **GRAND MILLENNIUM PLAZA, 181 QUEEN'S ROAD CENTRAL, HONG KONG**
TEL OF ESTABLISHMENT **(852) 2167 8200**

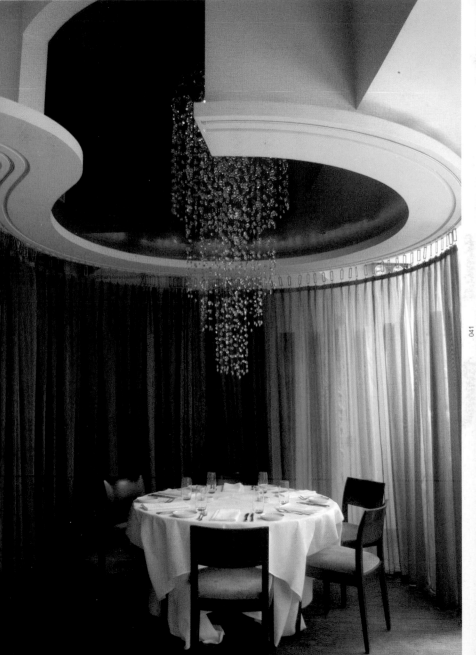

This stylish Italian dining venue has added much-needed character to The Piazza at Millennium Plaza. The owners eschewed the idea of yet another typical modern restaurant that has appeared only too often looking expensive but sterile. As such, the initial concept for this restaurant was to blend together a heady mixture of designs - intended to create an experience not unlike that of entering a friend's home for the first time. This slightly mismatched fusion was the architect's intention. It is described as "put together" rather than designed, which explains the more decorative approach.

The result is not only a layering of spaces, but also an assemblage of artefacts and designs from different eras - from the baroque-style flooring of the bar area, to the timber flooring of the restaurant (these being recycled pine planks sourced from London). A frieze of "antiqued" mirrored glass frames the perimeter of the space, as well as the extensive collection of artwork within the restaurant.

Throughout the restaurant, dramatic gestures punctuate the space, forming focal points within that particular realm. For instance, the bar area is decked in Ferrari-red leather and stitched in cookie-cutter motifs. At the opposite end, a crystal chandelier strung from nylon is encircled with gauzy, flowing drapes, forming a semi-private dining area that appears almost like a "stage". Further dining space at the rear is accompanied by an extensive wine cellar, which forms a dramatic wall feature in itself. A private dining salon features a framed window overlooking the kitchen. This room exists as an entirely distinct setting that excludes itself from the rest of the restaurant.

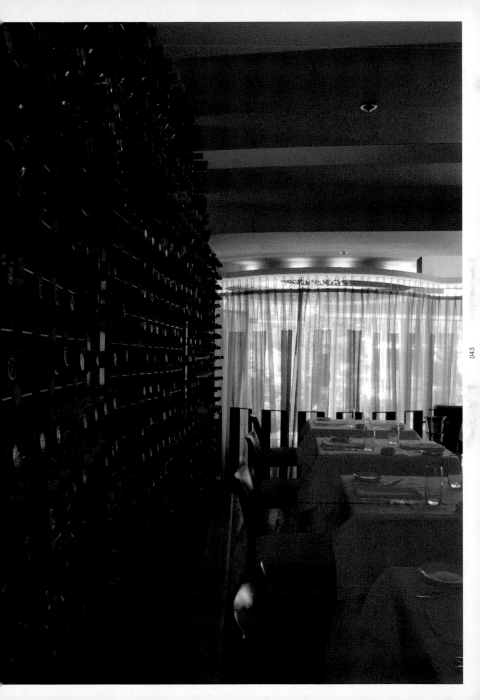

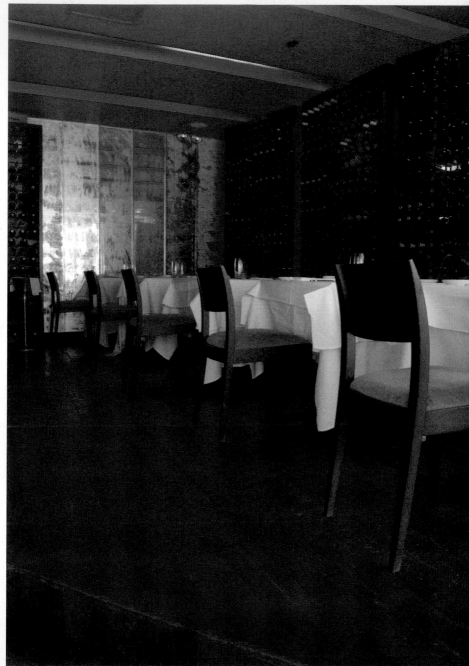

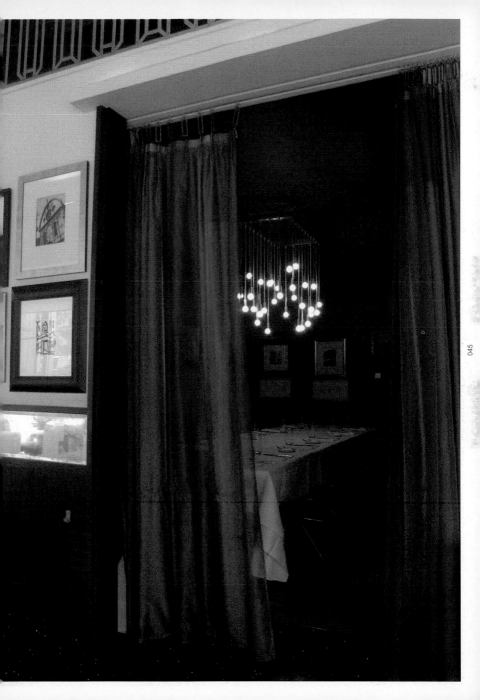

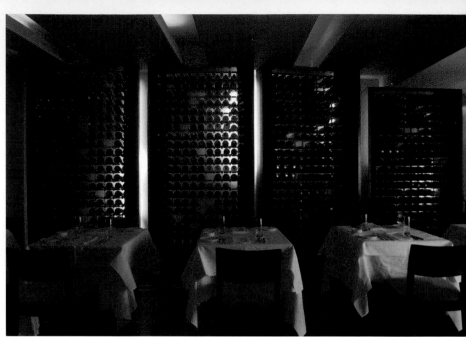

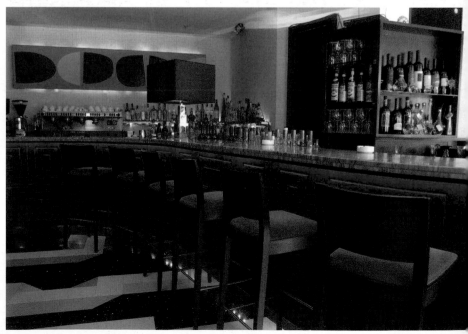

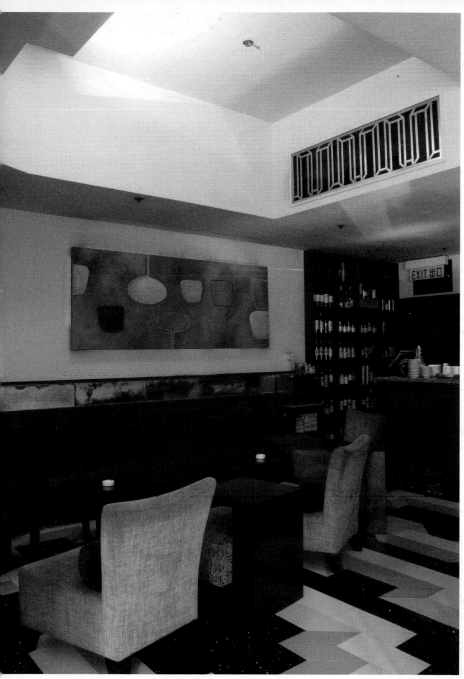

FRESH IDEAS

green

Located in an overhead pedestrian bridge elevated above the bustling traffic of Wanchai, Green is a stark response towards the issues of youth and environmental awareness.

NAME OF ESTABLISHMENT **GREEN**
OWNER/CLIENT **MASS CONCEPTS LTD**
ARCHITECT/DESIGNER **SUNAQUA CONCEPTS LTD**
PHOTOGRAPHER **ELAINE KHOO**
TEXT **ANNA KOOR**
LOCATION **SHOP 7, THE SANLITUN, 28 HARBOUR ROAD, HONG KONG**
TEL OF ESTABLISHMENT **(852) 2802 0666**

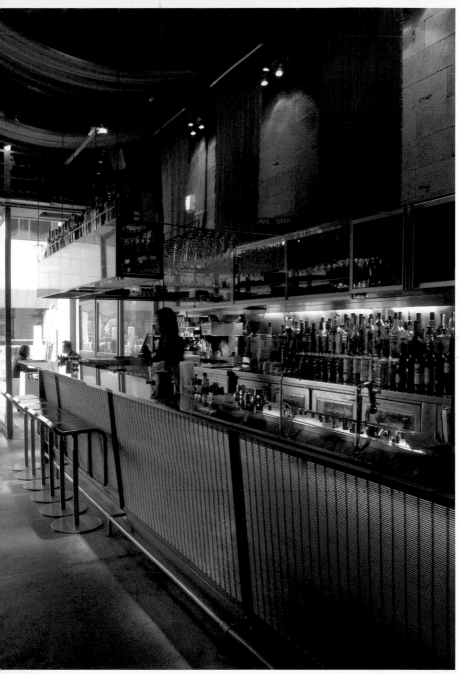

Conceived as a fusion of gastronomy and music, the hip Green bar and restaurant is distinguished by its unique site, which is elevated above the busy Wanchai traffic on a pedestrian bridge. The name "Green" was derived from the word's various associations, and this is central to the whole dining experience. Apart from making its appearance in green curries and basil herbs, "green" is associated with environmental sensitivity, as well as the energy of the young generation - whom the restaurant hopes to target.

The idea for a loft space was generated by the bar's unusually generous dimensions. Instead of indulging in luxurious materials and finishes - which is itself also a nod to environmental awareness - the loft look reinforces the existence of the original brickwork and services. Materials are employed in a way that defy their natural expressions. Hence, timber, which is normally perceived as tactile and warm, is cut into hard-edged, solid blocks. Likewise, metallic surfaces are treated softly in curved, organic forms. Amidst the myriad of shapes and textures, the materials are aligned along a horizontal datum to bring a sense of order and integrity.

To encourage interaction between strangers, as well as to feed a younger crowd's appetite for unconventional dining options, two large communal tables occupy the heart of the restaurant, and this is complemented by long benches on the fringe of the dining space.

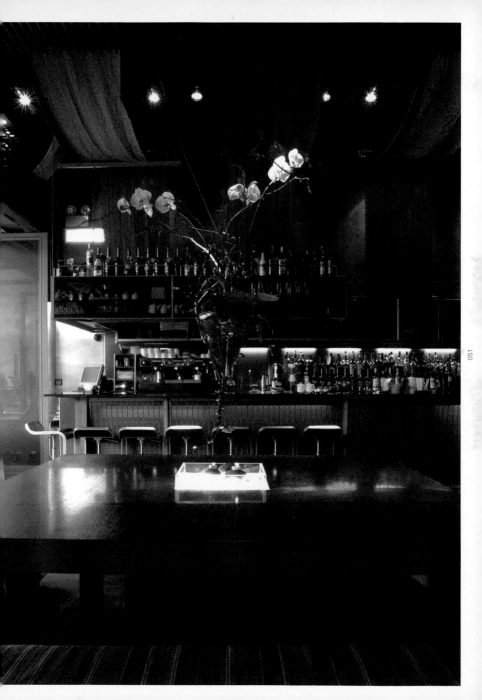

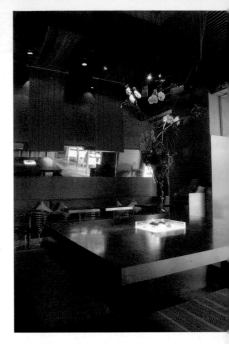

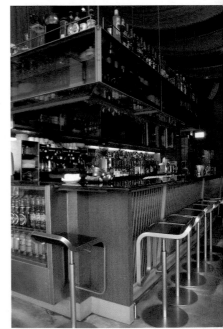

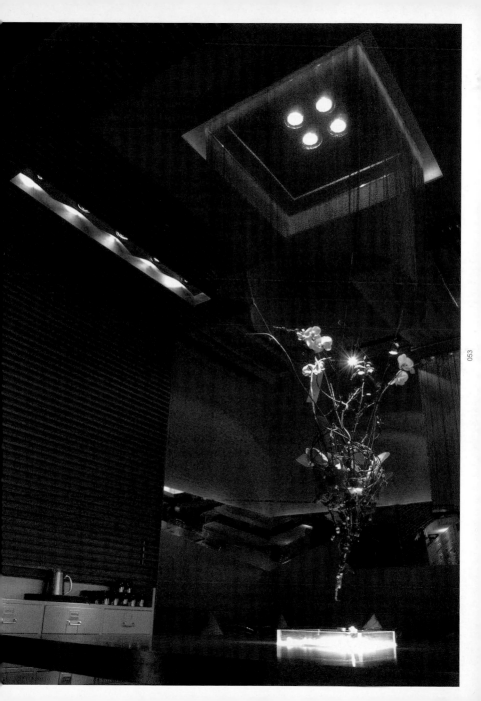

OPPOSITE ATTRACTION

heaven
on earth

Split into a restaurant section upstairs and a bar downstairs, Heaven On Earth is a manifestation of the dichotomy of opposites.

NAME OF ESTABLISHMENT **HEAVEN ON EARTH**
OWNER/CLIENT **KING PARROT GROUP**
ARCHITECT/DESIGNER **ZANGHELLINI HOLT ARCHITECTS**
PHOTOGRAPHER **ELAINE KHOO**
TEXT **ANNA KOOR**
LOCATION **G/F AND 1/F, 6 KNUTSFORD TERRACE, TSIM SHA TSUI, HONG KONG**
TEL OF ESTABLISHMENT **(852) 2367 8428**

This establishment sits on two levels, with a Chinese restaurant upstairs and a bar on the street level. The two distinct spatial zones of the restaurant have prompted the designer to explore the notion of a dichotomy of opposites, which subsequently also generated the name "Heaven on Earth". The designer has interpreted this dialectic relationship through the assemblage of various materials and colours that are apparently antagonistic - modern versus rustic, traditional versus contemporary.

The site is long and narrow, with no direct link between the two floors; the restaurant Is accessed only via a neighbouring lobby. Most fortunately, a balcony overlooking the street terrace helps to establish a visual link. There are many common threads in the treatment of both floors, primarily relating to the proportions of materials. While steel is used as a major element in the bar, it appears with much more rarity upstairs. The latter is more sedate and quiet, relying on the imaginative use of burnished materials such as aged-copper, timber panels and bamboo flooring.

The bar's frontage is defined by a Chinese "moon-gate", that has been exaggerated to permit a wider entrance. The plan's depth is counteracted in several ways. A glowing red "egg" at the back of the bar disguises private booth seating, and also projects itself onto the street, striking an immediate impact on passers-by.

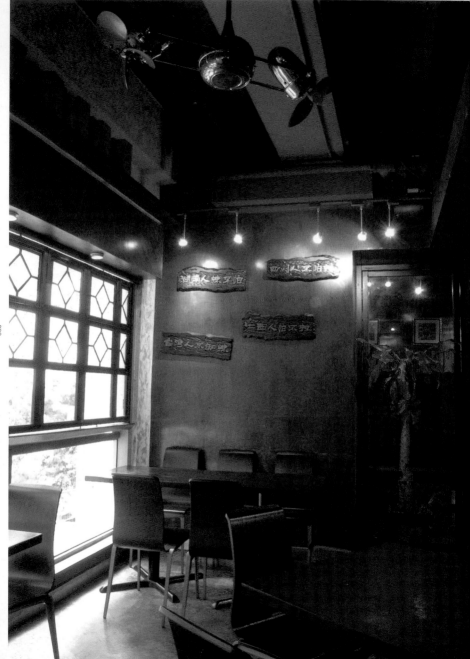

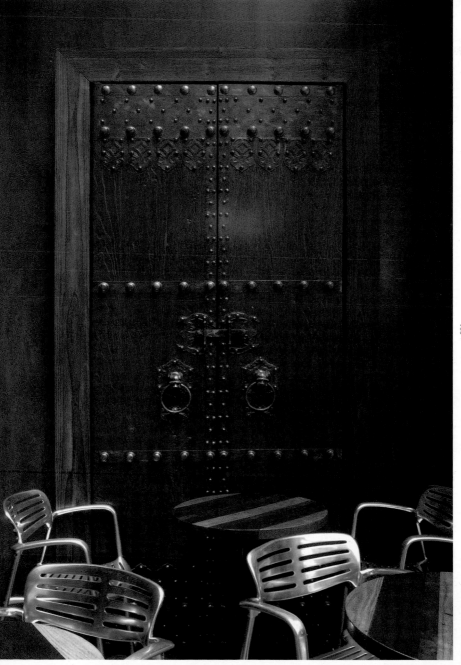

EUROPEAN CHARM

kee club

Inspired by the beautiful old apartments found in Europe, Kee Club is encouraged to be anything that its members shape it to be.

NAME OF ESTABLISHMENT **KEE CLUB**
OWNER/CLIENT **LIFE**
ARCHITECT/DESIGNER **COLLABORATE LTD**
PHOTOGRAPHER **WILLIAM FURNISS**
TEXT **ANNA KOOR**
LOCATION **6/F, 32 WELLINGTON STREET, CENTRAL, HONG KONG**
TEL OF ESTABLISHMENT **(852) 2810 9000**

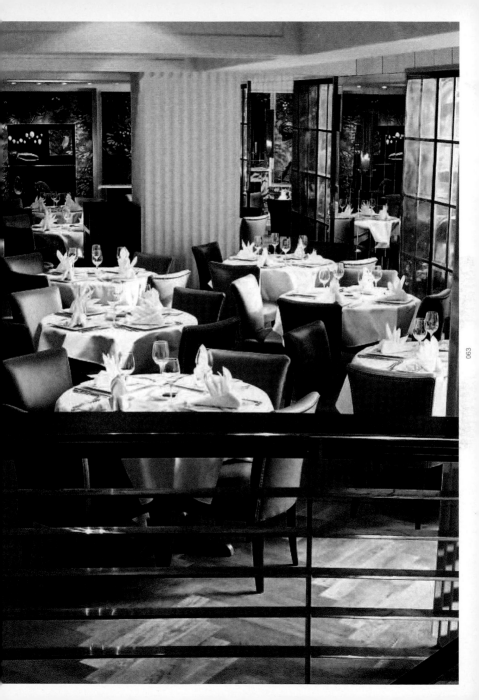

One is forgiven for thinking that this interior is to be found within a traditional European family apartment. Complete with ancestral portraits, a baby grand piano, and a homely mismatch of paintings and artefacts, it is not hard to see why. Inspired by the many beautiful old apartments of Europe that the owners have encountered on their numerous trips, the grandeur and luxury of Kee Club seek to cultivate the very same ambience of those apartments.

To achieve this, the layout is organised into big rooms that flow into one another. Yet, also central to the design programme is the need to accommodate simultaneous private functions, whilst ensuring that the needs of the members are met. The two floors of the club are treated very differently. The lower floor is cut lengthways with a grand lounge and a dramatic staircase, demarcating a public area. Successive spaces stretch down the remaining portion, joined by double doors and designed in the temperament of traditional European salons.

Neutral finishes and clean lines of zinc and granite in the grand lounge are textured by a leather-clad trellis of *fleur-de-lis*. This is most intense on a zinc-coated spinal wall, which is layered with the French emblem. The wall comes into play when adapting the space to different functions. It swivels ninety degrees to enclose the whole rear of the grand lounge. As one progresses into the more private spaces, richer details take hold. Each salon has a different colour palette - giving a kaleidoscopic effect as one stands at the end of the space.

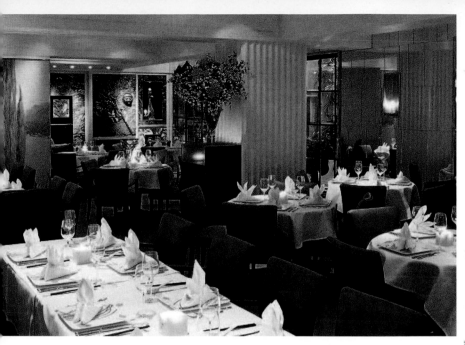

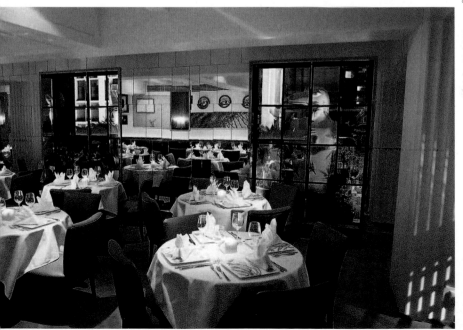

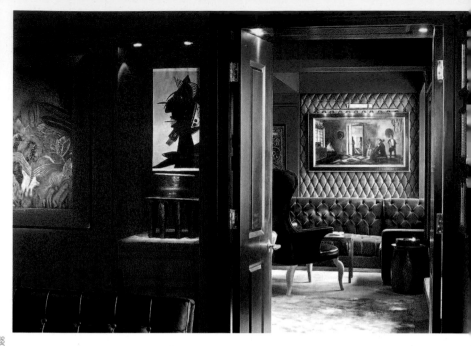

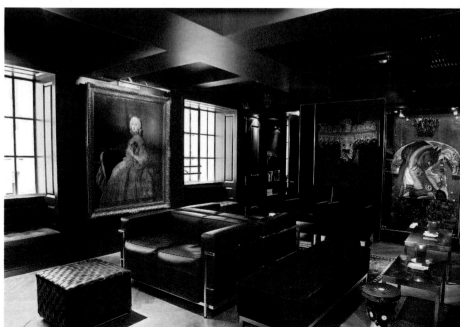

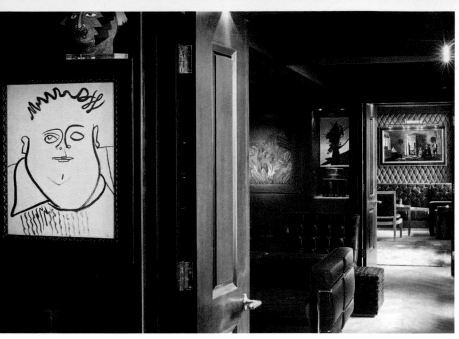

IN THE SHADE OF THE TREE

kokage

Under the multi-linguistic setting of cultures in Kokage, light and shadow interplay to cast an ambient experience that is like being in the shade of a tree.

NAME OF ESTABLISHMENT **KOKAGE**
OWNER/CLIENT **ELITE CONCEPTS**
ARCHITECT/DESIGNER **TONY CHI AND ASSOCIATES, EC STUDIO**
PHOTOGRAPHER **ELAINE KHOO**
TEXT **ANNA KOOR**
LOCATION **9 STAR STREET, WANCHAI, HONG KONG**
TEL OF ESTABLISHMENT **(852) 2529 6138**

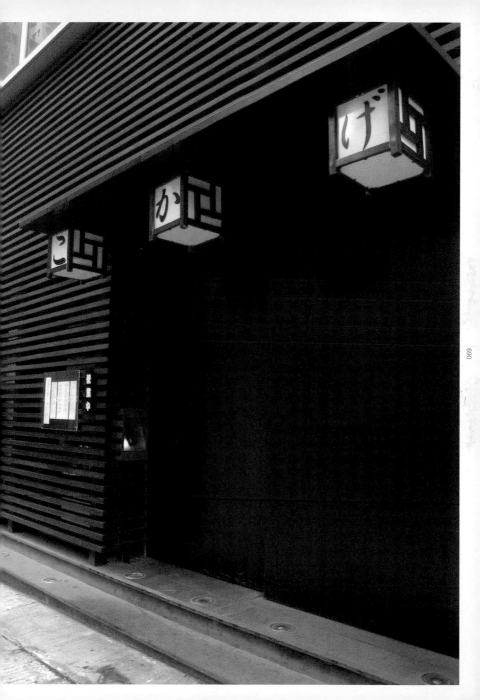

Kokage's design takes a jibe at all the formalities that go with modern dining. The restaurant's name means "in the shade of a tree", which is easily seen in the interpretation of the interior.

Columns are decked in green-glazed celadon roof tiles, vertically applied to imply the texture of bark. Spindle-backed chairs convey a twig-like quality, with overhead lighting filtering through their forms and casting shadows onto the floor, like sunlight filtering through a canopy of foliage.

The interior setting speaks more tongues than its American-Japanese cuisine. Allowing space to dissolve the rigidity of dining codes as set by meal times and conventions, the designer has broken the rules with a stark granite cocktail counter that is juxtaposed with the adjoining sushi bar and offset by glass-and-oak liquor cabinets. Kokage also extends the dining experience by putting the *sake* on show. Rather than simply displaying a feature, the designer lets customers see what there is on offer. Overlooking all of the theatrics of the bar and contrasting with the tendril shadows is a pair of semi-circular red leather sofas with tables fashioned from solid blocks of timber.

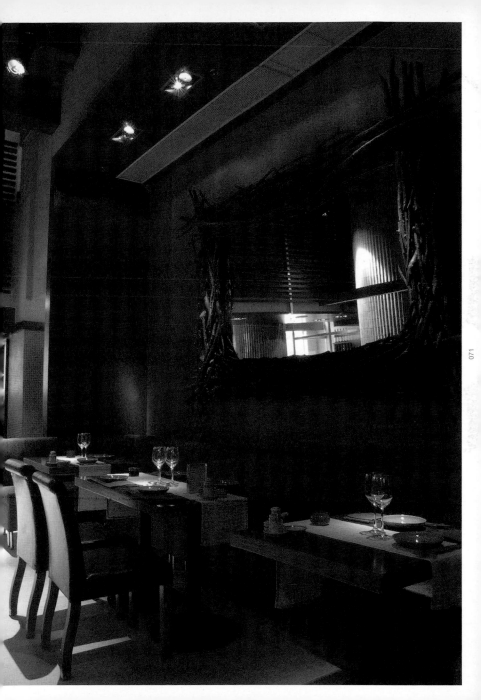

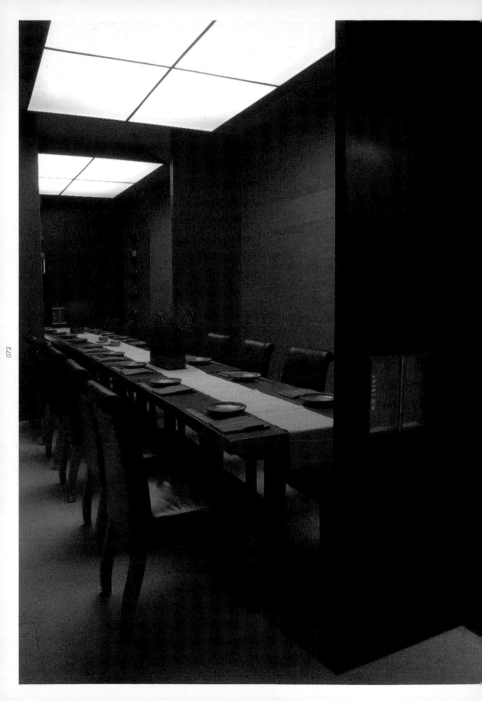

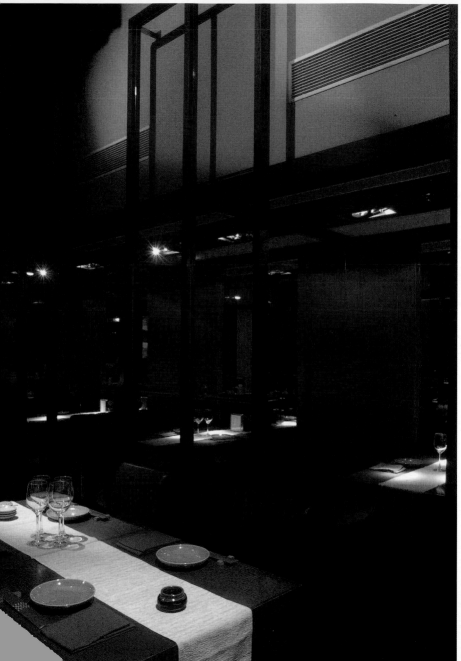

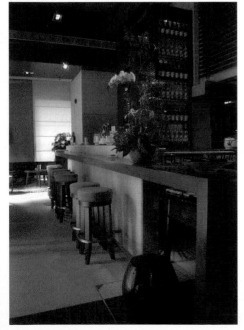
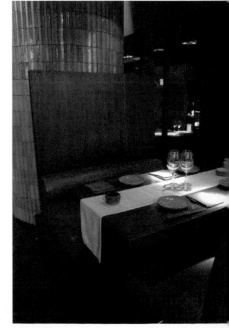

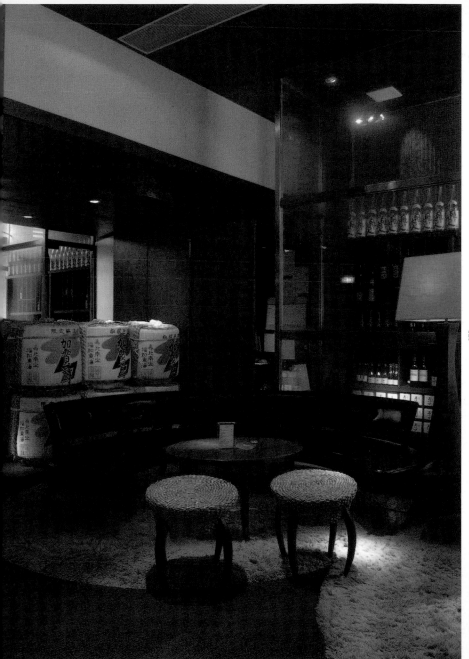

BORROWED NATURE

miso

Although ultra-modern in its forms and finishes, a journey into Miso is like a stroll through a traditional Japanese garden.

NAME OF ESTABLISHMENT **MISO**
OWNER/CLIENT **MAX CONCEPTS**
ARCHITECT/DESIGNER **RYMD INDUSTRIES LTD**
PHOTOGRAPHER **ELAINE KHOO**
TEXT **ANNA KOOR**
LOCATION **UNIT 15, BASEMENT, JARDINE HOUSE, 1 CONNAUGHT ROAD, CENTRAL, HONG KONG**
TEL OF ESTABLISHMENT **(852) 2845 8773**

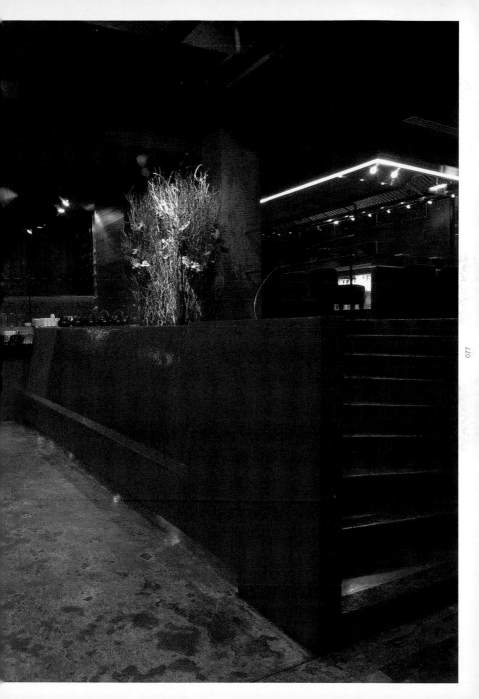

Although ultra-modern in its forms and finishes, a journey into Miso is like a stroll through a traditional Japanese garden. At the entrance, customers are able to view the entire 4,000 square foot restaurant from a concrete platform, before descending into the "forest" ahead.

The *teppanyaki* bar to the right of the entrance is a construction of distressed silver plastic laminate, an indication of the designer's efforts to employ unorthodox materials. Various walls are clad in rough wooden planks. Rectangular-sectioned columns that are clad with timber panels, bolted at the corners and lit from within, act as an abstraction of tree trunks.

If they venture as far as the eye can see, guests will find themselves drawn towards the sunset-orange rear wall. Panels of glass bolted onto it give protection from its rough-hewn surface. In between this, a rectangular coil of light is sheathed by Japanese rice paper and clear acrylic, highlighting the sushi bar and its "antique silver leaf" laminate finish. Mini-islands of seating are gathered around this central feature. Cosy corners of banquette seating are outlined by low partitions for some privacy.

In the washrooms, the heaviness of raw iron doors is a prelude to the floating elements inside - the mirror and the fibreglass washbasins that are mounted in a terrazzo trough, and faucets that are fashioned from copper plumbing pipe.

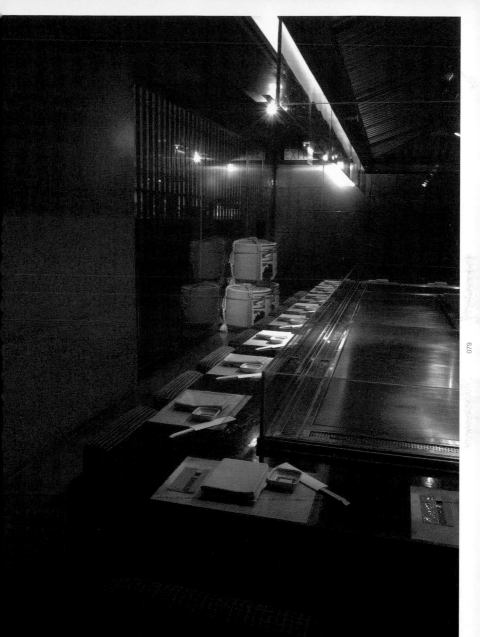

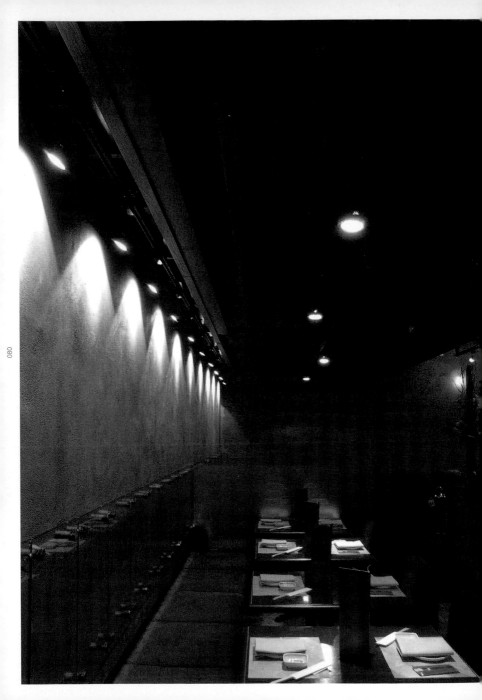

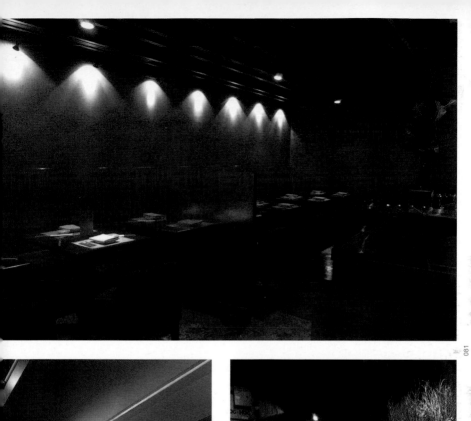

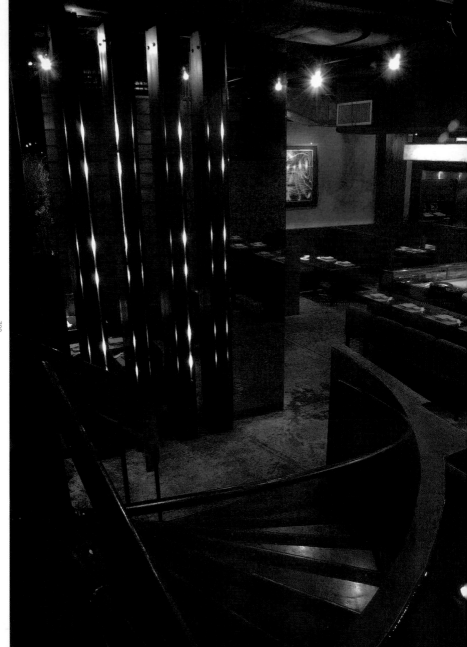

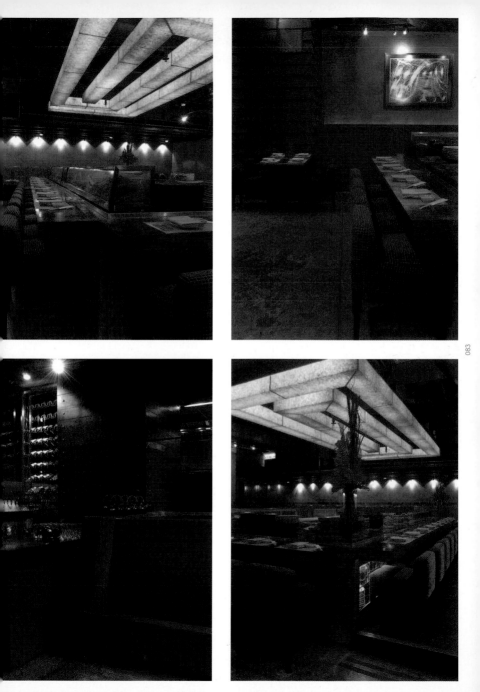

DIIVIDED WHOLE

one-fifth

Flanked by two lounges that are similar and yet varying in character, the bar becomes the centre of attention in One-Fifth.

NAME OF ESTABLISHMENT **ONE-FIFTH**
OWNER/CLIENT **ELITE CONCEPTS**
ARCHITECT/DESIGNER **TONY CHI AND ASSOCIATES, EC STUDIO**
PHOTOGRAPHER **ELAINE KHOO**
TEXT **ANNA KOOR**
LOCATION **9 STAR STREET, WANCHAI, HONG KONG**
TEL OF ESTABLISHMENT **(852) 2520 2515**

The entrance to One-Fifth is tucked down a cul-de-sac out of view and disguised by a 10 metre high wall of bamboo plants. Before reaching the bar, one navigates through a staircase and a soundproof, mood-lit bridge with a mirrored ceiling. This then makes way for an enormous hall that evokes the spatial qualities of a loft.

The scale of the space is unusual, and with a ceiling height that is in excess of two storeys, one would expect the proportions to be uncomfortable. However, the designers have accommodated these dimensions into the design perfectly.

Negotiating the long linear plan are two lounges created on each end of the space. One of the two lounges is outlined by ledges on which art is propped - a flexible gallery of sorts. The other is defined by ledges under the large windows around the perimeter of the lounge. Bare-bulb chandeliers, baroque mirrors, thick velour drapery and oversized leather armchairs upholstered with brass studs give the impression of a medieval castle. The earthy palette provides a muted counterpoint to the bar - which forms the central focus of the space - providing the opportunity for a little display of theatrics.

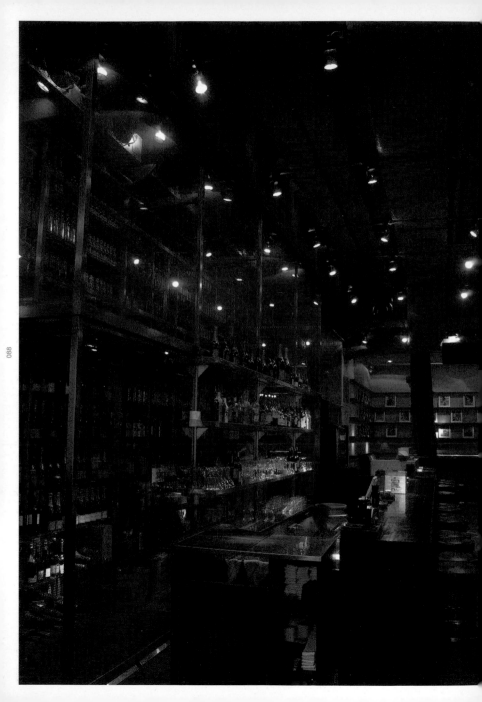

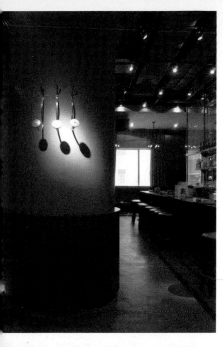
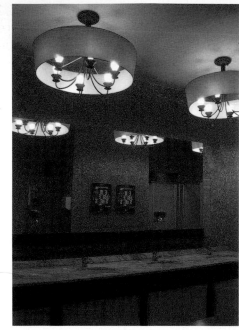

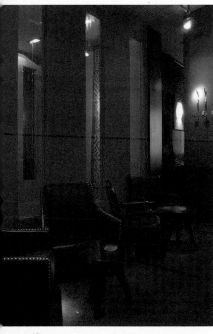
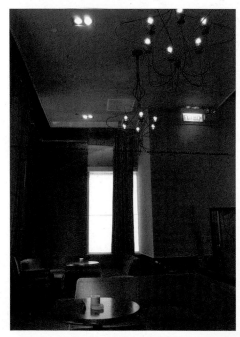

VIEW FROM ABOVE

Possessing a distinctly easy feel, Q8 attempts the cross-programmatic mix of an art gallery and a restaurant.

NAME OF ESTABLISHMENT **Q8**
OWNER/CLIENT **SUSANNA AND SALINA HO**
ARCHITECT/DESIGNER **DIALOGUE LTD**
PHOTOGRAPHER **ANDREW CHESTER ONG**
TEXT **ANNA KOOR**
LOCATION **1/F, 8 QUEEN'S ROAD CENTRAL, HONG KONG**
TEL OF ESTABLISHMENT **(852) 2167 8380**

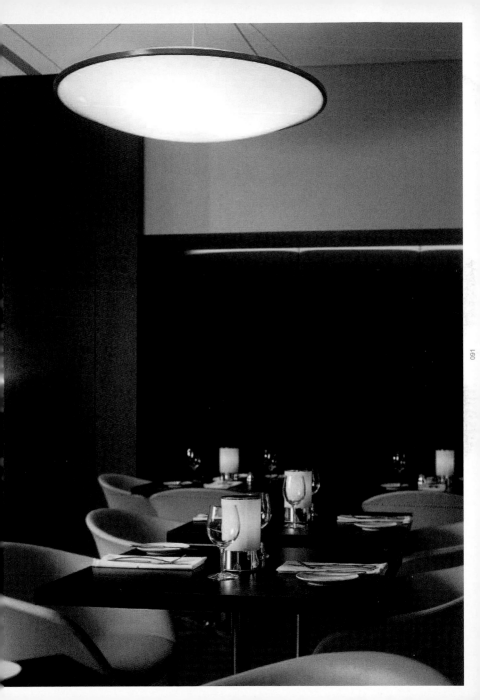

Cleverly combined with an art gallery, this eatery occupies a prime site on a major intersection. One of the prime concerns of the design was to play upon the restaurant's visibility from the exterior. The restaurant is fronted by huge expanses of glazing and enjoys generous ceiling heights. Through dramatic light fixtures - rendered as huge "saucers" of white perspex rimmed in stainless steel and suspended from the ceiling - the restaurant announces its location to the street in a quietly forceful gesture.

The restaurant has a distinctly easy feel. Much attention has gone towards the design of seating that is ergonomic. Tables and armchairs have been carefully dimensioned, such that patrons would feel as comfortable eating as they are enjoying a glass of wine, when seated. To exploit the views into the surrounding urban streetscape, as much seating as could possibly be achieved has been positioned around the window.

The gallery area serves as a transition space between the office tower and the restaurant. Drawn across its frontage is a curtain of slender chrome rods which ripple to the tune of the odd breeze from passers-by. An 11 metre long piece of artwork stretched across the full length of the space is decidedly organic. Coordinating with the material palette of the restaurant, the artwork offsets the cream "liquid leather" banquette seating, horsehair cushions and alligator-print leather tables perfectly.

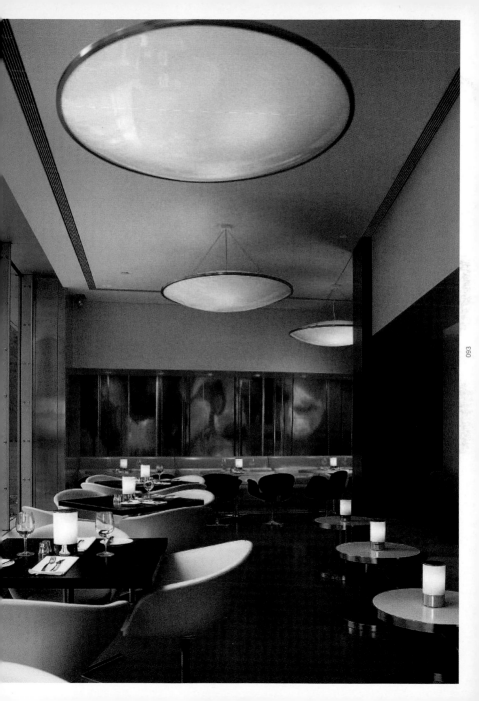

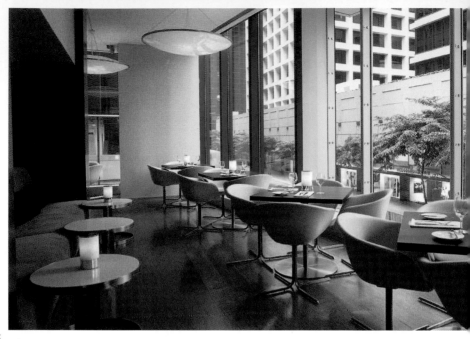

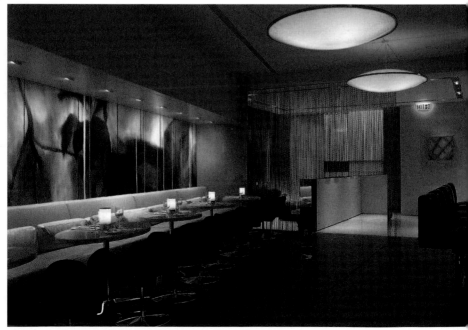

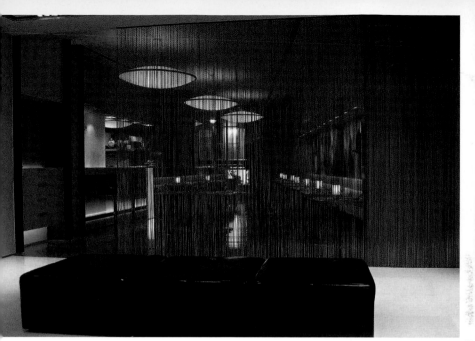

ICE QUEEN

solstice

At solstice, the cool, stark language of the interior marks its unconventionality and divergence from others.

NAME OF ESTABLISHMENT **SOLSTICE**
OWNER/CLIENT **PIZZAIOLO LTD**
ARCHITECT/DESIGNER **BUILDING DESIGN STUDIO**
PHOTOGRAPHER **ELAINE KHOO**
TEXT **ANNA KOOR**
LOCATION **8-9 SUN STREET, WANCHAI, HONG KONG**
TEL OF ESTABLISHMENT **(852) 2866 3089**

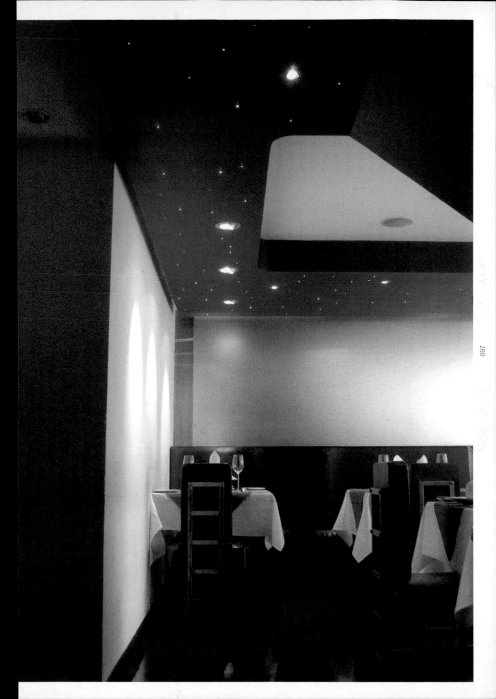

The first indication that Solstice is unconventional is the bar with its stark backdrop of frosted glass - not one bottle is in sight. The bar top is framed by a single steel element, which ascends up and overhead, supporting glassware along the way. The seating is all custom-designed and upholstered in satin blue vinyl.

A glass entrance, thinly framed in steel and raised on a terrace, makes for a pleasant change from the heavy traffic outside. The central bulkhead (the remainder of a disused cockloft) leaves a slither of double-height space around the edge of the interior, which has been punctured with windows, forming a perimeter light well that channels daylight, like a periscope.

With fenestrations detailed to appear completely frameless, the exterior is treated as a series of discreet elements that form a visual focus when the building is viewed from a distance. Enormous suspended sculptural lights add to the effect. A continuous seam of dark blue planes studded with stars runs across the interior, also concealing the jungle of services. The fact that traces of the original architecture, typical of this neighbourhood, still remains makes this space all the more intriguing.

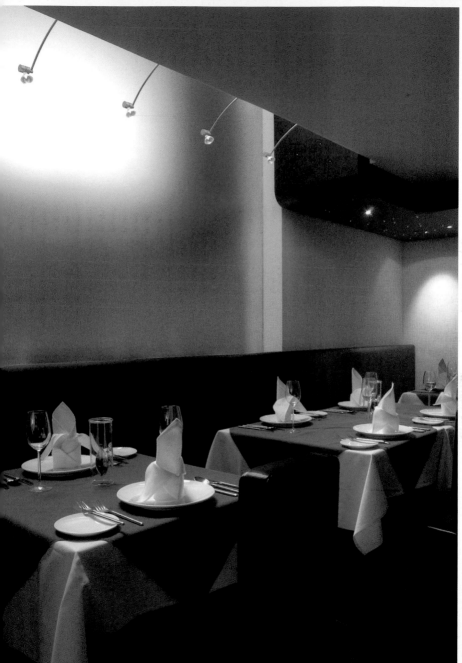

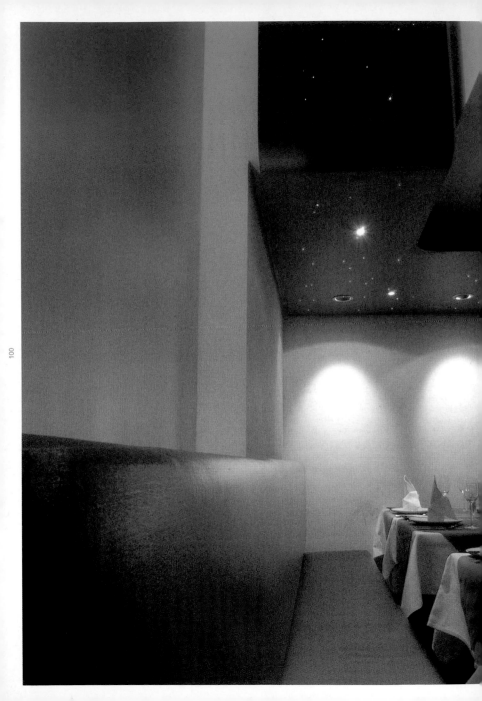

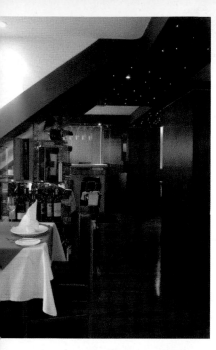

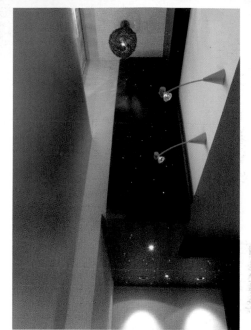

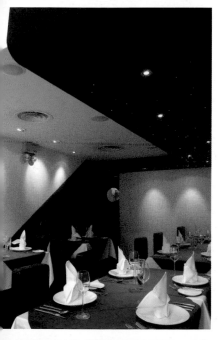

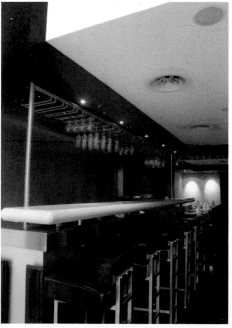

CASUAL COMFORT

thai basil

The casual ambience and clean contemporary design of Thai Basil makes it a draw for anyone seeking anything from a quick bite to a full meal.

NAME OF ESTABLISHMENT THAI BASIL
OWNER/CLIENT MAX CONCEPTS LTD
ARCHITECT/DESIGNER ZANGHELLINI HOLT ARCHITECTS
PHOTOGRAPHER MICHAEL CHUNG & ELAINE KHOO
TEXT ANNA KOOR
LOCATION LOWER GROUND FLOOR, PACIFIC PLACE, QUEENSWAY, HONG KONG
TEL OF ESTABLISHMENT (852) 2537 4682

Modern Thai cuisine defines a growing niche in Hong Kong and Thai Basil was one of the first restaurants to introduce it in a no-frills concept that is accessible to the masses. Styling the eatery as a café instead of a restaurant has helped to bring in guests throughout the day - the casual ambience a draw for anyone seeking either a quick bite or a full meal.

Being fully conscious of design features that could date, or that diners would tire of easily, the design of the interior avoided a "funky" theme. Instead, it is made sophisticated and inviting through warm notes of timber, interposed amongst the concrete and terrazzo floors, as well as monolithic walls. Screens of timber slats provide just enough separation from the general traffic of the shopping mall, offering diners a necessary sense of privacy whilst enticing passers-by with the prospects of what is being offered inside.

Nuances of Thai influences are detected in the accents of orchid pink, and the heavy grey elevations (which are an abstraction of the solid stone walls of Thai temples). The main circulation path within the café is denoted in grey granite and serves to connect the various elements of the entire space. A wide choice of seating options - ranging from bar and banquette seating to seaters of variable numbers - caters to different crowds and occasions.

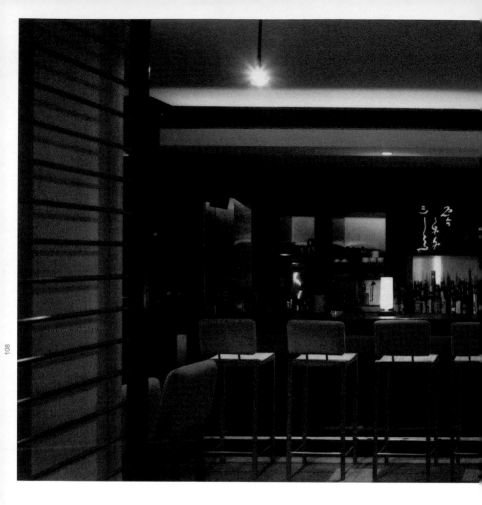

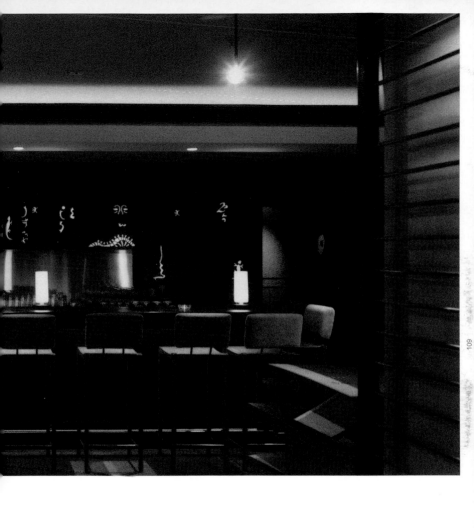

PSYCHEDELIC DREAMS

va bene
shanghai

Divided into small pockets of space, each area in Va Bene Shanghai tells a different story.

NAME OF ESTABLISHMENT **VA BENE SHANGHAI**
OWNER/CLIENT **MAXFOLD (HK) LTD**
ARCHITECT/DESIGNER **L & O LTD**
PHOTOGRAPHER **PAUL HILTON/JOLANS FUNG**
TEXT **ANNA KOOR**
LOCATION **7, NORTH BLOCK, XINTIANDI LANE, 181 TAICANG ROAD, SHANGHAI, PRC**
TEL OF ESTABLISHMENT **(86) 21 6311 2211**

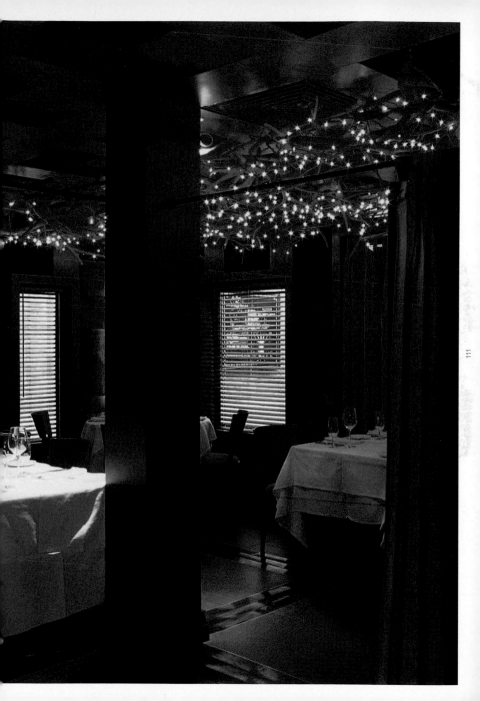

Designed by Leigh & Orange, the restaurant takes up two floors of a Shanghainese *shikumen* residence, and there is no mistaking the specific sense of history in the interior. Being much larger than its Hong Kong counterpart, Va Bene Shanghai is divided into smaller areas, each narrating a novel story. These zones can be opened up or shut off depending on the numbers of guests.

The interiors also reflect Shanghai's more extreme climes. The ground floor conservatory dining area feels like summer; a herbaceous landscape punctuated with parasols runs the entire length of the restaurant. The main dining room, lying adjacent, takes on a winter scene with its suede curtains and fur-lined walls. The duality of these spaces also determines night and daytime use.

Upstairs, the main bar is fronted by a backlit, digitally-enlarged image of the famous 1784 Nolli Plan of Rome. It is difficult to miss the cascading swags of wires overhead - a modern take on a medieval chandelier. Into the depths of the space lies the "grotto", a private dining area taking the form of a cavernous nook. The ceiling is finished in a papier-mâché effect and UV-sensitive paint that emanates an electric-blue glow. Chandeliers suspended beneath its mottled surface are decorated with crystals and oyster shells.

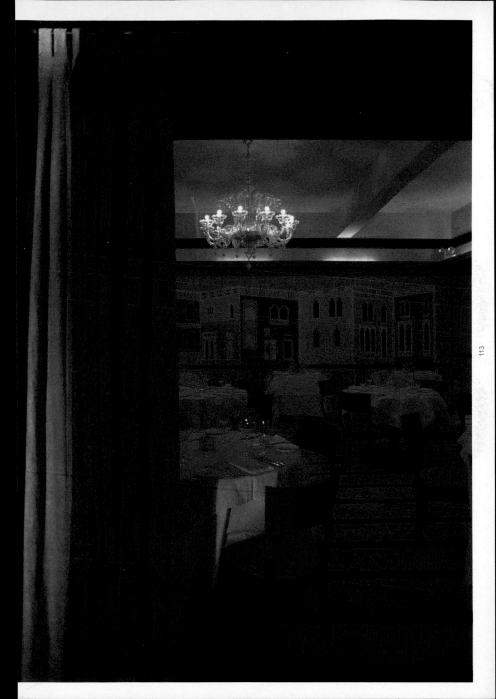

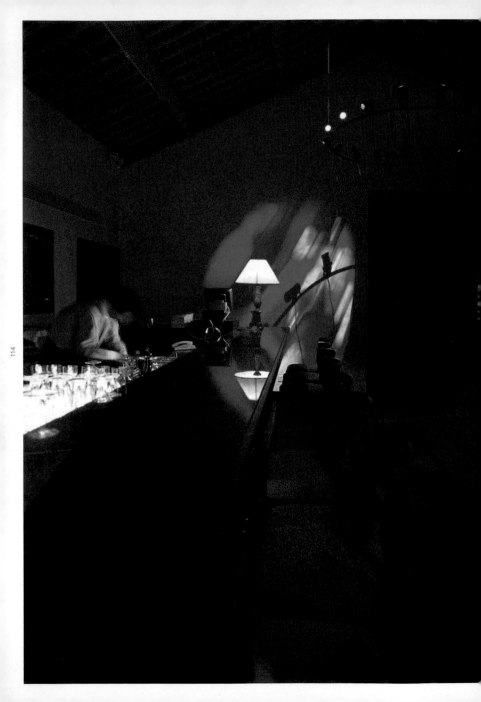

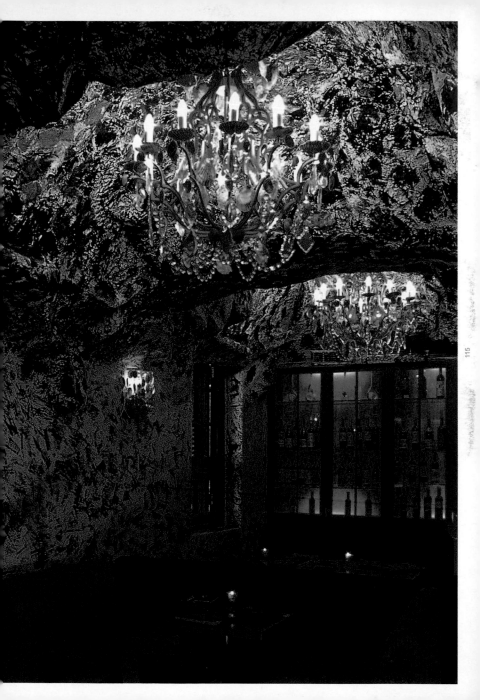

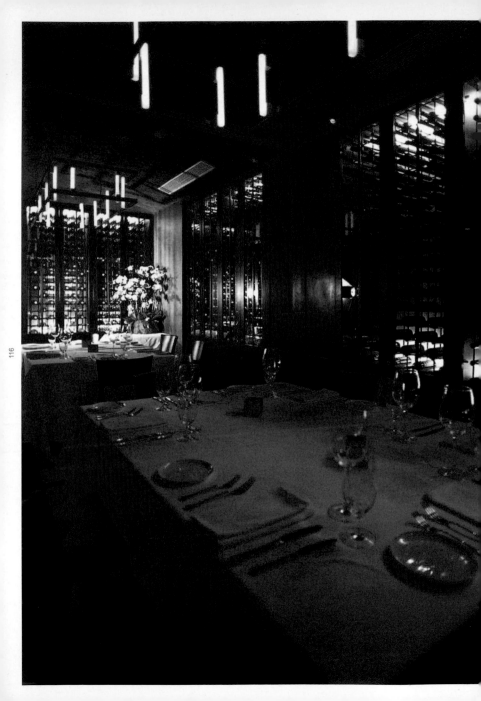

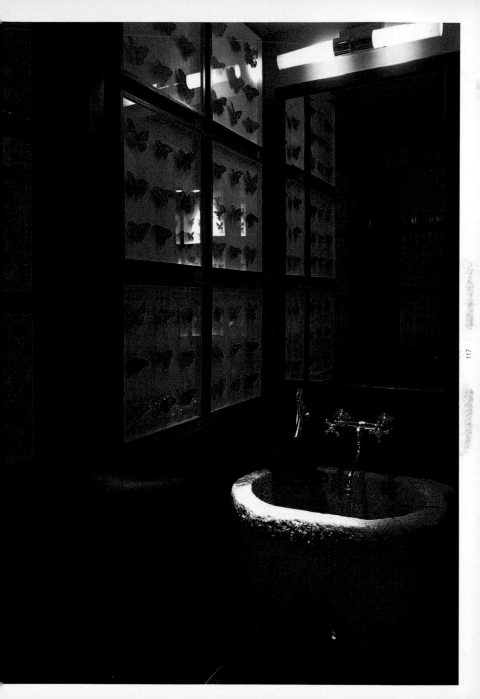

INTRICATE DETAILS

veda

Meaning "the source of all knowledge" in Sanskrit, "Veda" is the chosen name of this restaurant, which seeks its inspiration from the details of the great palaces of Rajasthan.

NAME OF ESTABLISHMENT **VEDA**
OWNER/CLIENT **HINDSTAR LTD**
ARCHITECT/DESIGNER **PURE CREATIVE ASIA LTD**
PHOTOGRAPHER **ONG YEW CHUAN**
TEXT **ANNA KOOR**
LOCATION **G/F, 8 ARBUTHNOT ROAD, HONG KONG**
TEL OF ESTABLISHMENT **(852) 2868 5885**

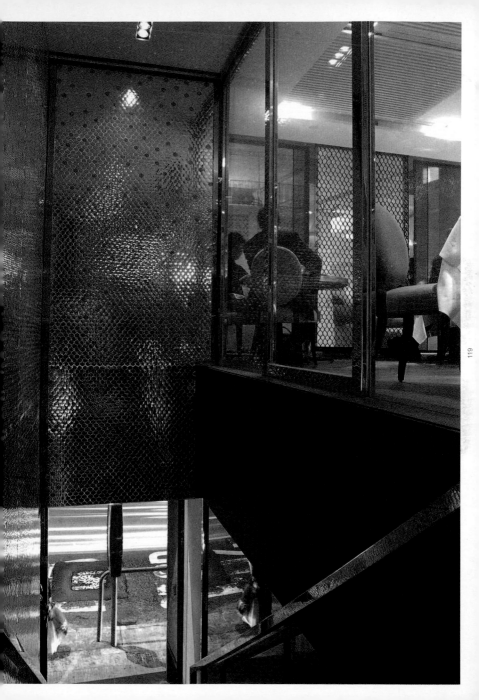

Appropriately poised above Hong Kong's drinking den of Lan Kwai Fong, the concept of Veda is modern-design-meets-food-philosophy. Grounded within the "culture of knowledge" - the name "Veda" is derived from ancient Sanskrit, meaning "the source of all knowledge".

The designer's inspiration for Veda came from the great palaces of Rajasthan. Desert hues of browns and sunset orange are melded with materials such as hammered Indian silver, which clads the bar and tabletops. From the earth-toned lounge and bar at ground level, an adjoining staircase - whose walls are clad in a mirror-mosaic of honeycombed, Mogul-inspired patterns - takes diners upstairs, to the restaurant.

During the day, natural light filters through window screens made from curled and entwined timber veneer, to bounce off the walls of banded grey, cream and emerald capice shell. Private dining space can be arranged by reconfiguring the walls of the restaurant into three separate areas. Veda is anything but a themed experience. What distinguishes Veda from that genre of themed restaurants is its level of craftsmanship, the modest but sharply contemporary use of traditional motifs, the custom-made fabrics and furniture, and the deft use of colour.

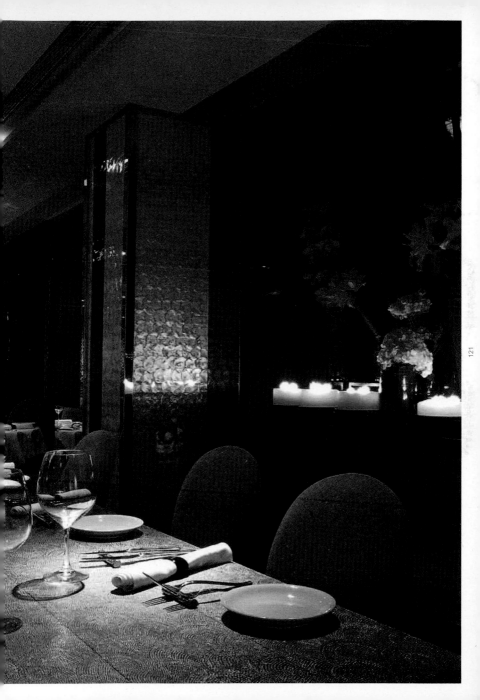

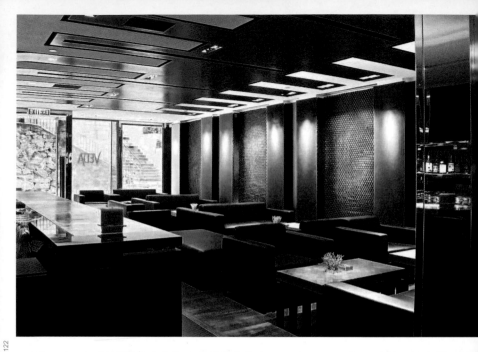

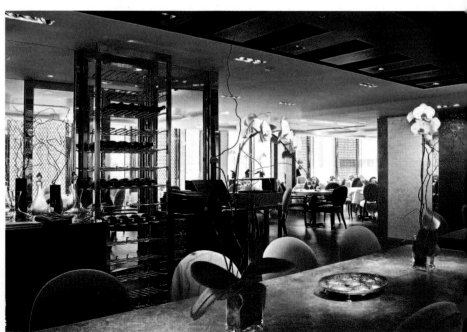

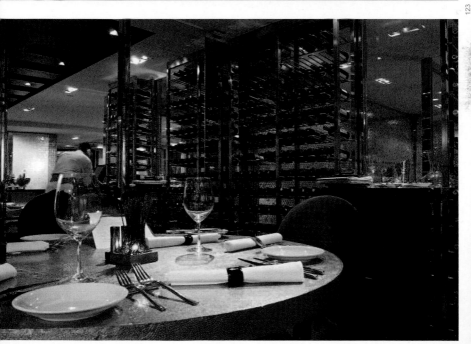

EASTERN ILLUSIONS

wasabisabi

As you cross the threshold into Wasabisabi, you will discover a world that is dizzyingly different from the shopping mall outside.

NAME OF ESTABLISHMENT **WASABISABI**
OWNER/CLIENT **DAVID YEO, RICHARD WARD**
ARCHITECT/DESIGNER **YASUMICHI MORITA, DAVID YEO, SATOMI HATANAKA, SEIJI SAKAGAMI**
PHOTOGRAPHER **ELAINE KHOO**
TEXT **ANNA KOOR**
LOCATION **13/F TIMES SQUARE, 1 MATHESON STREET, CAUSEWAY BAY, HONG KONG**
TEL OF ESTABLISHMENT **(852) 2506 0009**

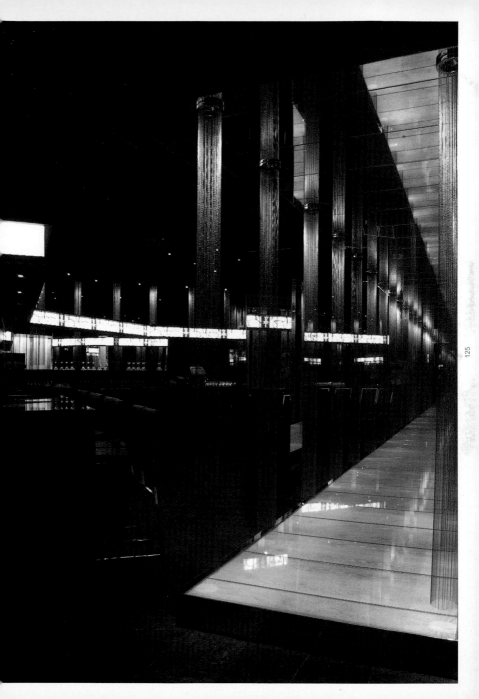

Once over the threshold of Wasabisabi, any lingering thoughts of the shopping mall outside are immediately eradicated. Ahead lies a different world - a dizzy concoction of mirror images, floating catwalk floors, and carousel tables. These are set against forms that start out vaguely Western, and then gradually become recognisably Japanese as tatami textures, wasabi-green tinges, and natural stone roll in across the interior.

The Japanese theme of the restaurant is accentuated towards the rear, with a wall of frosted glass that provides a shadowy veil to the forest of "trees" behind it. This subtlety is striking: Columns of strung steel beads line the catwalks like a flexible colonnade, forming a sensorially engaging feature within the restaurant. These swaying fringes make a shimmering and poetic reference to bamboo stems. Complementing these steel bead columns are the glass catwalks, which are not wholly transparent, but sandwiched with a layer of white Japanese ash veneer. Backlit to give a luminous effect, the catwalks make the process of physically moving through the restaurant a surreal experience.

In the sunken tatami room, a zig-zag banding of vertical metal plates alternately covered in aubergine and silver crushed velvet creates a mossy effect. On top of that, it introduces an element of privacy. The exaggerated use of mirrors effect in multiple reflections that give the impression of infinity within the space, not only dematerialising the walls, but also providing a permanent window through the space.

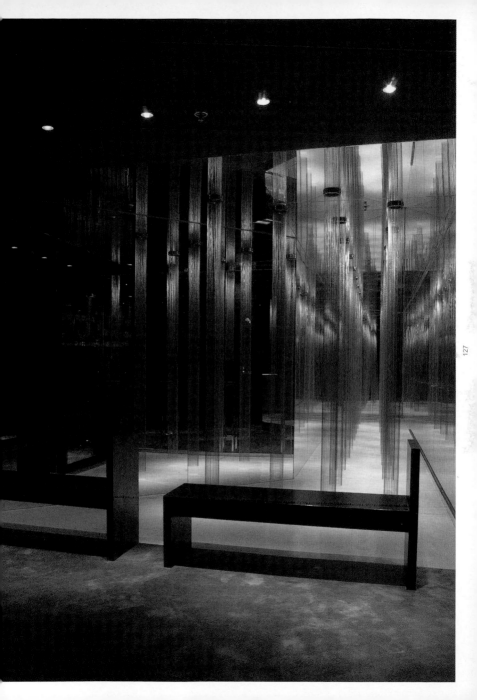

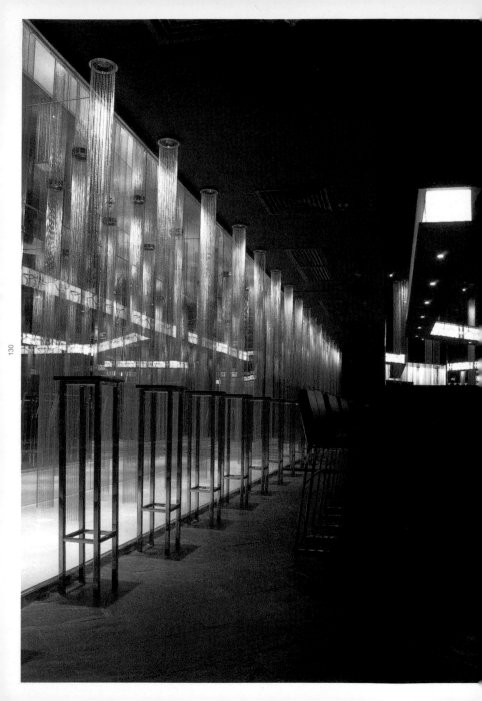

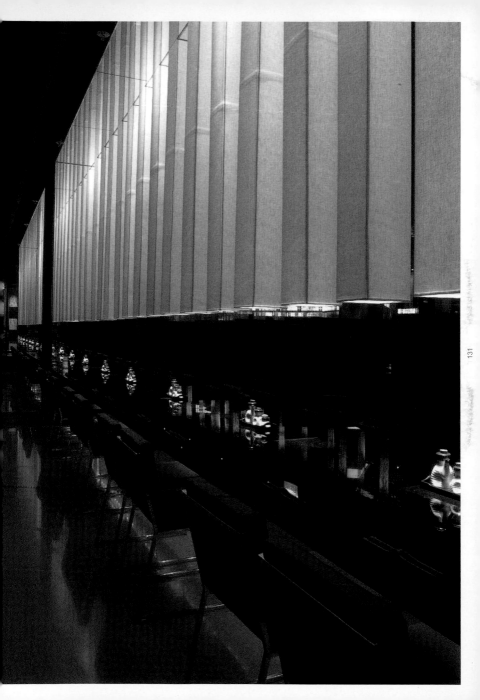

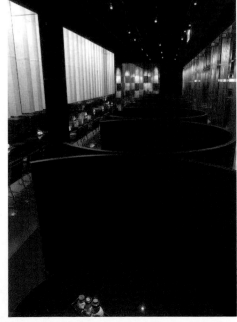
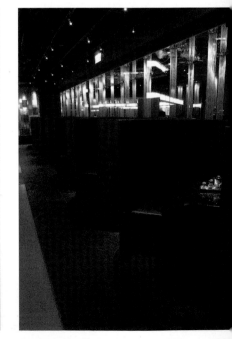

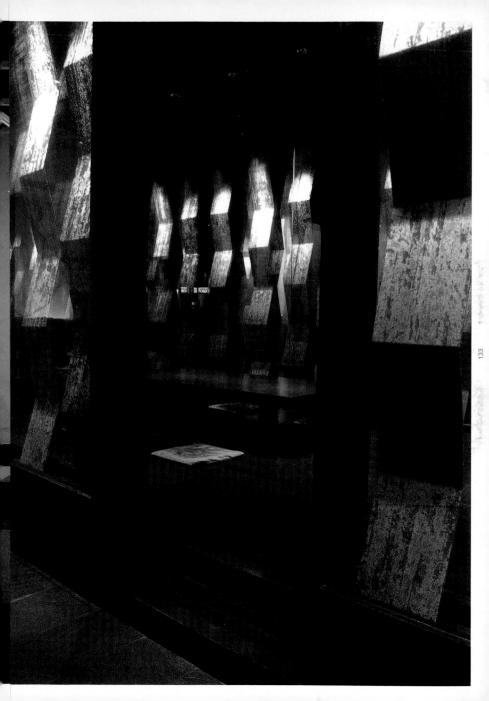

Fast food restaurants are not known for savvy interior design, but Wonderfood Café is a refreshing exception. This fast food outlet is decidedly different from its competitors, as the typical heavy use of colours is not to be found here. Instead, slatted timber and large swathes of single colours denoting different zones address the goal of clarity and efficiency.

The shop frontage is really the serving area that gets patrons "through the door". Acting as signage in its own right, its ridged timber appearance is, in reality, textured glass that has been painted on the reverse side. Also helping to guide the eye is a lining of polished stainless steel that enwraps the front wall and climbs up the ceiling in a seamless hike, before ending abruptly at the serving area.

Speed is a graduated element here; the front area is defined as a "street" - the idea being to keep people moving in the same direction. Speed is dictated through areas of different seating, each denoted in different colours - for a quick meal, diners can simply take the barstool seats in front, or choose between the booth seating or canteen benches at the rear for more leisurely dining. They can also make their way into the "garden", where the designers have decided to play on the theme with a yellow laminated arbour that provides the cosy enclosure of a garden pavilion.

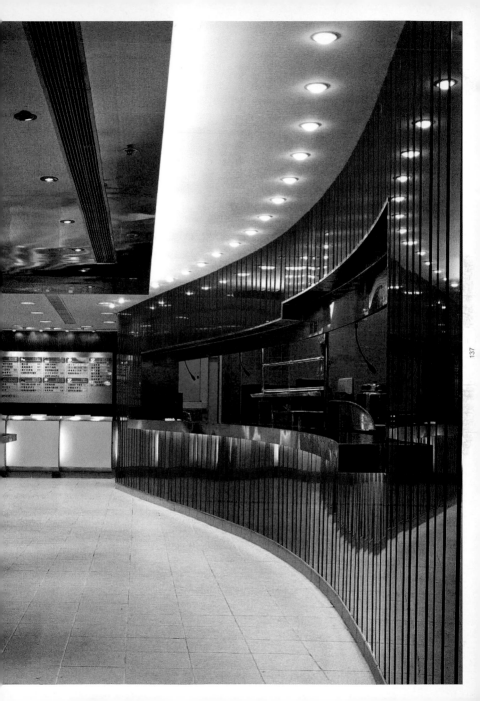

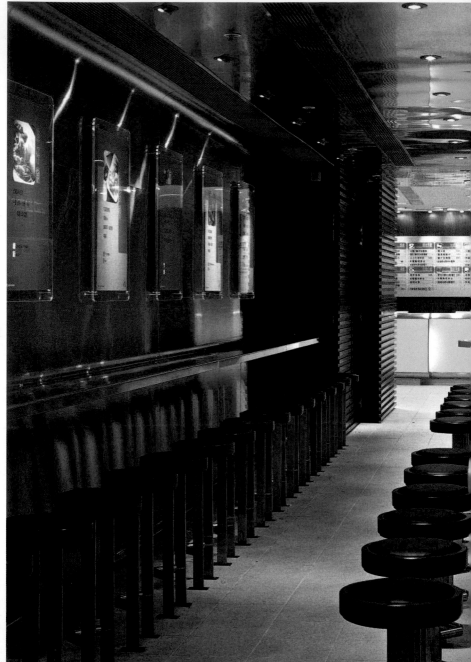

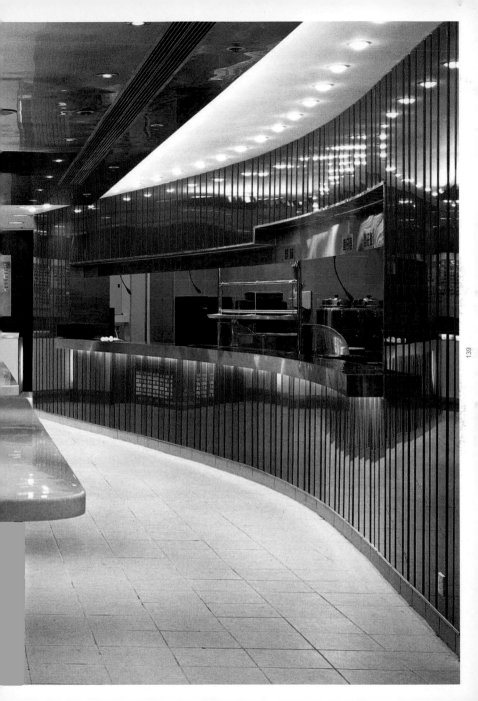

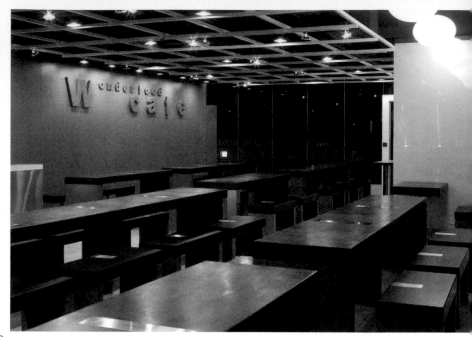

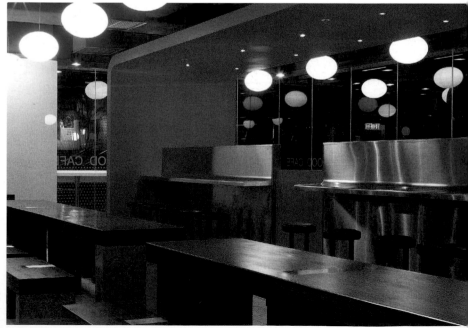

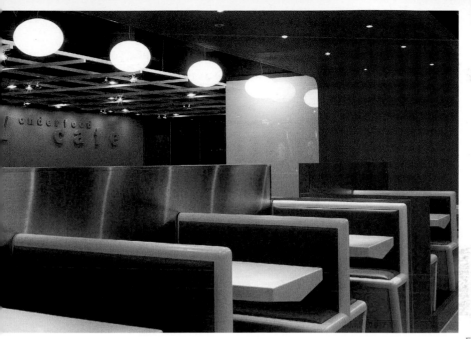

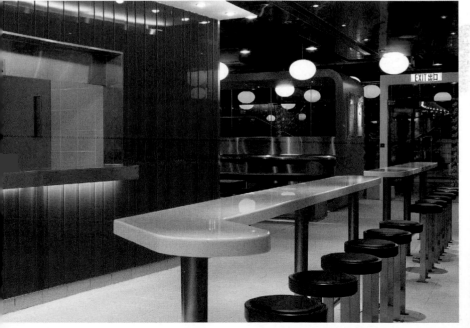

SECRET ATTIC

zen shanghai

Occupying the attic of a restored Shanghainese *shikumen* residence, this restaurant breaks away from the industrial expressions of its neighbours in the locality.

NAME OF ESTABLISHMENT **ZEN SHANGHAI**
OWNER/CLIENT **ZEN CHINESE CUISINE LTD**
ARCHITECT/DESIGNER **ANDRE FU/AFSO DESIGN, FRED LAU/RYMD INDUSTRIES**
PHOTOGRAPHER **JOHN BUTLIN**
TEXT **ANNA KOOR**
LOCATION **2 XIN YE LU, XINTIANDI, SHANGHAI, PRC**
TEL OF ESTABLISHMENT **(86) 21 6385 6385**

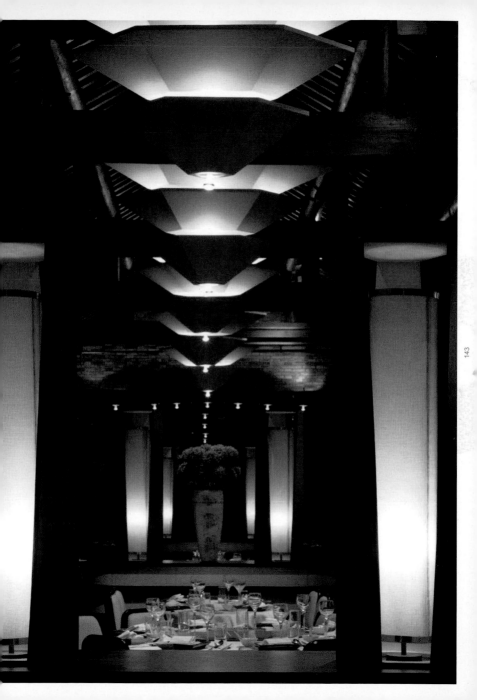

Zen Shanghai occupies the attic space of a *shikumen* in Xintiandi - a giant development of restored traditional Shanghainese residential buildings. While many of Zen's neighbouring establishments are eager to respond to the distinctive architectural envelope with rustic or industrial expressions, Zen takes a different approach.

The entrance to this restaurant has been downplayed against the prominence of the building housing it. Ascending what appears to be a flight of illuminated glass treads, one will be surprised to discover that they are blackened timber; only the undersides have been glazed.

Colour makes a swift entrance upstairs as baby-blue and cherry blossom-pink set the basis for the general colour theme. The main dining room is rectilinear in plan, with a ceiling stretching into the pitched eaves of the building and punctuated by slender columns. Structured through the use of gateway serving stations, the space has been compartmentalised into more intimately sized dining sections. Mechanical services are cleverly concealed within an ebony-painted perimeter bulkhead, leaving the eyes to feast on a series of panelled mirrors at the rear.

The focus of the restaurant lies in an amorphous pearl-white globular shell that obtrudes into the dining area. In a surprising twist, this "cocoon" accommodates the kitchen. Beautifully crafted - the surface cement having been hand-polished to perfection - the form fluidly embraces the columns. Pierced with circular windows, it allows guests to take a glimpse at dishes being prepared.

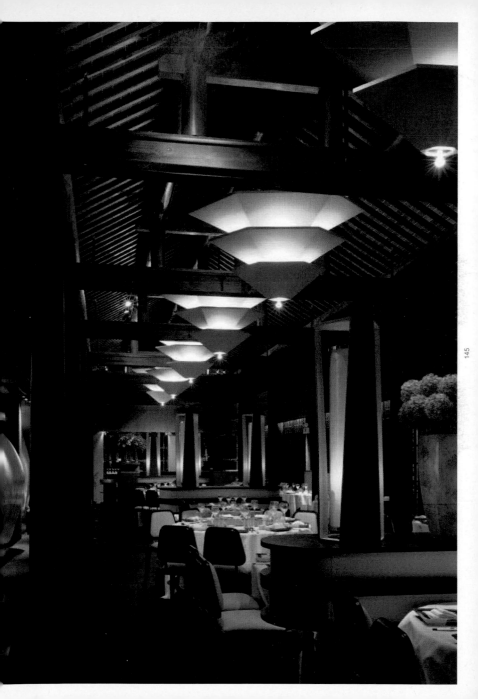

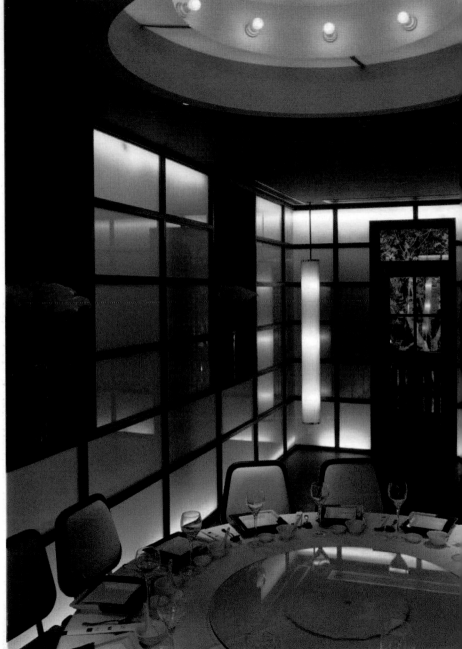

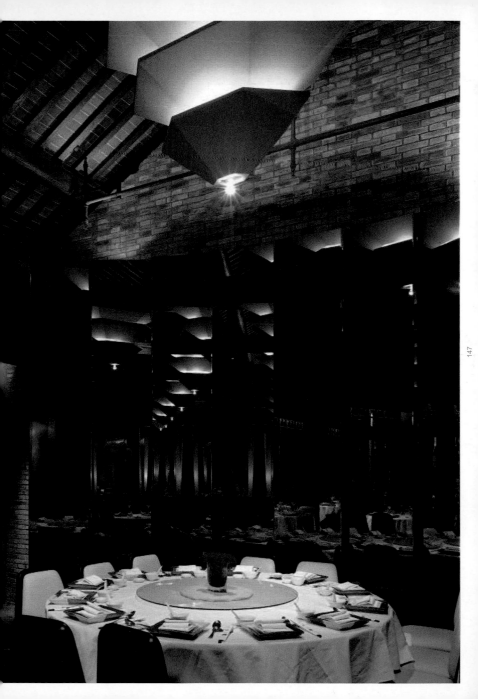

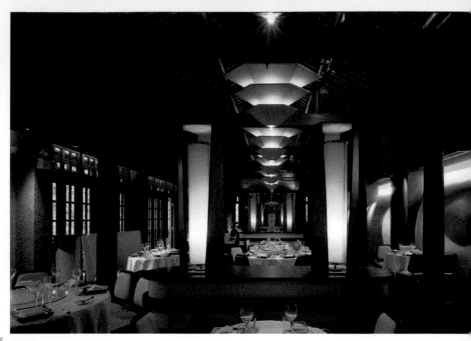

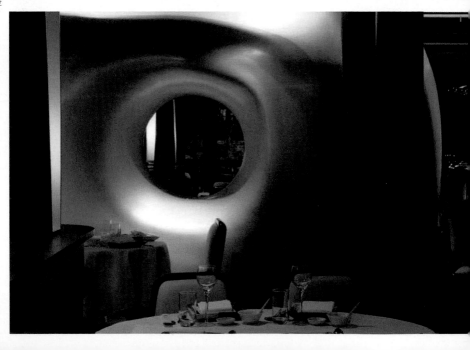

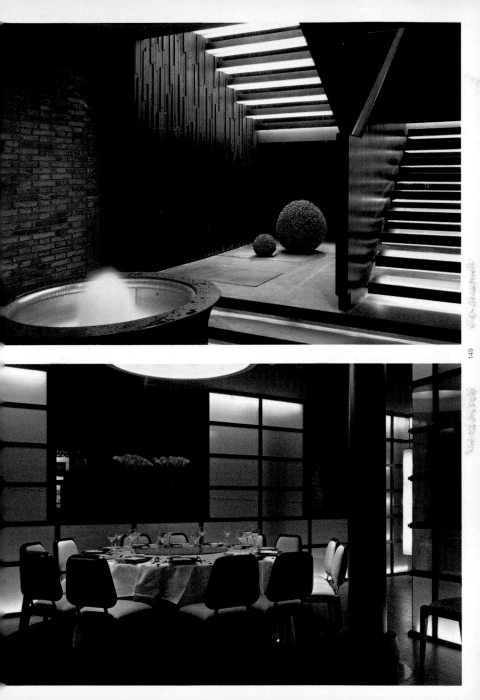

INTERNAL LANDSCAPE

zenses

Coaxing a closeness to nature, Zenses is a tranquil haven that departs from the bustle of the street.

NAME OF ESTABLISHMENT **ZENSES**
OWNER/CLIENT **CAPITAL LEADER CORPORATION LTD**
ARCHITECT/DESIGNER **AB CONCEPT LTD**
PHOTOGRAPHER **ELAINE KHOO**
TEXT **ANNA KOOR**
LOCATION **5 QUEEN'S ROAD CENTRAL, HONG KONG**
TEL OF ESTABLISHMENT **(852) 2521 8999**

Intended to be a tranquil haven contrasting with the bustle outside, the 7,000 square foot restaurant that seats a mere 200 people is all about a closeness to nature. Raw, variegated timber boards - sanded and polished with beeswax - cover the floor. Self-levelling concrete flooring picks up shadows from a forest of sculpted branches that create a soft break down the centre of the expansive space.

Zenses' inconspicuous frontage has implied the need to direct attention onto its entrance. A light box which also acts as a divider is placed as a backdrop to the takeaway counter next to the main entrance, simultaneously providing a semi-private barrier to the bar such that only a glimpse of the red lanterns inside is allowed.

This aura of calmness is a counterpoint to the vibrancy of the bar, which is raised. Mirrors behind the lanterns are tilted downwards to bask the dining area below in their radiating glow. The process of discovering the many subtle details within this restaurant is appreciated when the guest is seated. Although the layout of the restaurant is straightforward on plan, interpretations become richly layered as one realises that no wall in the dining hall is parallel. They run obliquely, creating subtle distortions that exaggerate the perspective from the wide entrance.

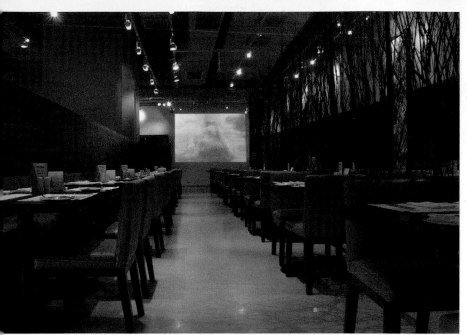

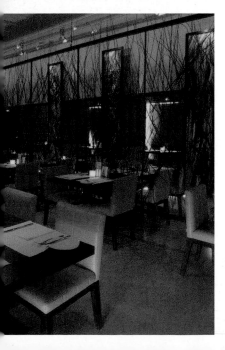

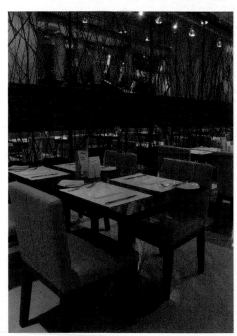

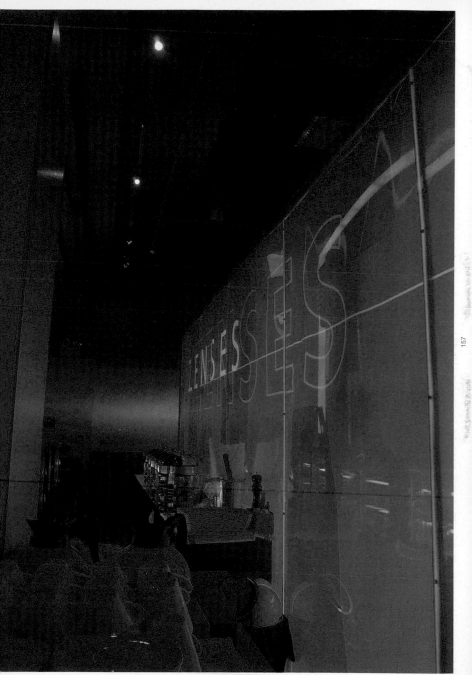

157

CRAFT OF LIGHT

cha cha hana

Through the skillful manipulation of light, an old residence is given a dramatic facelift and transformed into a modern restaurant.

NAME OF ESTABLISHMENT **CHA CHA HANA**
OWNER/CLIENT **KAZUMI SADAHIRO/RAV CO LTD**
ARCHITECT/DESIGNER **TSUJIMURA HISANOBU DESIGN OFFICE, MOON BALANCE**
PHOTOGRAPHER **KOZO TAKAYAMA**
TEXT **KWAH MENG-CHING**
LOCATION **1-1-1 KABUKI-CHO, SHINJUKU-KU, TOKYO, JAPAN**
TEL OF ESTABLISHMENT **(81) 3 5292 2933**

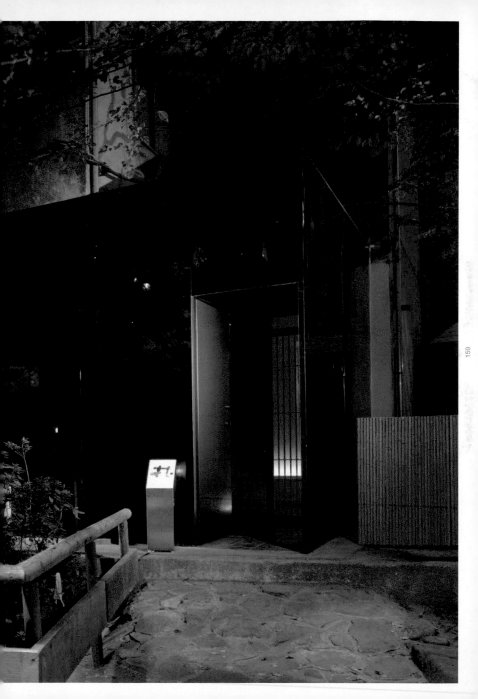

Standing in an anonymous 2-storey timber building, cha cha HANA looks just like any traditional Japanese residence from its exterior. Yet, with a skillful play of light, the interior of this old house has been transformed into a dramatically different 2,690 square foot restaurant.

A strip of warm yellow lighting illuminating a staircase softly lights up the entrance foyer. Ushered up this staircase, guests arrive at the main dining hall on the upper floor, where the designer has thoughtfully detailed various types of seating. The chief spatial and visual focus is the "Court of Light" - a pebbled courtyard that is flushed in cool blue light and opened to the sky. This unique spatial scenograph not only defines the main character of the restaurant; it also instills an element of surprise while seemingly paying recognition to the restaurant's location in Kabuki-cho - Shinjuku's most famous town of the wild underworld.

The second level of the restaurant hosts the private rooms and a variety of other seating options, including sofas, counter and table seating. These areas are all connected by passages laid in toughened glass, coated with a special film to emulate the Japanese *shoji*. Lit from the underside, one seems to be floating on light while walking along these passages. The soft white glow from the floor and the warm yellow spotlighting that is cast dramatically onto the dining tables strike a strange but sure harmony with the timber structure of the old house. Using light as a medium for architectural expression, the designer has rendered a new interpretation of Japanese aesthetics within a traditional framework.

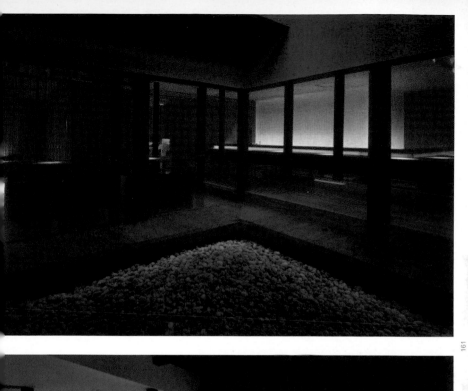

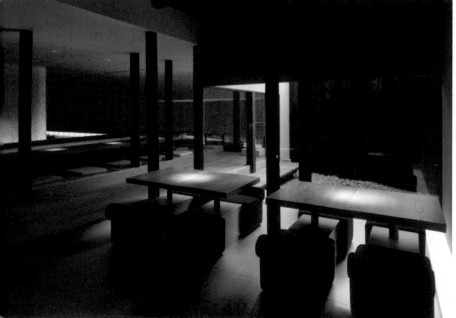

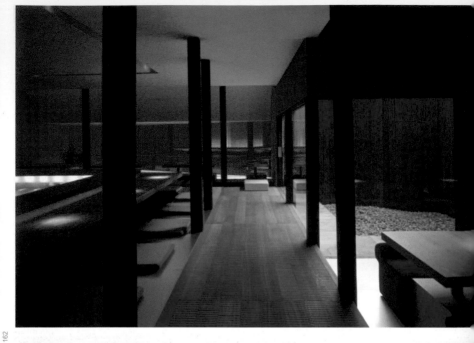

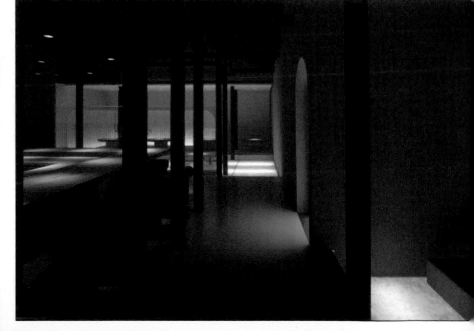

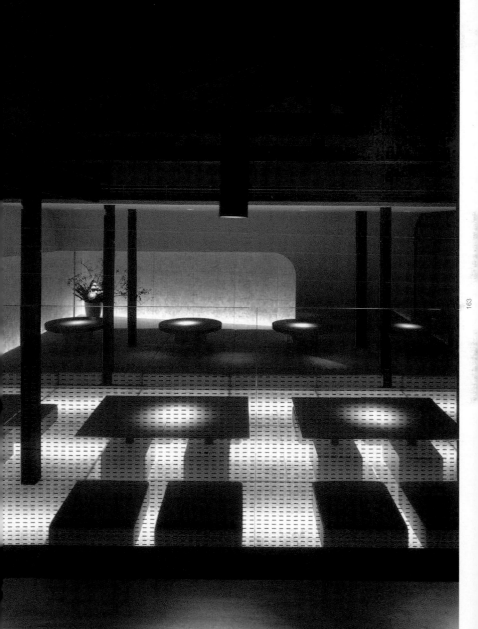

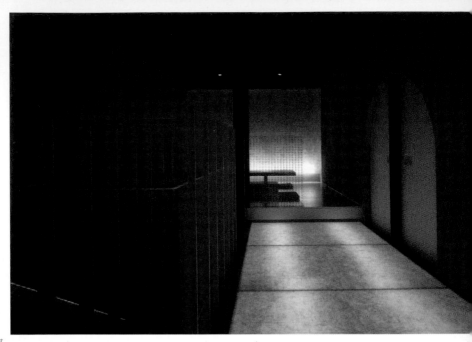

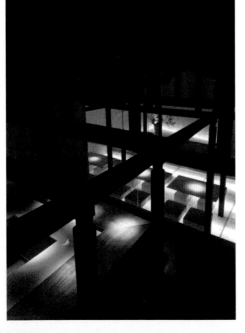

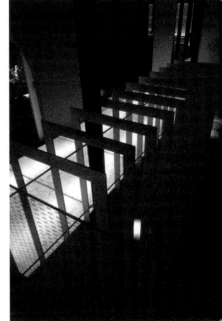

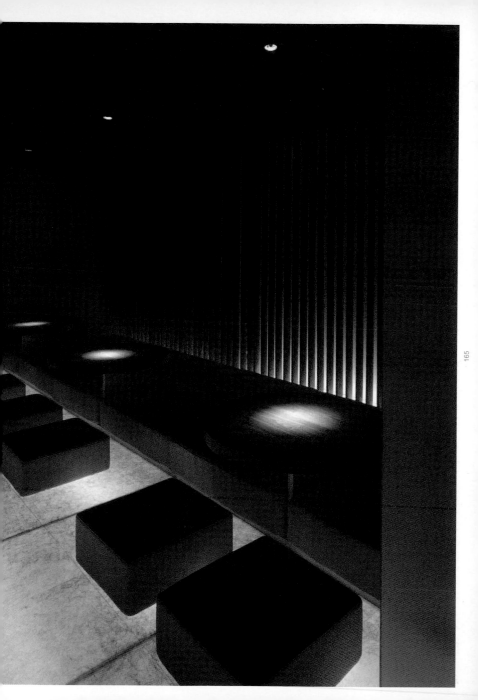

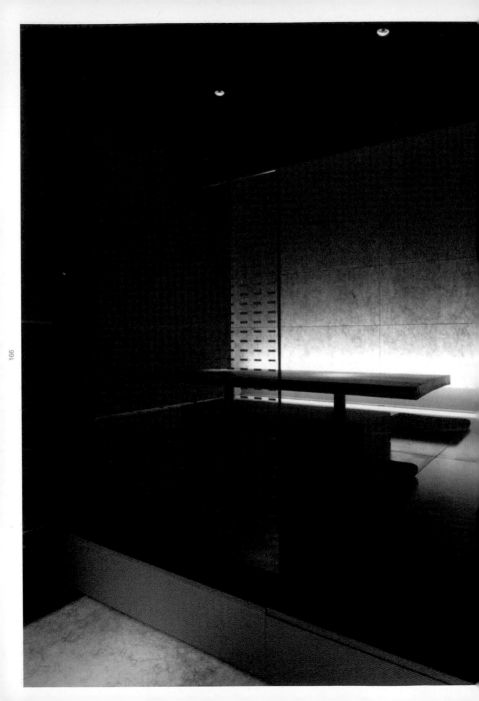

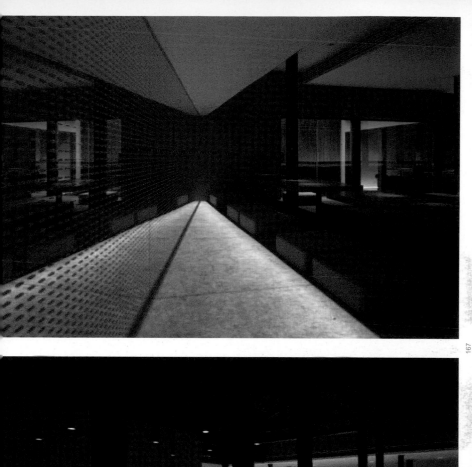

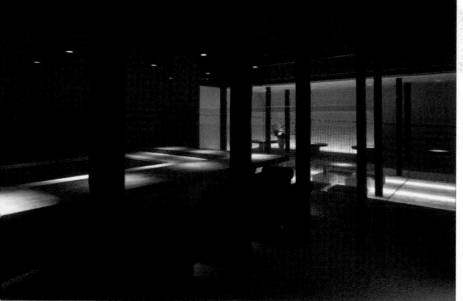

WINE APPRECIATION

dec five

The design of this wine shot bar closely follows the technology that has allowed the taste and character of wine to be preserved for prolonged enjoyment.

NAME OF ESTABLISHMENT **DEC FIVE**
OWNER/CLIENT **EVERYDAY-WINE INC**
ARCHITECT/DESIGNER **YASUTO NAKANISHI, IKU KAKOTO/000STUDIO (SYOHEI MATSUKAWA + MASAYUKI KURAMOCHI)**
PHOTOGRAPHER **DAICHI ANO**
TEXT **REIKO KASAI, MASATAKA BABA**
LOCATION **1/2 FLOORS, AOYAMA SEVEN HEIGHTS, 1-7-5, SHIBUYA, SHIBUYA-KU, TOKYO, JAPAN**
TEL OF ESTABLISHMENT **(81) 3 5468 8270**

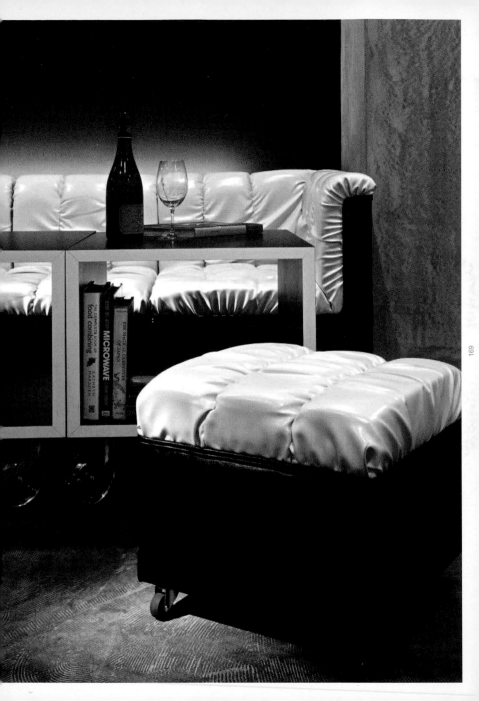

Dec Five counts among the first wine shot bars in the world. At other wine specialty stores, it is not surprising to find that wines are sold only by the bottle, as the taste and character of wine changes as soon as it comes into contact with air. However, at Dec Five, one can sample wine by the glass, as a special technology that prevents air from coming into contact with the wine has been developed. Due to the adoption of this new technology, the layout of this wine restaurant is perceivably different from others as well.

The wine restaurant is spread over two levels. Entering the restaurant by its ground level, one's attention is quickly captured by bottles of wine that are attractively arranged along a long counter. This counter takes up most of the ground level, which is rendered in a palette of cement screed, black and white finishes. Such a palette has effectively formed a neutral backdrop whereby guests are fully able to appreciate the dazzling array of wines available.

A lounge takes up the entire upper floor, where guests may bring their personally selected wines - by the glass - to slowly indulge in the enjoyment of the exquisite wines. Here, the furniture has been fixed onto castor wheels and can be shifted around as desired, allowing for a little casualness and spontaneity amongst guests as they enjoy their wines.

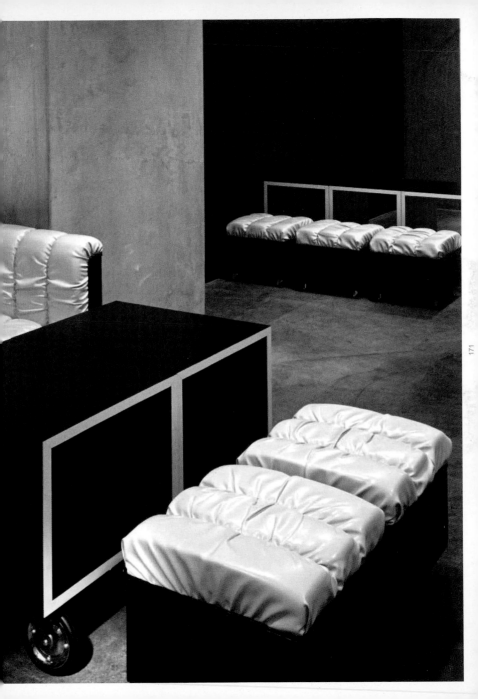

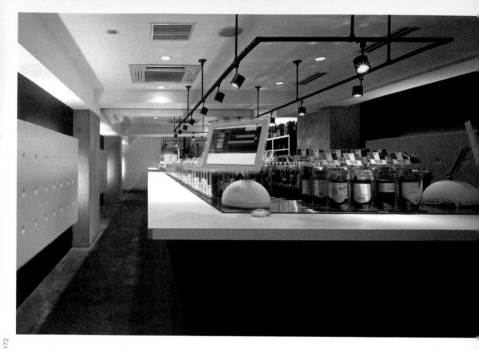

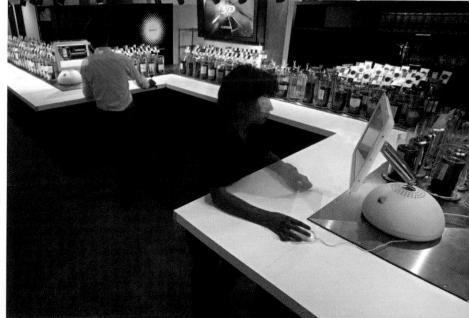

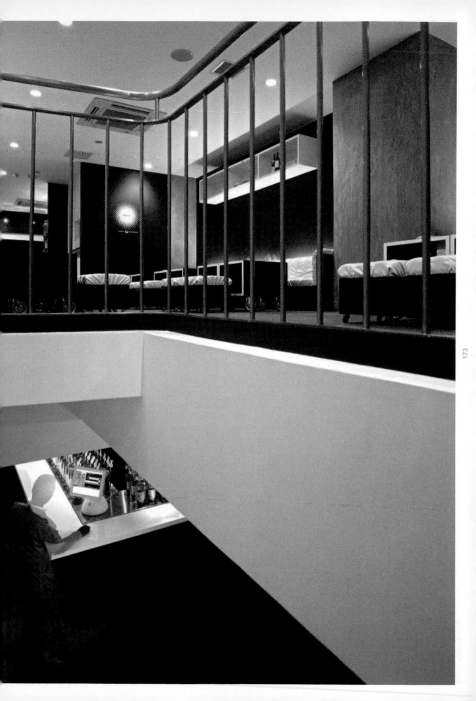

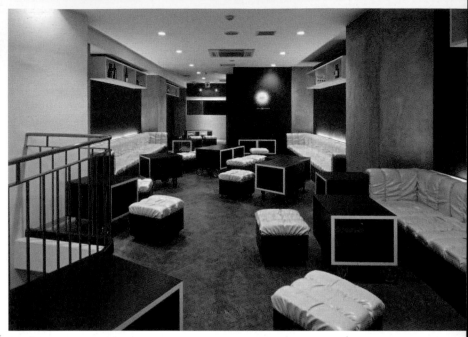

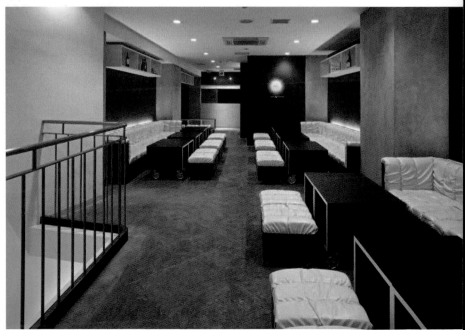

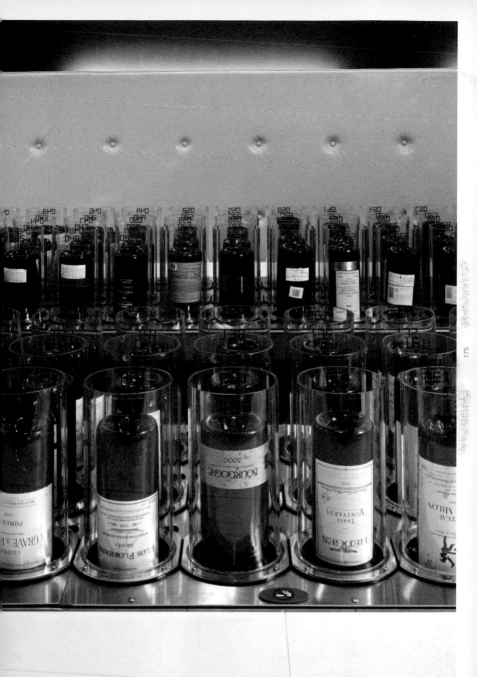

AN EXUBERANCE OF POP

bape café!?

Well-hidden in a basement, Bape Café!? marks "A Bathing Ape" creator Nigo's foray into the world of the light culinary experience. With his signatory underground and undercover trademark, Nigo provides Tokyoites with a fashionable place to wine and dine.

NAME OF ESTABLISHMENT **BAPE CAFE!?**
OWNER/CLIENT **NIGO**
ARCHITECT/DESIGNER **MASAMICHI KATAYAMA/WONDER WALL INC**
PHOTOGRAPHER **KOZO TAKAYAMA**
TEXT **KWAH MENG CHING**
LOCATION **B1, 5-3-18 MINAMI-AOYAMA MINAKO-KU, TOKYO, JAPAN**
TEL OF ESTABLISHMENT **(81) 3 5778 9726**

BAPE CAFE!?

Designed by Nigo's long-time collaborator, Masamichi Katayama of Wonder Wall, the hip Bape Café!? in up-market Aoyama bears the double-edged concept of pop: it exhibits both lightness and mysteriousness. The entrance treatment to the café is minimal but exudes a seductive ambience. The neon-blue ceiling and the dark-coloured wall (bearing simple signage reading "BAPE CAFE!?") contrast with the white-washed stairway, whose ceiling is decorated with Hajime Sorayama's erotic paintings. Amidst these funky gestures, which give a hint of what lies beneath, an illuminated handrail leads one down to the heart of the café.

The main space below is a spacious white base canvas hemmed by objects bearing the Ape trademark. A four-metre-long Ape table, with a corresponding Ape cut-out luminous ceiling above, forms the central focus of the space. Surrounding it are miniature Ape cut-out tables with Bape camouflage stools. Adding to the extravagance of the space is a lime-green-coloured rear wall, which is decked with intimate square booths lined in sound-absorbent material, and illuminated by pendant lamps from Artemide.

The words "sexy" and "mysterious" perhaps best describe the unworldly atmosphere of the private VIP lounge. Its exclusivity is enhanced by the installation of UMU glass panels, which not only physically separate the lounge from the main space, but can further be adjusted from transparent to translucent and back again. The red sofa, mirrored ceiling, and Achille Castiglioni's Arco floor lamp further add to the delirious atmosphere.

Fashion and food may be unrelated, but the creators of Bape Café!? have managed to stamp the café with the same brand identity that marks the "A Bathing Ape" boutiques, and at the same time, surpass their extravagance and chic.

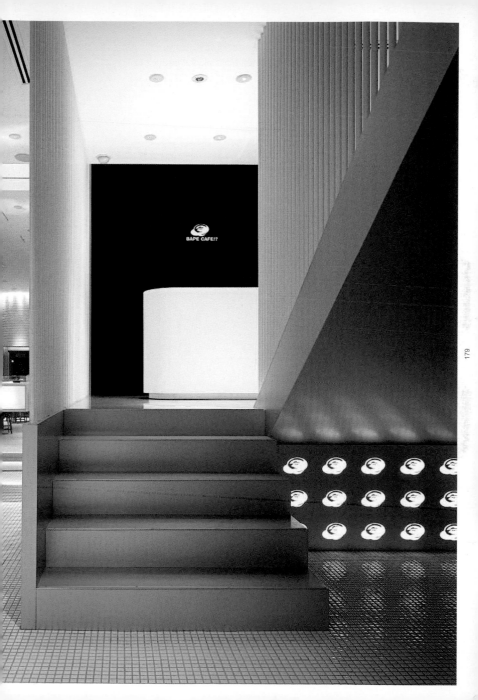

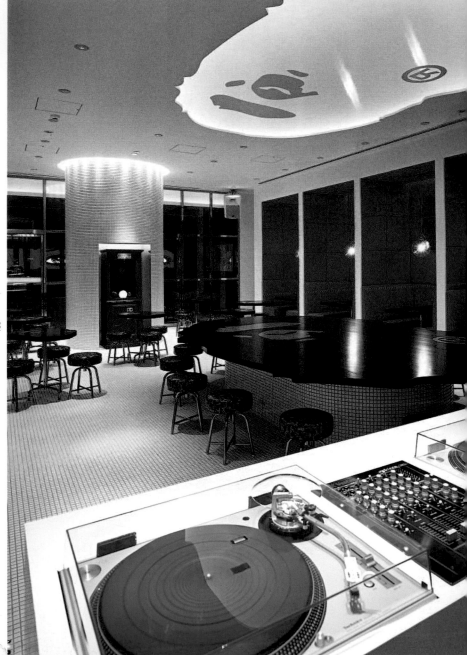

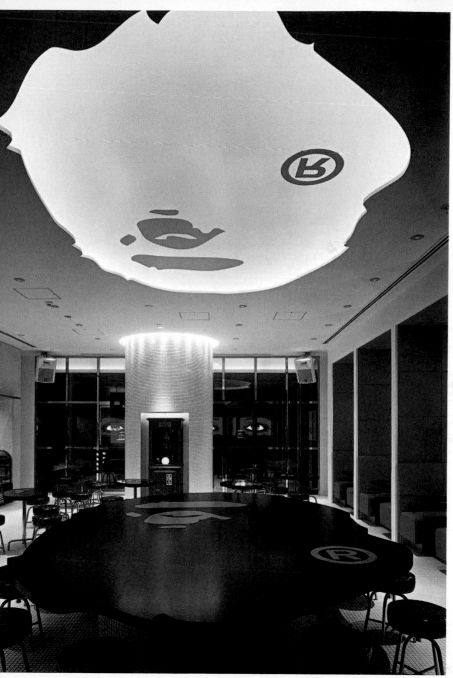

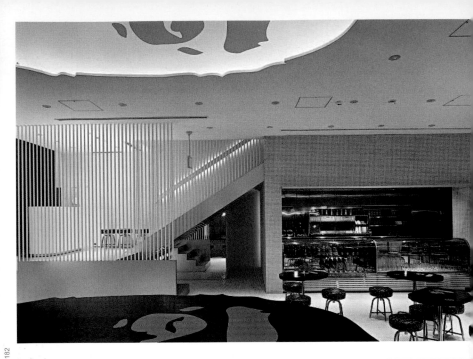

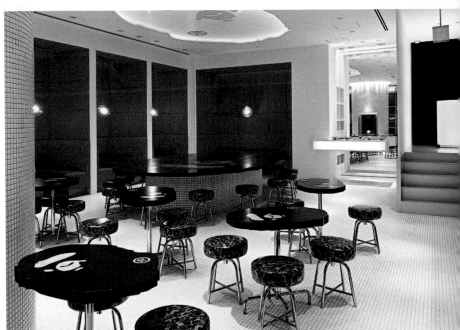

NATURAL OCCURRENCE

le cocon

Stalagmites and cocoons make an awe-inspiring occurrence in this restaurant with a cave-like interior spread over 2 levels.

NAME OF ESTABLISHMENT **LE COCON**
OWNER/CLIENT **HIDEO HORIKAWA**
ARCHITECT/DESIGNER **HIDEO HORIKAWA/HIDEO HORIKAWA ARCHITECT & ASSOCIATES**
PHOTOGRAPHER **IMAGES COURTESY OF HIDEO HORIKAWA ARCHITECT & ASSOCIATES**
TEXT **KWAH MENG-CHING**
LOCATION **UNION SQUARE BUILDING, 1F/B1F, 2-8 UGUISUDANI-CHO, SHIBUYA-KU, TOKYO, JAPAN**
TEL OF ESTABLISHMENT **(81) 3 5459 5366**

An owner of a handful of restaurants and wine bars himself, architect-designer Hideo Horikawa has always favoured using natural materials to yield an organic design in his wining and dining establishments. Horikawa's organic approach towards design extends beyond the material palette; believing that deep within their psyche, humans hold a preference for fluid, circular forms over the angular constructs of our physical environment, the designer creates a space that aims to rouse the inner self.

Winner in the 2001 JCD Design Award, the restaurant occupies two levels - a ground storey and a basement. The entrance is a contrast of pristine glass and rugged timber that gives a suggestive glimpse into the world beyond. Once past this, one is greeted by a cave-like space containing hanging sculptural timber "stalagmites". Constructed out of plywood, the wall and ceiling have been clad with 4,624 triangular-shaped pieces. This cavernous space extends to the rear of the restaurant, where a staircase brings one down to the dining room in the basement. An air well connects both levels and allows one to still be able to catch a view of the imposing timber stalagmites even when one is in the basement.

In the basement, there are 9 cocoon-like private rooms. These slightly rounded, organic-shaped, earthen walled "cocoons" vividly contrast with the angularity of the timber stalagmites above, creating an interesting visual dialogue.

187 at right edge of page, rotated

IN GOOD TRADITION

mitsui murata

Throughout this modest *izakaya*, **small symbols of the Japanese culture are inserted to lightly hint at the cuisine served here.**

NAME OF ESTABLISHMENT **MITSUI MURATA**
OWNER/CLIENT **ERATO INC**
ARCHITECT/DESIGNER **YASUMICHI MORITA/GLAMOROUS CO LTD**
PHOTOGRAPHER **NACASA & PARTNERS INC**
TEXT **KWAH MENG-CHING**
LOCATION **2-4-5 SONEZAKISHINCHI, KITA-KU, OSAKA, JAPAN**
TEL OF ESTABLISHMENT **(81) 6 6442 4180**

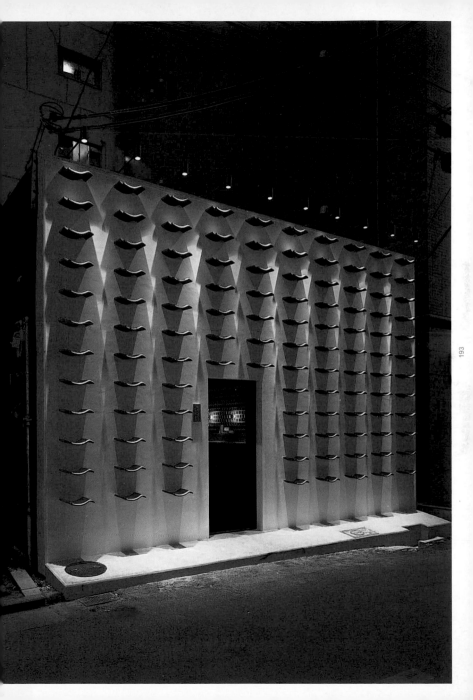

Mitsui Murata is a modest *izakaya* (Japanese dining bar) designed by self-taught designer Yasumichi Morita. Standing at a mere 711 square feet, this *izakaya* shines like a small gem in the dark.

The exterior façade is a most unusual composition of a mortar-finished wall, planted with traditional Japanese roof tiles at regular intervals and in a perpendicular direction. Under lighting at night, the ashen colour of the wall floats in the dark against the tiles, casting interesting shadows. The subtle and unusual treatment of the façade with a material that signifies the Japanese culture lightly hints at the cuisine served in its premises, something which is not easily perceivable just by judging the shopfront.

Passing through the glass door, one enters into the main space where counter seating lines one side of the passageway and table seating lines the other. Here, warm timber and soft lighting sets the atmosphere for the dining bar. The floor and ceiling have been finished in dark colours, so as to draw one's eyes naturally to the two long walls on the sides. At first impression, these walls appear to be made up of many "pigeonholes". It is only upon closer inspection that one realises that these are actually timber containers used by the Japanese traditionally as a standard measure to gauge an amount of rice or wine. Here, the designer has successfully given an everyday folk article a new lease of life through a fresh interpretation. He has mounted an impressive 3,500 pieces of the timber container onto the walls, illuminating them with specific lighting, creating a pleasant feature that does more than dress up the space. A *shoji* (rice paper) installation on the wall, infused with unconventional materials like zinc and rope, further enhances the atmosphere.

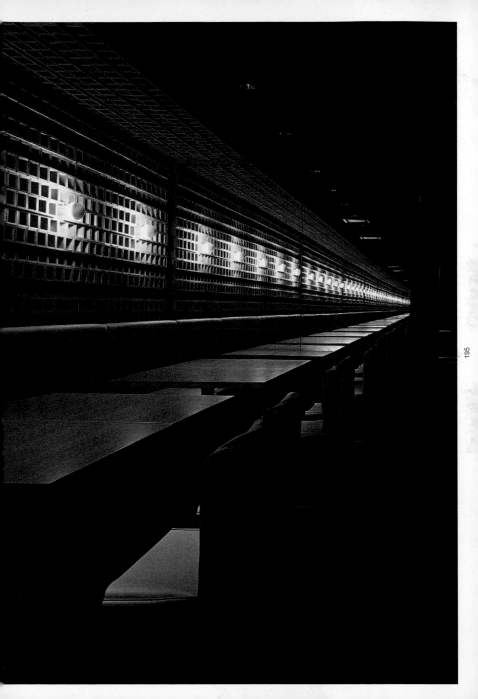

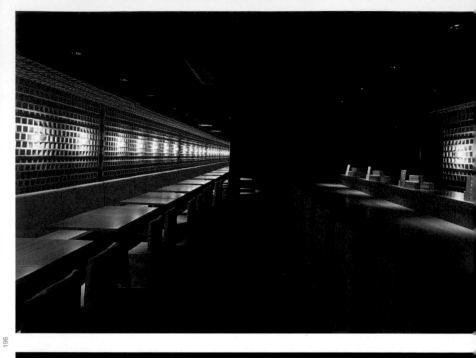

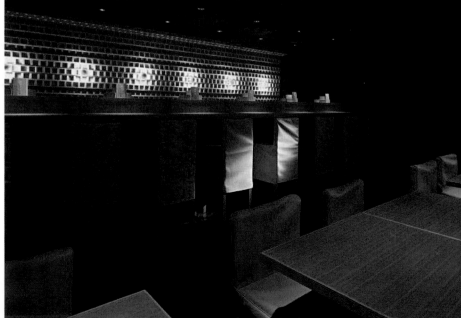

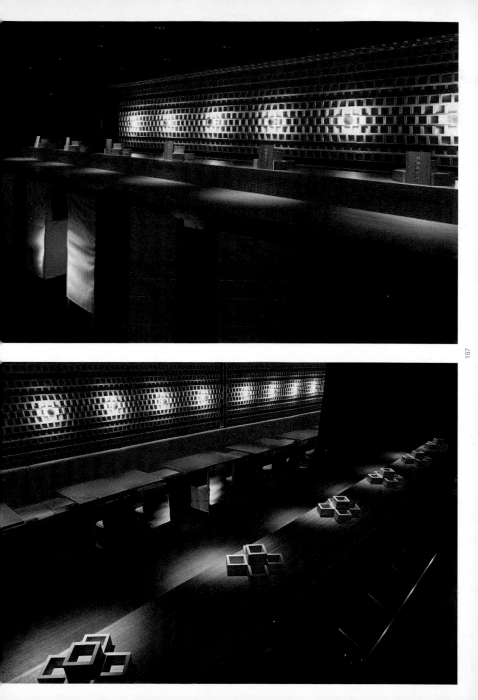

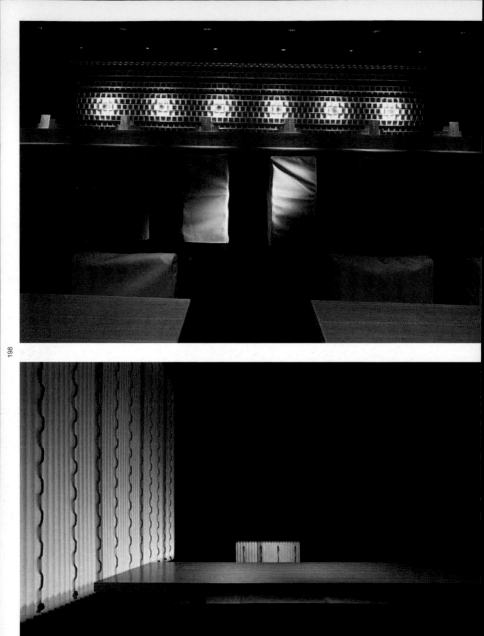

SYMPHONY OF PLEASURES

neige lune fleur

Walls scale and coalesce with floors and ceilings to orchestrate a symphony of sensory pleasures in this restaurant serving traditional Japanese cuisine.

NAME OF ESTABLISHMENT **NEIGE LUNE FLEUR**
OWNER/CLIENT **MASATOSHI MUTOH**
ARCHITECT/DESIGNER **ATELIER HITOSHI ABE**
PHOTOGRAPHER **SHUNICHI ATSUMI/STUDIO SHUN'S**
TEXT **KWAH MENG-CHING**
LOCATION **2F, 2-5-17 KOKUBUNCHO, AOBA-KU, SENDAI, JAPAN**
TEL OF ESTABLISHMENT **(81) 2 2212 3055**

lune

Walking into the premises of delicate cuisine and soothing music, the senses are seemingly unlocked as one ventures into Neige Lune Fleur. Deferring from the structured directives of Japanese society, Neige Lune Fleur is entirely in a world of its own - where spatial conventions are openly defied.

The intention of the owner in creating such a restaurant was none other than to offer to the tired urbanite an experience that offers liberation from the mundanities of daily life. The cuisine served here, though based on traditional Japanese cuisine, seeks invention within old culinary frameworks. Similarly, the interior design of the restaurant looks to reinvent itself while being locked within the existing architectural framework of yet another nondescript urban building.

Located within Sendai's entertainment district, Neige Lune Fleur has a typical windowless long and narrow floor space. The approach from street level to the restaurant is via a flight of dimly lit stairs that sets the ambience in a prelude to the restaurant. As one ascends, one slowly draws away from the hustle and bustle of the street, and away from reality.

The highlight of the project is manifested in two "twisted" walls at the entrance. Defined by two waves of different cycles, the walls extend into the innermost part of the restaurant. Besides being inviting, the form of these walls also concretises the effects of site forces, such as the varying room volumes and existing structural elements. Akin to natural topographical forms, these walls act like interior façades to the restaurant, coalescing splendidly with the floor and ceiling into a symphony that stimulates all of the senses.

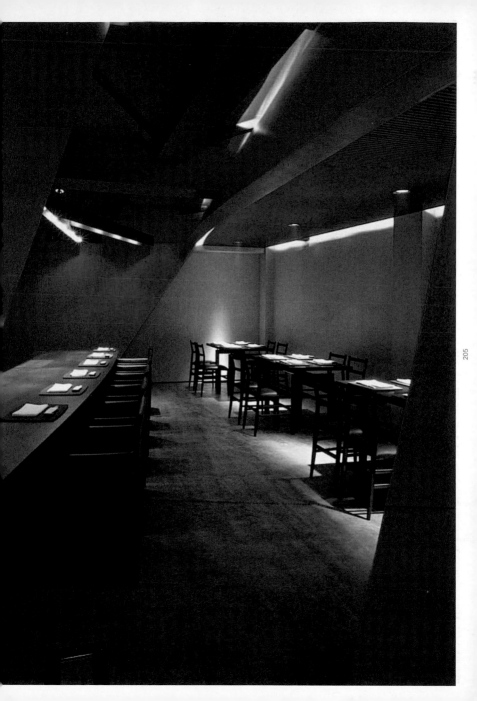

SHANGHAI NIGHTS

Transporting guests into an imaginary Shanghai in the year 2050, this Chinese restaurant is a lavish feast of colours and images.

NAME OF ESTABLISHMENT **NIU**
OWNER/CLIENT **STILLFOODS INC**
ARCHITECT/DESIGNER **YASUMICHI MORITA/GLAMOROUS CO LTD**
PHOTOGRAPHER **NACASA & PARTNERS INC**
TEXT **KWAH MENG-CHING**
LOCATION **2-9-8-B1 KITA-AOYAMA, MINATO-KU, TOKYO, JAPAN**
TEL OF ESTABLISHMENT **(81) 3 5785 3766**

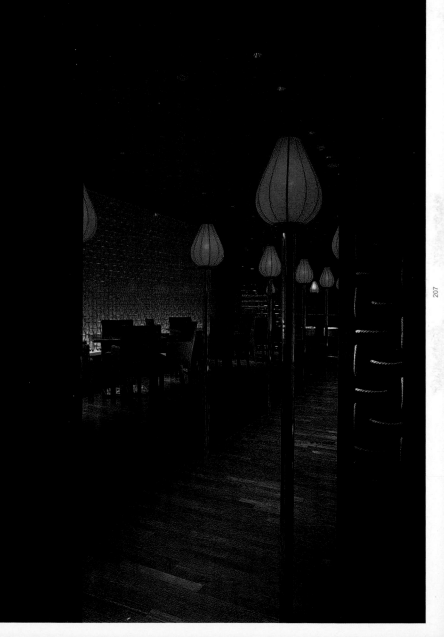

Designer Yasumichi Morita based his design of this Chinese restaurant on an imaginary Shanghai of the year 2050. Located underground, this restaurant enjoys a rich colour scheme that lavishes upon the guest more than just a gastronomical feast; it is also a visual one.

The theme of the scheme is derived from the colours of the lotus plant - the leaves, the flowers, the root. A general wash of reddish-brown, appearing on the finishes of the floor and ceiling, sets the canvas to bring out the palette of the restaurant, which is highlighted with shades of green, pink and yellow. The space is punctuated by a series of lotus-bud shaped lamps. Besides demarcating a path through the centre of the restaurant, the yellow light emitted from these lamps enlivens and adds a formal rhythm to the space. Reflections of the surroundings on the stainless steel stands of the lamps also add to the visual feast of colours and images.

The quintessentially Chinese dragon motif makes its appearance here as layered prints on the bar wall. The "flying dragon" comes to life and is seemingly posed to spring out of the wall as one moves along its length. The dining hall further gains drama through a gradual but contrasting colour change from green to pink. A weaving pattern of hemp ropes set on illuminated walls on one side of the restaurant subsequently adds textural interest and rhythm to the design. Successfully capturing the essence of the culture from a Japanese perspective, NIU is a lively representation of Chinese dining sophistication.

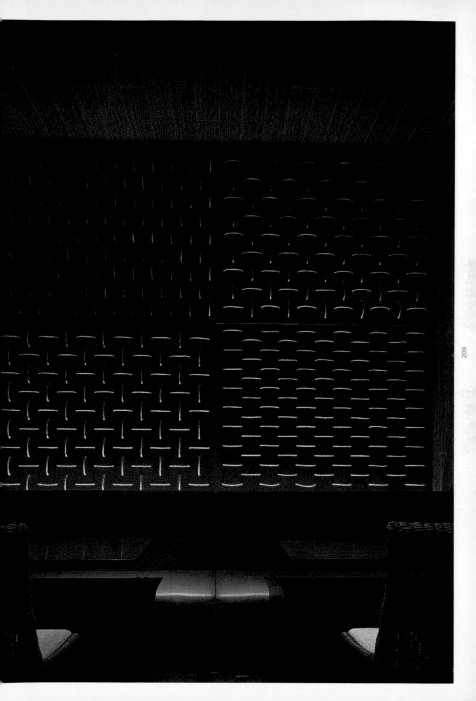

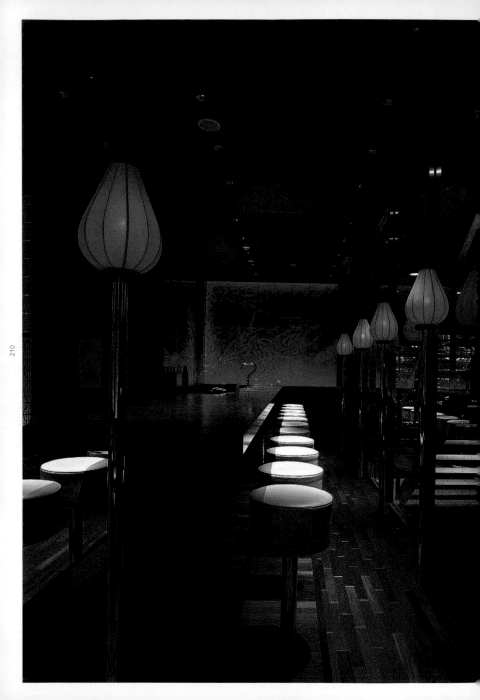

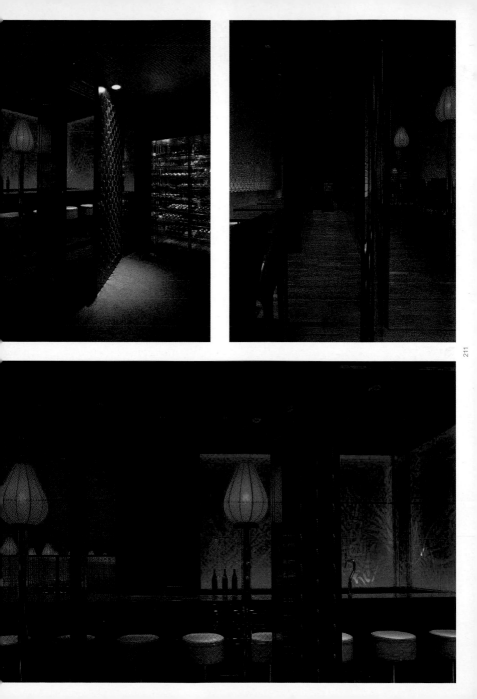

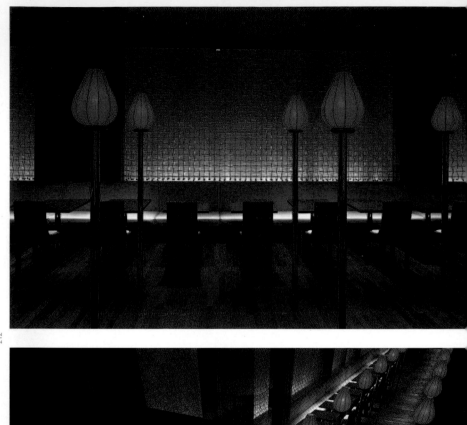

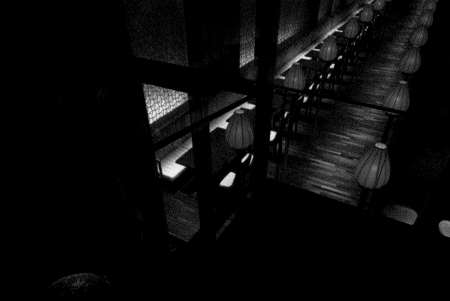

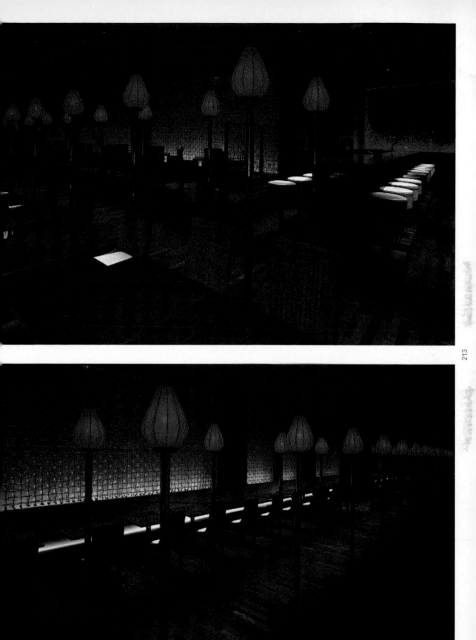

SIDE PROFILE

bon bon
brasserie & bar

In this restaurant, the food as well as the diners play key parts in articulating the overall ambience of the place.

NAME OF ESTABLISHMENT **BON BON BRASSERIE & BAR**
OWNER/CLIENT **ALEXIS MANAGEMENT**
ARCHITECT/DESIGNER **JOHN DING, KEN WONG, RAMESH SESHAN, YIK SWOFINTY/UNIT ONE DESIGN CONSULTANCY**
PHOTOGRAPHER **HILTON PHOTOGRAPHERS SDN BHD**
TEXT **RICHARD SE**
LOCATION **20 JALAN TELAWI 2, BANGSAR BARU, BANGSAR, KUALA LUMPUR, MALAYSIA**
TEL OF ESTABLISHMENT **(60) 3 2283 1100**

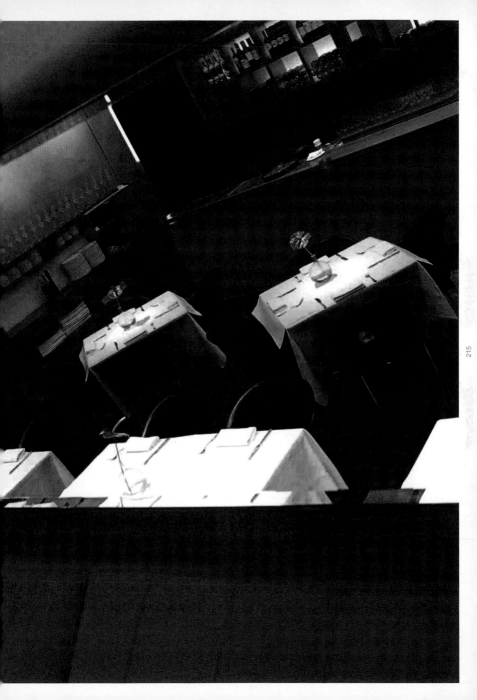

The design of Bon Bon is a bold move away from the conventional interpretations of a fine dining environment. In this restaurant, it is not merely the cuisine, but also the diners, that come together to play key parts in articulating the overall ambience of the place.

Taking full advantage of the corner site on which the unit is situated, the designers have used its valuable side wall to maximum effect. Drawing in natural daylight and external views through a strip of glazing along the wall, a visual and contextual relationship is drawn between the restaurant and its exterior.

Bound by this strip of glazing, is a steel display bar that has been mounted onto the wall. A wine rack seemingly floats over the display bar, and this composition concludes a visual focus for the entire restaurant interior.

Banquette seating set in niches with dropped ceilings afford the privacy of enclosure. Angled mirror strips reflect the tabletops as well as the diners' selections. A flexibility in spatial division is afforded by the use of full-height sliding doors, a design strategy that has facilitated the option of either indoor or alfresco dining options to the diner. These are repeated on a slant to conceal storage located at both the front and rear of the restaurant.

The designers have intentionally kept the range of materials to a limit, thereby emphasising the expression of the inherent quality of the neutral material selection. At the same time, the detailing of all elements and joinery are also kept simple, in keeping with the restaurant's contemporary air.

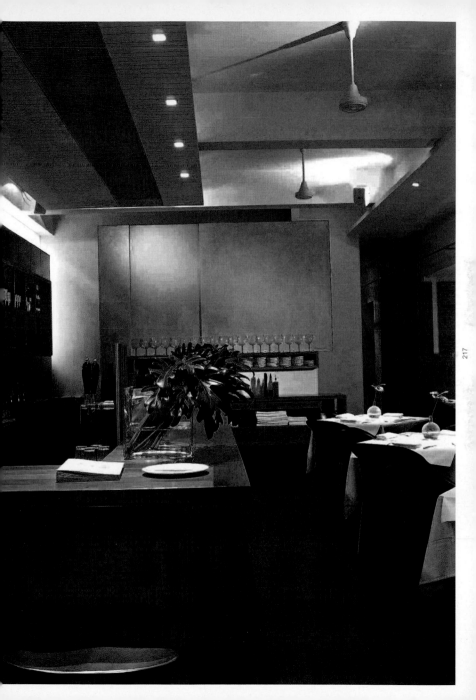

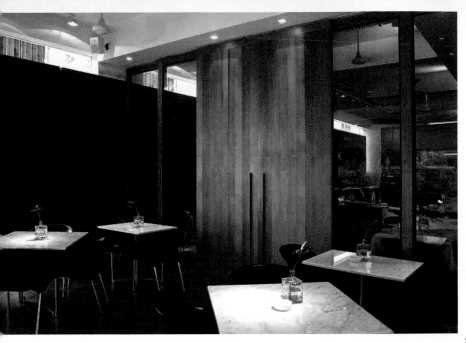

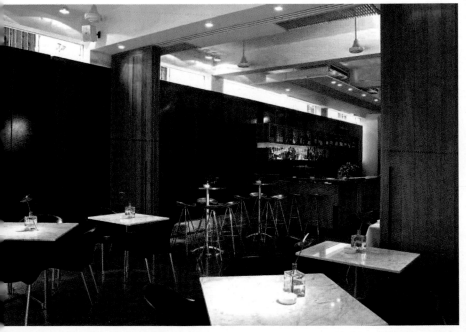

ACCENTS OF WHITE

frangipani restaurant

Transforming a row of three disused Art Deco shophouses, the interior of this restaurant is contrastingly minimal in comparison with its architecture, while being accented by playful notes of colours and flower shapes.

NAME OF ESTABLISHMENT **FRANGIPANI RESTAURANT**
OWNER/CLIENT **FLYIN PAN SDN BHD**
ARCHITECT/DESIGNER **ZDR SDN BHD**
PHOTOGRAPHER **RICHARD SE**
TEXT **RICHARD SE**
LOCATION **CHANGKAI BUKIT BINTANG, KUALA LUMPUR, MALAYSIA**
TEL OF ESTABLISHMENT **(60) 3 2144 3001**

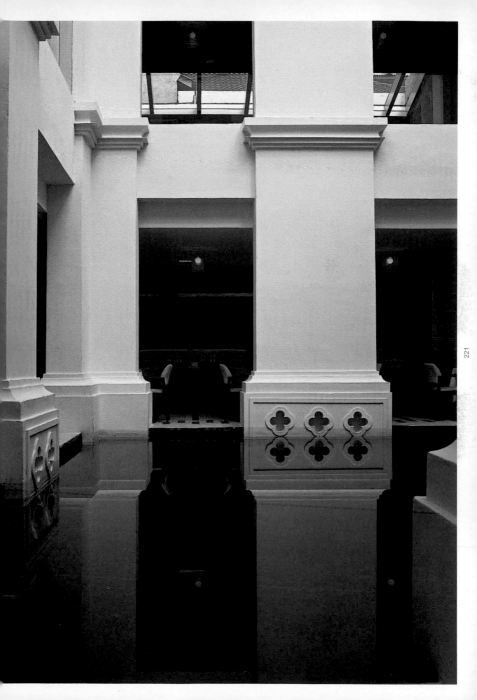

This project involved the transformation of three disused adjoining Art Deco shophouses into dramatic dining premises that offer an experience crossing interestingly between old and new. To preserve the charming character of the shophouse, the existing structure and building features, such as the balconies, columns, plasterwork and detailing, have all been retained as far as possible.

With the inserted design, the designers have aimed to create a lush sense of airiness and lightness through the restaurant. This is achieved successfully through the sensitive introduction of new architectural features such as glass screens and skylights, as well as visual tools like a light colour palette. What results is not only a better-illuminated internal environment, but also an atmospheric envelope of light that serves to accentuate the Art Deco architecture.

The main feature of the design is a transparent decorative wall constructed out of perforated stainless steel panels, which acts as a dividing element between the various spaces within the restaurant. Uplit from the bottom, the wall glows and filters a soft light into the adjoining rooms.

Overlooking a skylit courtyard is the dining room, where a rectangular black-tiled reflective pool plays as the spatial focal point. The overall décor of the restaurant is set in a minimal tone, with accents of coloured fabric, textured walls and decorative metal panels adding the occasional point of interest. However, the designers have prudently allowed a more playful atmosphere in the private dining rooms, which are rendered in bright colours and interlocking fabric wall panels fashioned in the shape of abstracted frangipani flowers.

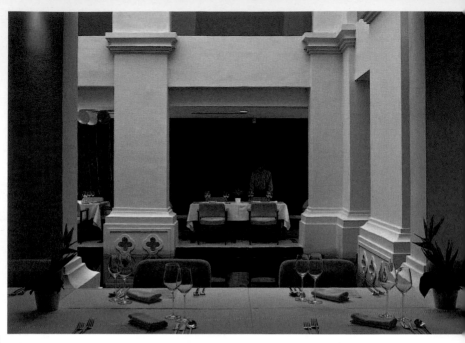

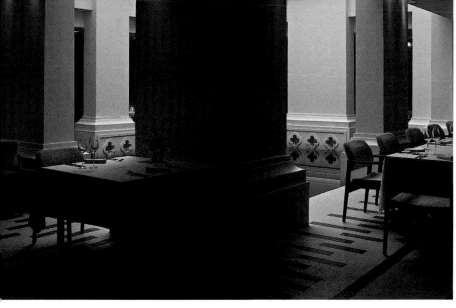

PLEASURE GROUNDS

grappa soho

A huge mural in the style of Francesco Clemente (un)wittingly disguises this restaurant as an avant-garde gallery. Within, you will find the perfect backdrop to enjoy the sinful pleasures of life - eating, drinking and flirting.

NAME OF ESTABLISHMENT **GRAPPA SOHO**
OWNER/CLIENT **OLYMPIA LEISURE**
ARCHITECT/DESIGNER **ALLAN POWELL PTY LTD**
PHOTOGRAPHER **RICHARD SE**
TEXT **RICHARD SE**
LOCATION **2 JALAN BUKIT BINTANG, KUALA LUMPUR, MALAYSIA**
TEL OF ESTABLISHMENT **(60) 3 2145 0010**

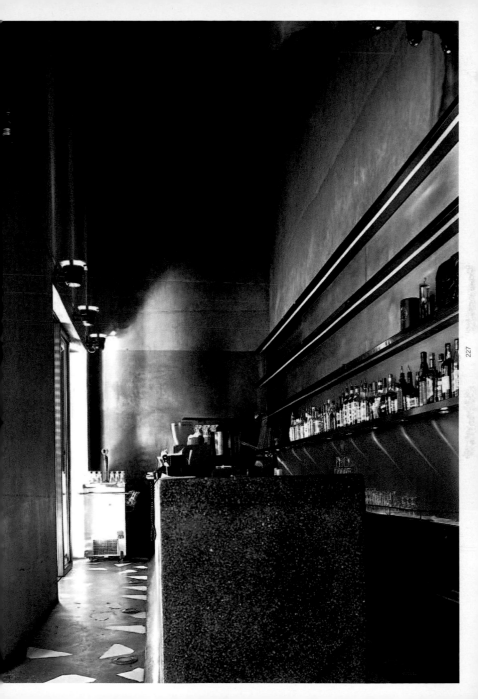

At Grappa Soho, one will not find the easily palatable sort of design that can be readily described as "beautiful". Instead, its avant-garde aura is what that distinguishes it from surrounding establishments, bringing it an appeal that is above the ordinary and appreciated by the discerning few.

Although located right in the heart of Kuala Lumpur's shopping district, Grappa Soho stands rather discreetly along the sidewalk of the busy Jalan Bukit Bintang. The most obvious sign of its existence is a huge Francesco-Clemente-styled mural that takes the place of loud signboards. There is no distinct entrance to the restaurant, except for a raised terrace on the ground floor facing the street. An alfresco area where diners can enjoy a drink or two, the terrace is reminiscent of the many sidewalk cafes in New York where the hip and happening hang out.

The ground floor of the restaurant is a narrow strip of space behind the raised terrace. Next to the bar counter on this floor is a raw concrete spiral staircase that leads up to the heart of the restaurant on the upper floor - where the design is presented in completeness. The space appears to have been gutted out completely, painted black all over, and then furnished and decorated with the paintings, which are either hung or informally propped against walls. These paintings contribute an important quality to the space; they "complete" the "unfinished" setting of the space.

The garnishing touches of the space are surprisingly soft and sensuous: sheer curtains in dark tones are hung throughout the interior to soften the edges of the hard finishes. A fluid sheet of orange Perspex literally drapes over the bar counter like a dress, posing as a statement of design.

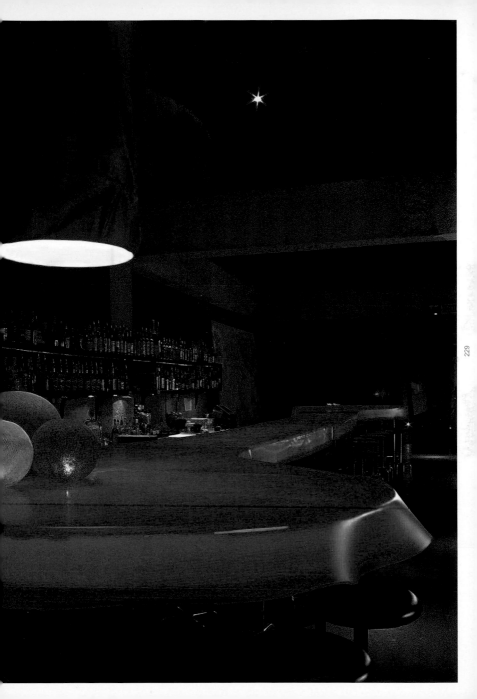

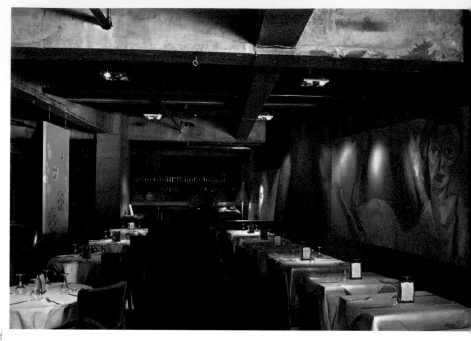

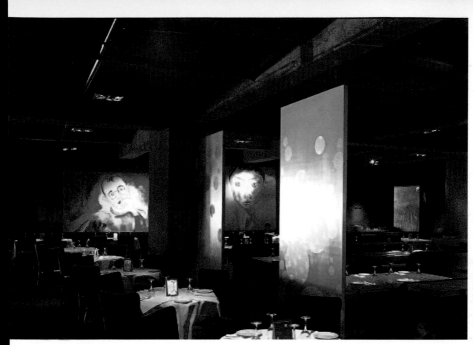

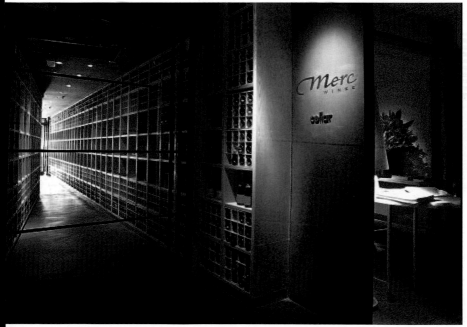

POSTI PRENOTATI

oggi restaurant and bar

Diners can seat themselves on over-sized turntables in this Italian restaurant, where light that changes from red to violet to pure white emanates from mysterious hidden sources.

NAME OF ESTABLISHMENT **OGGI RESTAURANT AND BAR**
OWNER/CLIENT **THE REGENT KUALA LUMPUR**
ARCHITECT/DESIGNER **DAN KWAN/TRIBECA DESIGN**
PHOTOGRAPHER **SC SHEKAR**
TEXT **RICHARD SE**
LOCATION **THE REGENT, 160 JALAN BUKIT BINTANG, KUALA LUMPUR, MALAYSIA**
TEL OF ESTABLISHMENT **(60) 3 2141 0661**

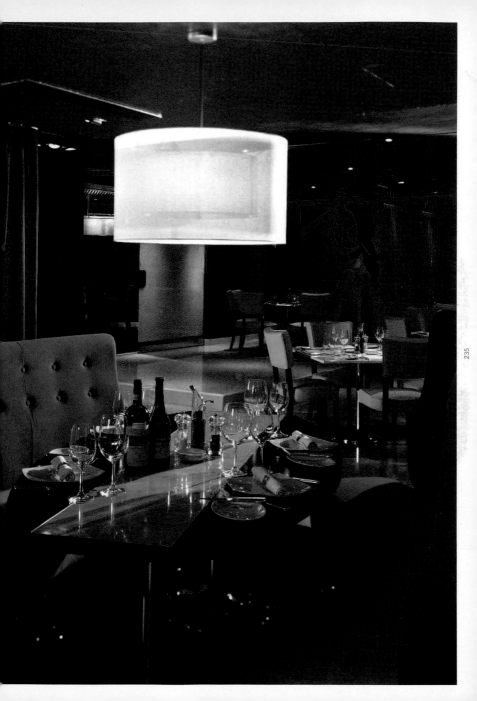

Meaning "today" in Italian, OGGI is name for the most stylish Italian restaurant in the current wine and dine scene of Kuala Lumpur. To match its acclaimed fare, OGGI Restaurant and Bar features a sassy, modern and unpretentious design.

At the entrance of the restaurant, a meeting of various white, brown, red, gold, pearl, blue and grey tones paints a warm and lively atmosphere here. Burgundy curtains and shimmering gauze fabrics replace walls and partitions, combining with an eclectic palette of warm golds and browns and cool blues and greys to form a profusion of colours. Proceeding further into the main dining hall, white marble, upholstery, tabletops, and china paint a sea of white that primes the senses for a gastronomical feast. The mood within the restaurant is given a constant gradual shift by hidden strip lighting, which changes from red to violet to pure white. Complementing the Italian theme of the restaurant, replicas of paintings by famous Italian artists Paolo Uccello and Raphael adorn the walls.

The open kitchen, which has been tiled in a stunning blue, features the quintessential Italian wood-fire oven. The restaurant also stocks an extensive range of wines, decoratively arranged in a transparent wine display wall that partitions off a private dining room. The bar outside continues the theme of the main dining hall, where a water feature at the bar is illuminated with changing lights that correspond with those within the restaurant. Deep armchairs and thick carpet add the final touches to the lush comfortable feel of the bar space.

A unique feature of OGGI is its turntable booth seating, where each booth can accommodate up to six diners. Inspired by the "lazy susan" widely used in Chinese restaurants, diners seat themselves on a life-sized turntable, which rotates to offer them different views of the restaurant. Sure to please those who appreciate good design along with good food, OGGI has seats *posti prenotati* tonight.

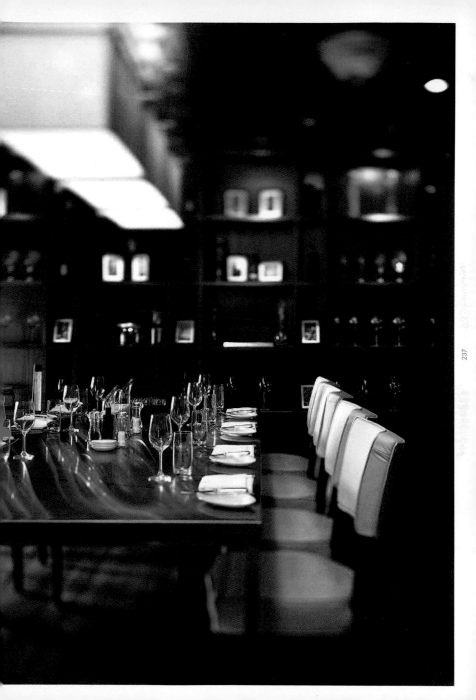

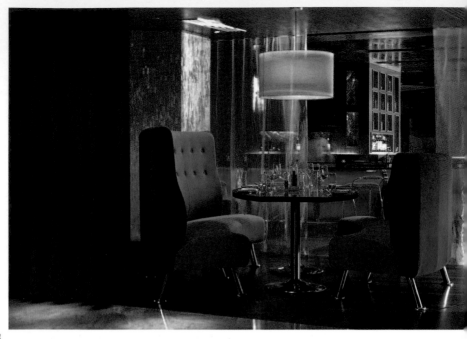

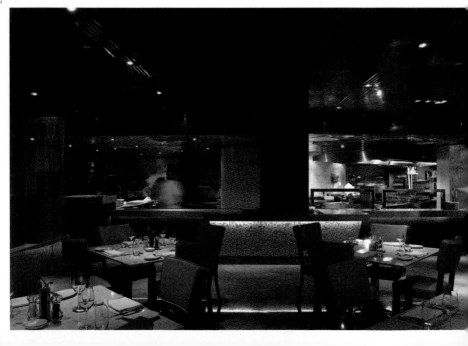

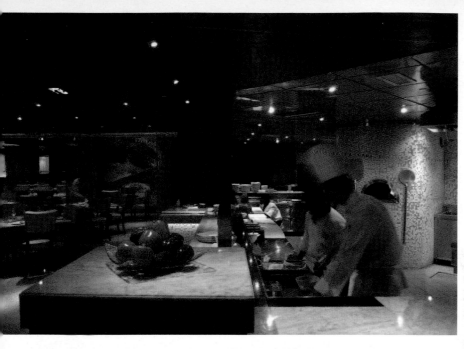

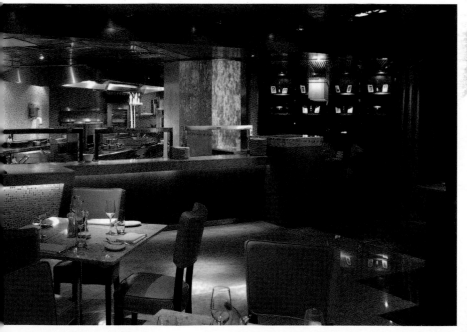

239

DARK ANONYMITY

balaclava

When you are in Balaclava, you take on the persona of a veiled character - engaged in confidential dealings amidst cigars, liquor and deep conversations.

NAME OF ESTABLISHMENT **BALACLAVA**
OWNER/CLIENT **SAM YEO/IMAGININGS PTE LTD**
ARCHITECT/DESIGNER **CECIL CHEE, ROBIN TAN, NG LAY ENG/WALLFLOWER PTE LTD**
PHOTOGRAPHER **KELLEY CHENG**
TEXT **ANG HWEE CHUIN, WALLFLOWER**
LOCATION **1 RAFFLES BOULEVARD, #01-01B SUNTEC CITY CONVENTION CENTRE, SINGAPORE**
TEL OF ESTABLISHMENT **(65) 6339 1600**

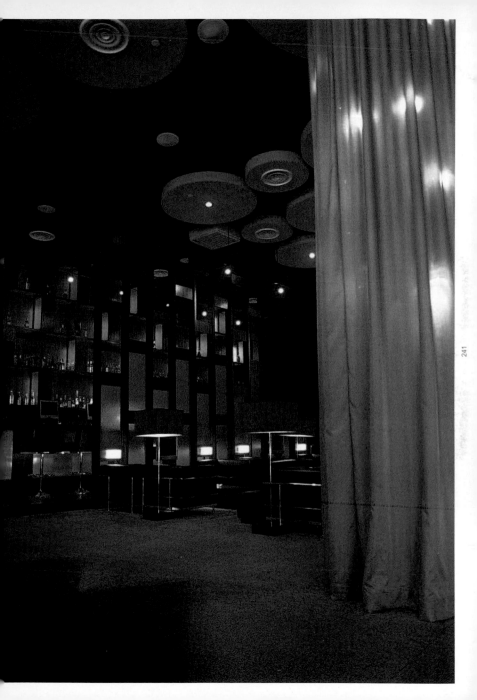

Stepping into Balaclava seemingly transports one into a filmic world of an embassy in the deepest ends of Prague. Inspired by master architect Le Corbusier's iconic designs of lounges and armchairs, the design of the bar attempts to propogate the timeless and austere character of these classics into the atmosphere within the bar. When you are in Balaclava, you take on the persona of a veiled character - engaging in confidential dealings amidst cigars, liquor and deep conversations.

The physical mise-en-scene within which this scene unfolds is a cool double-volume space warmed by a substantial and structured use of black leather, timber, red and orange textures and materials, and yellow lights. The first feature to capture your attention as you enter the bar are the many circular panels of plasterboard suspended from the ceiling, which house air-conditioning vents to form an aesthetic option for dressing up functional uses.

A full-height composition of timber display shelves set behind a long bar extrapolates the deepness of the space here. Brooding with entrenched solemnity, the bar is an epic display of an ironic sense of suppressed openness that is abounding within Balaclava.

Seating is designated along the main bar, as well as in clearly defined pockets of space planned rhythmically around the interiors. Translucent fabric curtains and timber lattice screens infilled with both textured glass and veneered panels gently demarcate individual seating enclosures. Flatscreen plasma monitors set into these screens insert a sudden intervention by advanced technology into the political retrogression depicted in this filmic scene.

Intimate in their proximity but vertically overshadowing the spaces that they confine, these screens also imply another corridor, corner or space where another "quiet conversation" may be taking place. Essentially, Balaclava is a subtle recluse from the urban milieu.

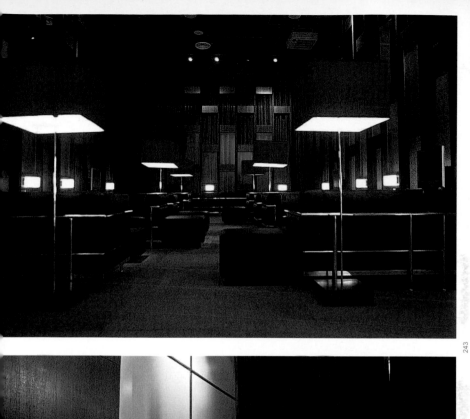

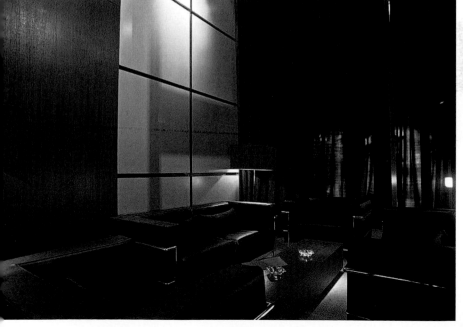

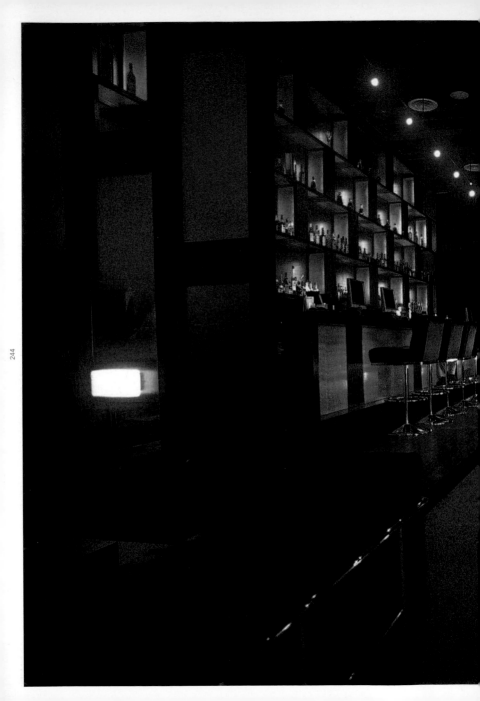

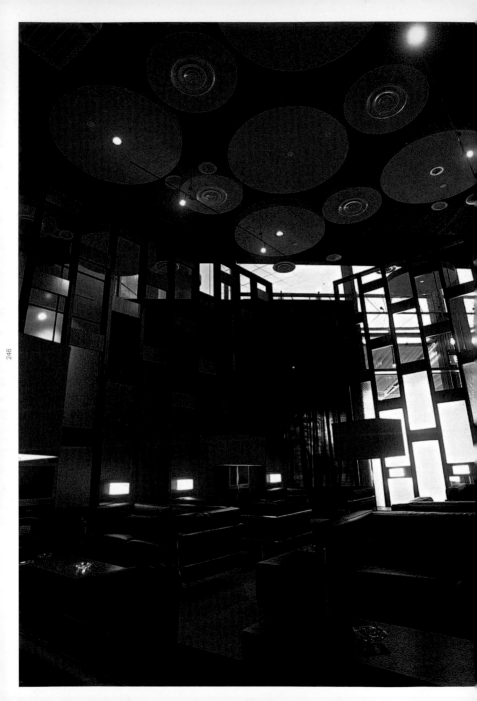

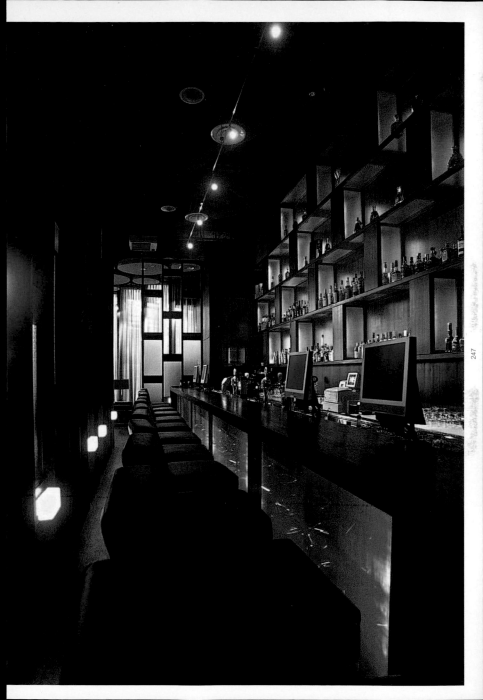

PASSAGE THROUGH LIGHT

da paolo e judie

Designing spaces that alternate between light and darkness, the designers have shaped a phenomenological experience through the restaurant that is akin to a musical crescendo.

NAME OF ESTABLISHMENT **DA PAOLO E JUDIE**
OWNER/CLIENT **PAOLO AND JUDIE SCARPA**
ARCHITECT/DESIGNER **MOK WEI WEI, EDMUND NG, SUSAN HENG, YAO CHIN LENG/WILLIAM LIM ASSOCIATES PTE LTD**
PHOTOGRAPHER **KELLEY CHENG**
TEXT **ANG HWEE CHUIN**
LOCATION **81 NEIL ROAD, SINGAPORE**
TEL OF ESTABLISHMENT **(65) 6225 8306**

Located within a three-storey conserved shophouse, the essence of the design for this fine Italian restaurant is manifested in three fundamental elements - a "tunnel", an airwell and the main dining hall. The architects have carefully manipulated a sequential experience for patrons, who will find themselves transiting as if unconsciously from the outdoors into a restaurant through a tunnel-like passageway, which is separated from the exterior only by a 3 metre by 3 metre pivoting timber door.

Along this passageway, low seats furnish the space as a pre- and post-dinner area for guests to enjoy some drinks. This experience of slowly transiting into the restaurant culminates at the airwell, where natural daylight flushes through its glass covering to bathe the space in an ethereal glow that softly melts into the darkness of the passageway preceding it.

At this point, a bar counter marks the space as an area of reception for guests. Finished elegantly with polished reconstituted marble and stainless steel details, the reception poses as a subtle prelude to the restaurant above. A flight of open stairs lead up to the dining hall on the second floor - a gesture that has elevated the dining activity from all other happenings on ground level. Detailed with skins of glass, mirror and maple-veneer wall panelling, the dining hall bespeaks a quiet stylishness. By designating the restaurant's service zone in a linear arrangement, the flow of space in the dining hall from front to back is contiguous and fluid.

Diffused lighting plays an important design role here, as various forms of concealed top and bottom lighting interact with the interior elements to develop patterns of light, shade and reflection, injecting perceptual interest into the dining environment. At the same time, natural light interacts with the spatiality of the shophouse to form alternating pockets of light and darkness that blend into one another fluidly, resulting in a sensuous architectural experience.

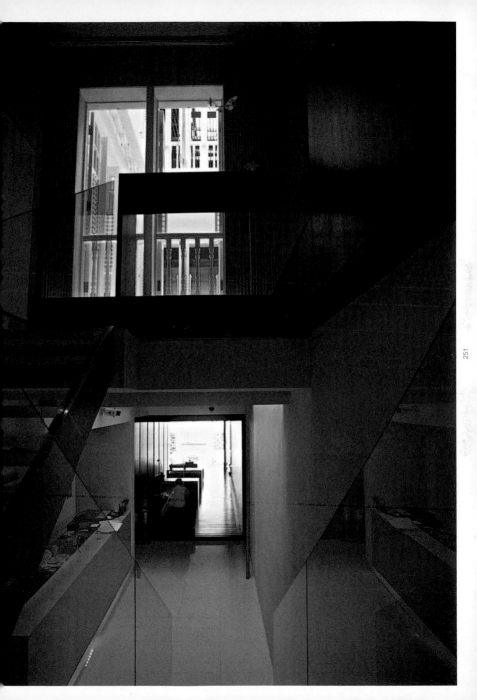

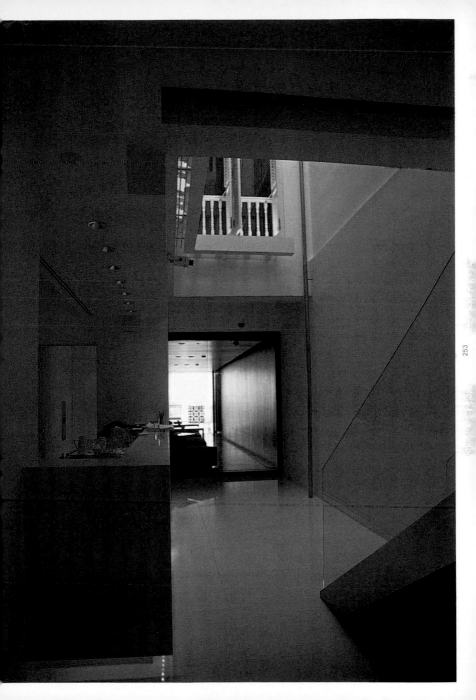

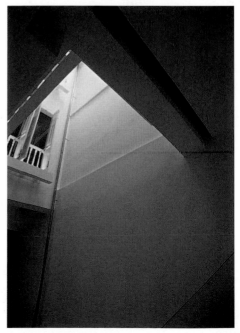

CHINOIS CHIC

hu cui/
lau ling bar

Drowned in its mealtime bustle, Hu Cui is a lively riot of textures, tastes and sights.

NAME OF ESTABLISHMENT **HU CUI/LAU LING BAR**
OWNER/CLIENT **CRYSTAL JADE GROUP OF RESTAURANTS**
ARCHITECT/DESIGNER **YASUHIRO KOICHI/SPIN DESIGN STUDIO**
PHOTOGRAPHER **KELLEY CHENG**
TEXT **ANG HWEE CHUIN**
LOCATION **391 ORCHARD ROAD, #02-12 NGEE ANN CITY, SINGAPORE**
TEL OF ESTABLISHMENT **(65) 6238 1011**

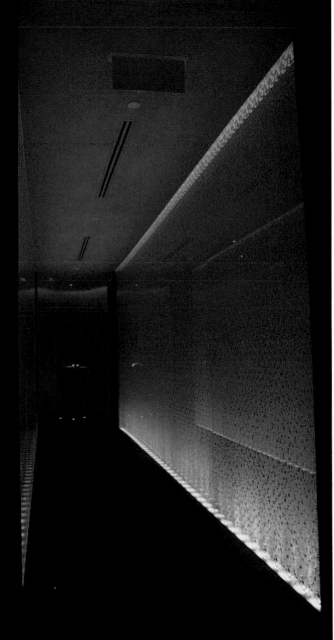

Set within the insipid setting of a shopping centre, the restaurant is fronted by an inconspicuous façade. Its planar treatment has deceptively masked over the procession entailing the entrance, which is a spatial odyssey through moods and senses.

The entrance into this Shanghainese restaurant and bar is an elaborate expression of a long dark flamed granite catwalk, flanked by silk-screened glass and bottom-lit with diffused light. As one moves along this passageway, the subtle forms, sounds and smells of the restaurant's activities surface sensuously from behind the glass walls.

Entering the dining hall, elements such as timber screens carved in Chinese motifs and wall panelling set with Japanese fabrics lend an Oriental flavour to the otherwise contemporary dining arrangement. In a broad sweep, this strategy has expressed the designer's understanding of Shanghai - from where Hu Cui's cuisine originates - as one of the greatest melting pots of China, blending Eastern traditions and Western cultures.

Art is an important aspect of the design here, as every piece of furniture or decoration has been chosen for its inherent ideas and concepts. For instance, the fabric wall panelling in fact depicts the flow of the tides of time from past till present and into the future. Illuminated from different angles and varied in orientation, these panels form art pieces in themselves, representing the multiple facets of people, life, cultures and societies.

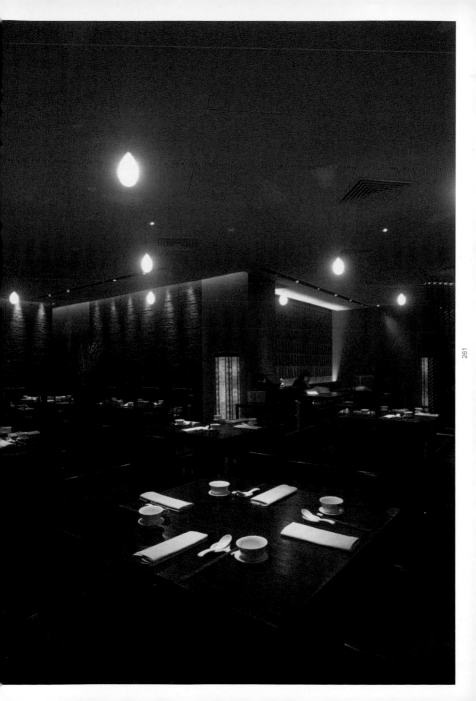

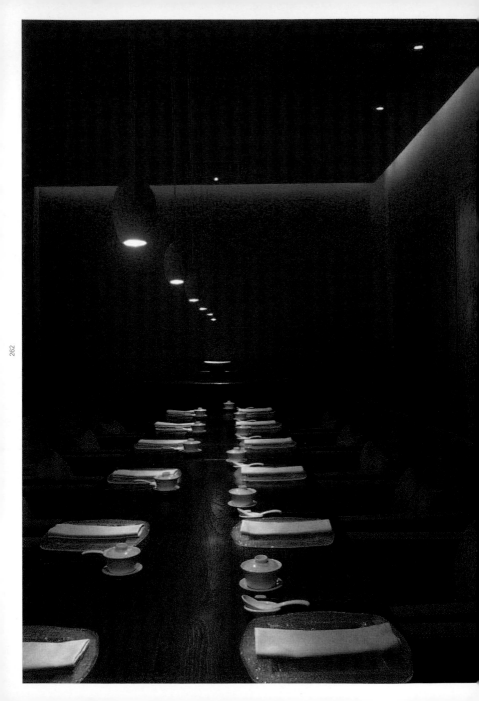

FEAST FOR THE SENSES

kuishin-bo

Beyond its unassuming entrance front, Kuishin-Bo sinuously invites you into its gastronomically lustrous premises.

NAME OF ESTABLISHMENT **KUISHIN-BO**
OWNER/CLIENT **RE&S ENTERPRISES**
ARCHITECT/DESIGNER **WARREN BRADLEY CHAN, LLIA GOH, DAVID GUAN/PT.ID PTE LTD**
PHOTOGRAPHER **KELLEY CHENG**
TEXT **AYS TAN**
LOCATION **3 TEMASEK BOULEVARD, #03-002 SUNTEC CITY MALL, SINGAPORE**
TEL OF ESTABLISHMENT **(65) 6238 7088**

Termed a "Japanese gourmet bazaar", this restaurant departs from the usual concepts of a Japanese eatery. The spatial ensemble within this 530 square metre interior entices one not merely into an anticipation for the food, but also a greater appetite for something more.

A gently curved entrance screened by timber poles on one side of the passage masks the busyness of the restaurant inside. Fusing interior lighting with a hint of daylight, the poles cast silent rhythmic shadows on the surfaces, creating an illusory sense of peace that turns into a surprising scene of bustle beyond.

Categorised by three main restaurant operations - kitchen, purchase and consumption - the planning of the restaurant relies on an arterial circulation route to connect the individual spaces, at the same time allowing for distinct zoning. Patrons transit along this artery to browse the fresh displays of food, before making their selection and settling in dining areas set on the other bank of the path. Elevated from typical mass dining venues such as "foodcourts", the designer has employed suggested "rooms" in the dining areas. Each "room" is marked by either an arched or flat structure composed of timber strips. Rolling out like rafters under a roof, they afford a structural texture to the gridded ceiling, while being subtly punctuated by service niches to demarcate "rooms". Compressed stone and dark brown wenge veneer have been employed as the materials of finish for the tables and stools, adding a warm, sumptuous dimension to the mood of the space.

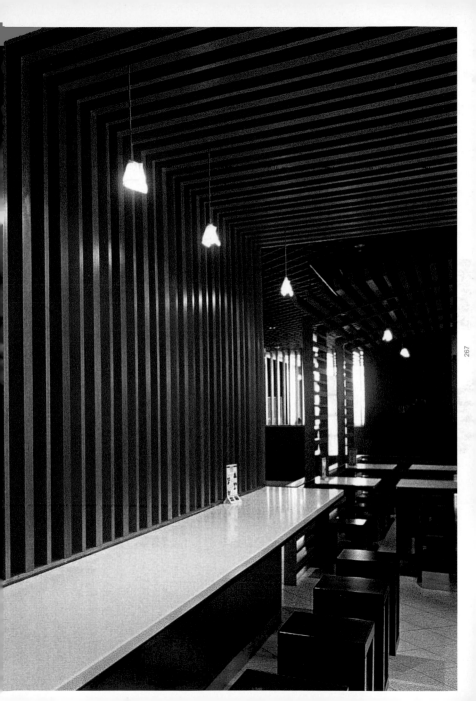

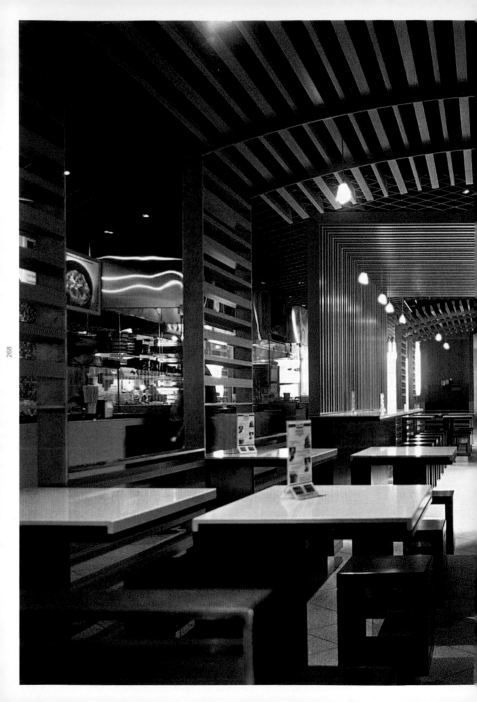

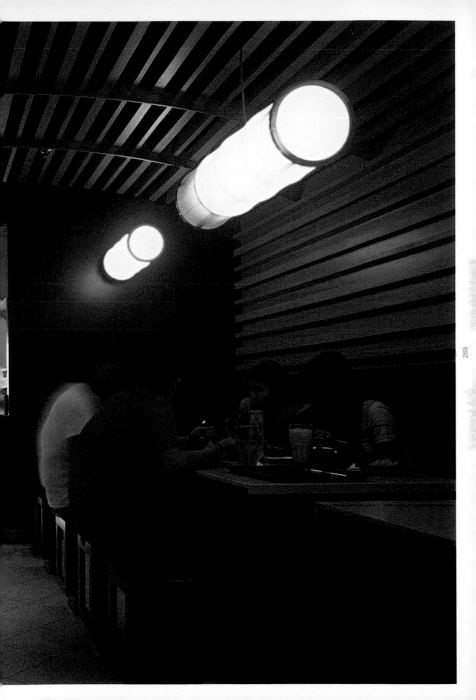

STEPPED TERRAIN

kuriya dining

Occupying what was previously a space designed to house a cinema, this restaurant exploits the unique stepped interior architecture to the fullest.

NAME OF ESTABLISHMENT **KURIYA DINING**
OWNER/CLIENT **RE&S ENTERPRISES**
ARCHITECT/DESIGNER **WARREN BRADLEY CHAN, LLIA GOH, DAVID GUAN/PT.ID PTE LTD**
PHOTOGRAPHER **KELLEY CHENG**
TEXT **ANG HWEE CHUIN**
LOCATION **1 KIM SENG PROMENADE, #02-42 GREAT WORLD CITY, SINGAPORE**
TEL OF ESTABLISHMENT **(65) 6738 0888**

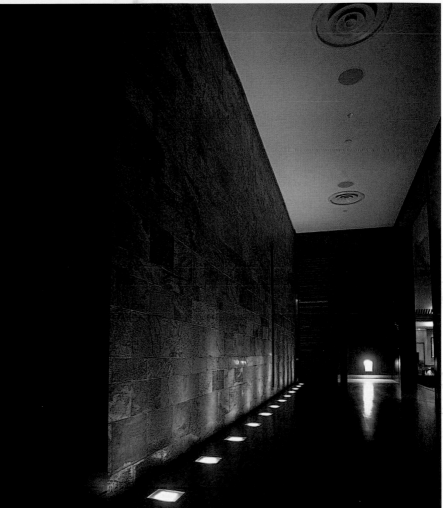

Leading up a short flight of steps, the entrance passage to Kuriya Dining ushers guests in an elevated gesture, differentiating itself from the shopping mall environs to which the restaurant is confined.

Unknown to its guests, this restaurant occupies a space that was designed to house a cinema theatre originally. However, having been left vacant for many years, there appeared to be no suitable use for this space given its stepped floor and generous ceiling height - until Kuriya Dining was leased the space. Upon entry into the restaurant, the intimate scale of the main dining hall erases all past traces of its former incarnation as a cinema. In order to achieve this, the floor was raised, a false ceiling was dropped, and a sequential flow of spaces was planned throughout the restaurant. A clear, concise spatial zoning is apparently the best strategy to inject navigability and structure into an interior that encompasses various spaces of differing spatial qualities.

Adding to the warm, intimate character of the space, timber veneer and soft illumination are liberally employed in the interior. In tandem with the design of the restaurant's cuisine (which features a la carte dishes, terikyaki and shabu shabu) the restaurant interior has been spatially differentiated into three zones. These three zones are each raised to a different floor level, and separated from the adjacent zones with glass and timber partitions. A large courtyard has been constructed within the restaurant, and adapted into an outdoor dining area, fully displaying the former spatial grandness of the cinema theatre.

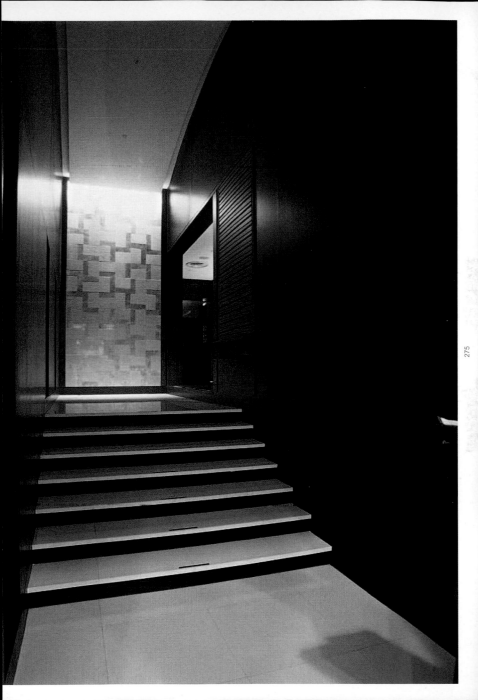

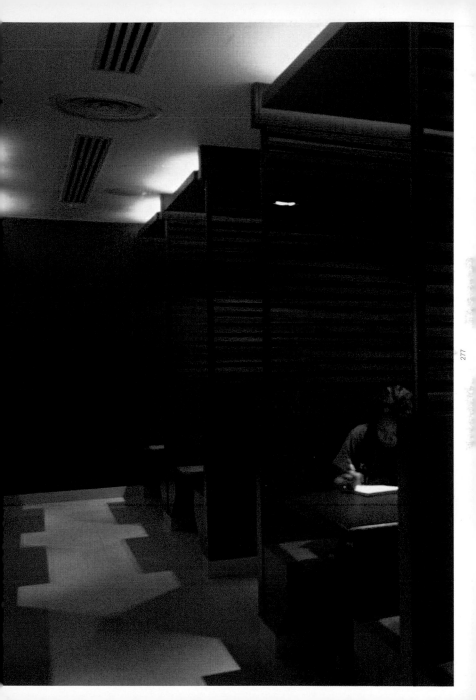

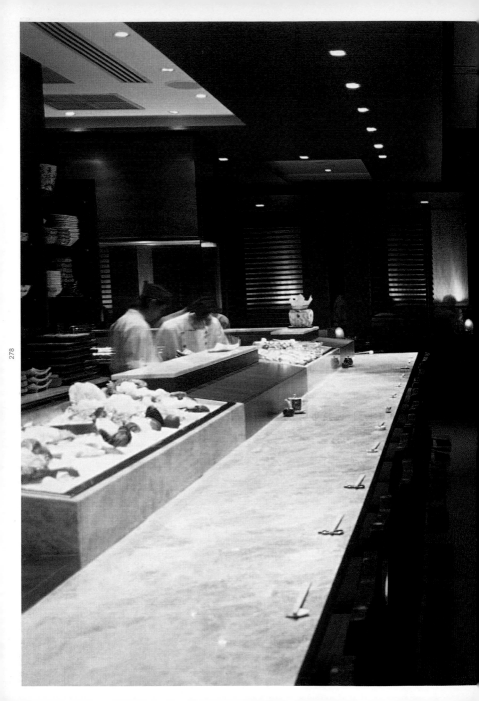

QUIET LUXURY

marmalade

Screened off from the street by a wall of frosted glass, luxury is a subtly flaunted asset in this stylish modern European restaurant.

NAME OF ESTABLISHMENT **MARMALADE**
OWNER/CLIENT **THE MARMALADE GROUP PTE LTD**
ARCHITECT/DESIGNER **ALBANO DAMINATO**
PHOTOGRAPHER **KELLEY CHENG**
TEXT **ANG HWEE CHUIN**
LOCATION **36 PURVIS STREET, #01-02, SINGAPORE**
TEL OF ESTABLISHMENT **(65) 6837 2123**

Easily tagged by a "minimalist" label, this restaurant flaunts low-key luxury. Dressed in a beguilingly indulgent palette of white linen, dark stained timber and smooth frosted glass, the interior works at creating a subtle and sensual mood that accentuates the stylish food creations served here.

The designer's strategy is to execute the spatial planning in a simple and clean manner, paying attention to detail, form and proportion instead. The restaurant is housed within a shophouse, which has very much pre-determined the configuration of the spaces. The restaurant opens into the main dining room, with a sleek bar counter lining one side of the restaurant. A sliding screen of panes of alternating clear and sandblasted glass separates a second dining saloon from the bar, expressing the concept of "visual exclusion".

Much concerted effort has gone into concealing the lighting and woodwork details. Sandblasted glass, walnut-stained timber, linen and waxed concrete flooring dominate the interior palette. As far as possible, the spatial and tonal qualities of the shophouse in which the restaurant is housed are maintained. Playing with soft diffused lighting, the generous ceiling height and robust structure of the shophouse are highlighted through the soft contrasts made between light and shadows.

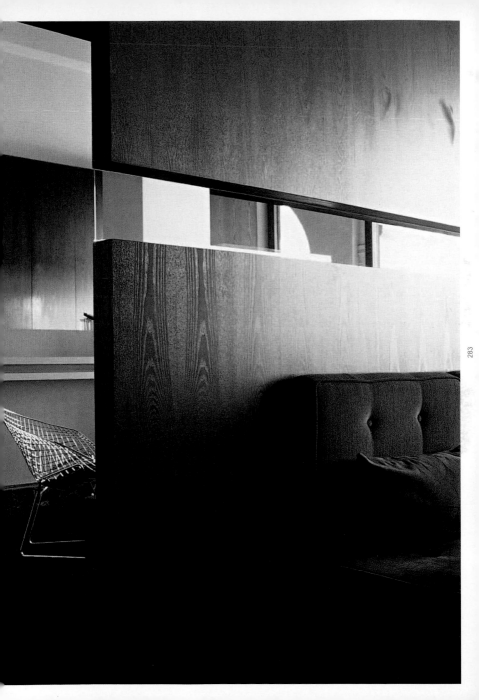

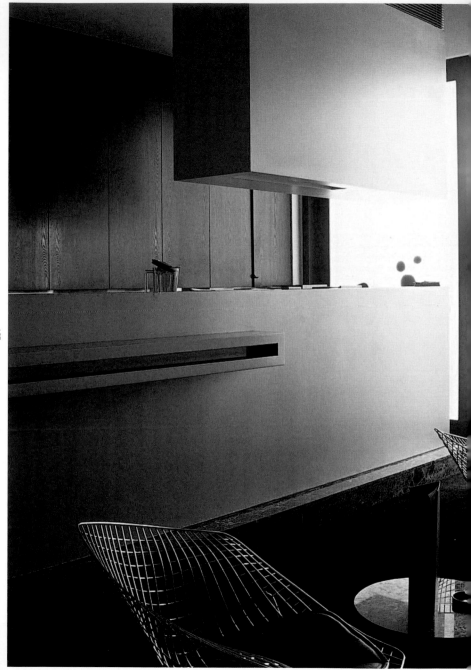

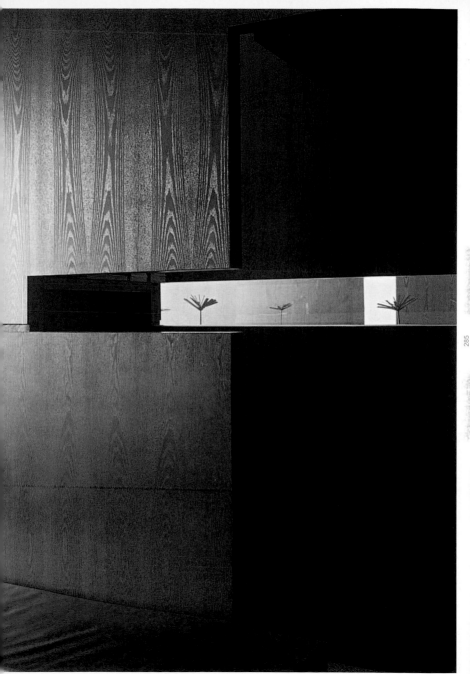

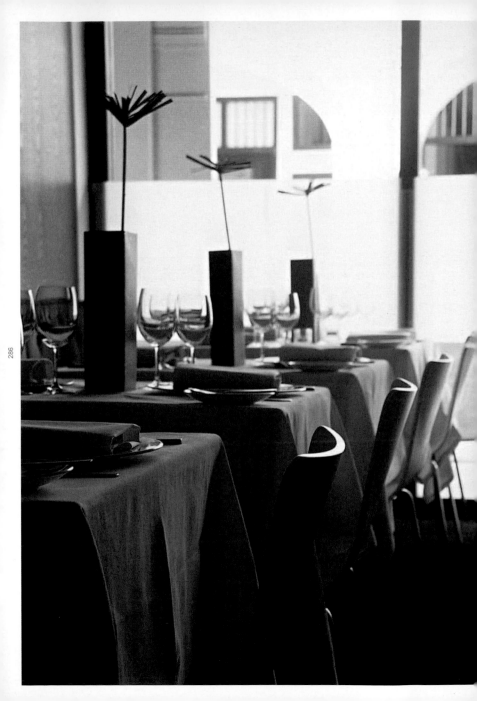

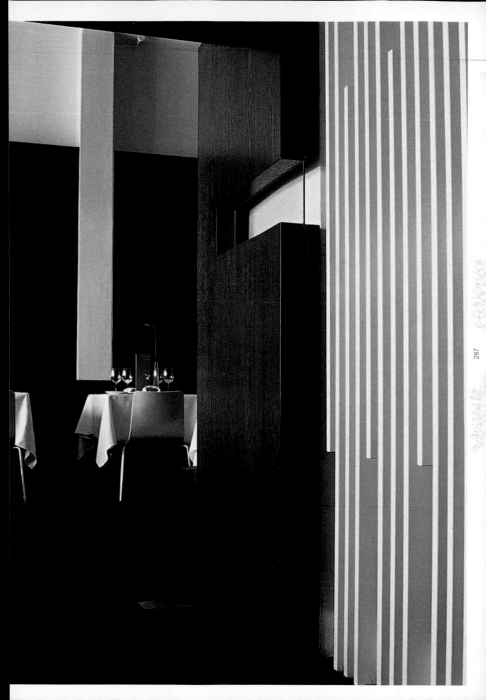

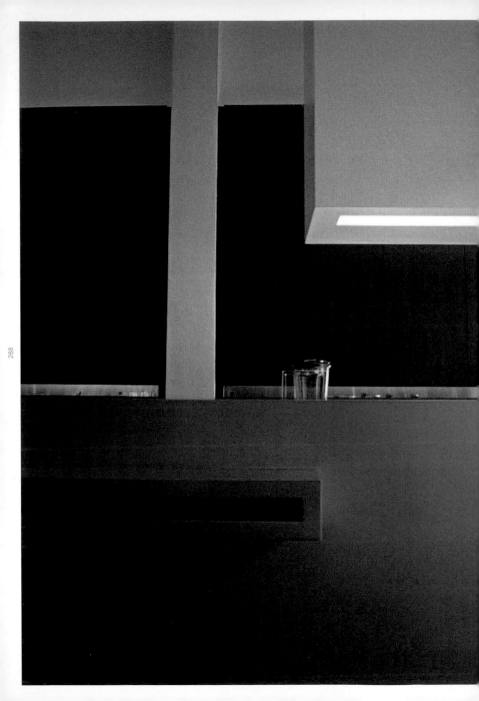

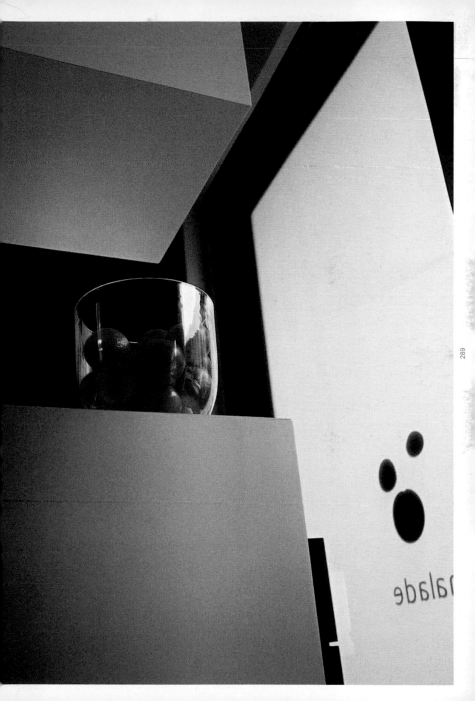

IN PRAISE OF SHADOWS

raku japanese restaurant + bar

Glowing lamps gently sway amongst shadows in the deep, dark interior of Raku, lending a curious draw to this intimate establishment.

NAME OF ESTABLISHMENT **RAKU JAPANESE RESTAURANT + BAR**
OWNER/CLIENT **BENJAMIN YING, BOONI TAN, WILLIE TAN**
ARCHITECT/DESIGNER **HARPAJAH SINGH, COLLIN WEE/MUTIARA INTERNATIONAL**
PHOTOGRAPHER **KELLEY CHENG**
TEXT **ANG HWEE CHUIN**
LOCATION **273 HOLLAND AVENUE, #01-02, SINGAPORE**
TEL OF ESTABLISHMENT **(65) 6469 6646**

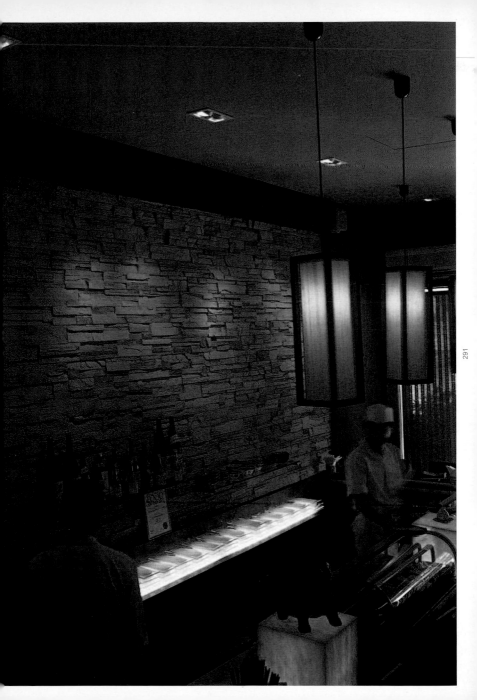

Pushing through Raku's clear glass doors, we enter a small oasis of calm that draws stark contrast with the busyness of the street. The enveloping dimness of the interior hangs in delicate balance with the diffused light thrown off its grey and fawn textured walls. Within this narrow strip of shophouse space, a soothing environment dedicated entirely to warm service and delicious food aromas has been created.

Sitting within a modern shophouse upon a slope, the kitchen and dining area of the restaurant negotiate two split levels, with the service areas tucked on one side. This arrangement sculpts a tunnel-like quality in the restaurant, with natural light admitted only through the two ends of the space. Glass balustrades segregating the upper and lower levels ensure a sense of visual and spatial continuity through the whole restaurant. The low level of illumination within the interior enhances the cloister-like character of the restaurant. The decor also rings with a flavour that amalgamates Japanese, Southeast-Asian and contemporary, employing Thai silk, teak and nyatoh, cultured stone, hand-painted concrete walls, upholstery, glass and stainless steel.

When one enters the restaurant, a sashimi bar lining one side of the restaurant accentuates the linearity of the shophouse architecture, while grabbing one's attention immediately. Onyx box lamps throw a soft light over displays of fresh seafood sitting on beds of ice along the bar, splashing colour against the warm timber scheme of the interior. Linked to the open kitchen on the upper level by a small flight of steps, the sashimi bar and the kitchen open up interesting scenes to the dining area, providing visual interest while one is waiting for orders to be served.

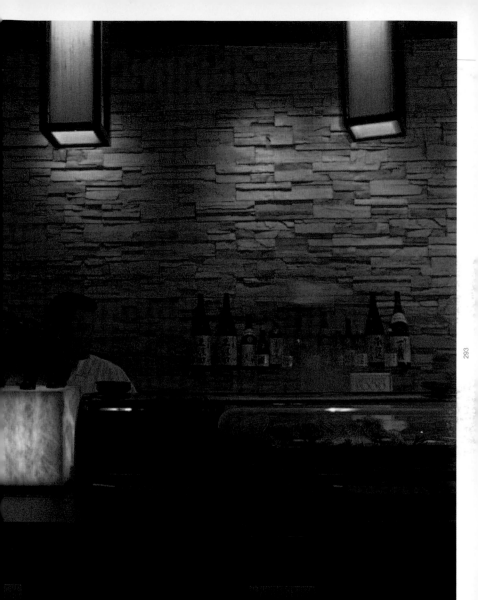

FLORENTINE TOUCH

senso
ristorante & bar

Formerly a wine bar and disco, the five shophouse units occupied by Senso were stripped and transformed into a polished expanse of understated elegance.

NAME OF ESTABLISHMENT **SENSO RISTORANTE & BAR**
OWNER/CLIENT **LAMINE GUENDIL/SENSO RISTORANTE & BAR PTE LTD**
ARCHITECT/DESIGNER **LG INTERIOR FITTING & CONTRACT PTE LTD**
PHOTOGRAPHER **KELLEY CHENG**
TEXT **ANG HWEE CHUIN**
LOCATION **21 CLUB STREET, #01-01, SINGAPORE**
TEL OF ESTABLISHMENT **(65) 6224 3534**

Its name meaning "senses" in Italian, Senso is a classy wine and dine establishment that offers sophisticated Italian cuisine in a sprawling 5-shophouse-unit space. Catering mainly to a well-heeled clientele, the design of the restaurant and bar is themed around creating a sense of luxury and richness.

Thanks to the ample amount of space, the restaurant offers generous wining and dining spaces to match its plush theme. Entering the restaurant, a well-illuminated reception area receives the guests. As with the rest of the restaurant and bar, the walls are painted a luxurious gold colour in a brushstroke texture, evocative of the old painting techniques of Florence, Italy. Large diamond-shaped panels of timber line the two sides of the space to achieve the effect of heightening the low ceiling.

Turning right, one enters the bar area, where a curved bar clad with striking blue backlit glass forms the visual focus. Square timber panels adorn the walls here, and warm hues of orange, earth and green cover the upholstered seats to portray a sense of lushness. Passing through a quaint courtyard, patrons enter the restaurant, which, though bearing its own characteristic decorations and finishes, maintains a consistent palette of nyatoh, parquet, gold walls and velvet upholstery as with the rest of the establishment. However, a more relaxed ambience prevails here. Softer colours and concealed lighting peeking out from behind banquette seats craft a soothing dining environment that allows guests to fully appreciate the cuisine.

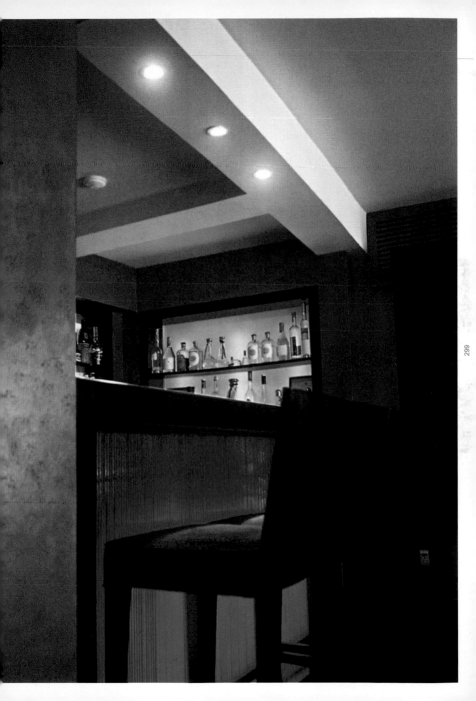

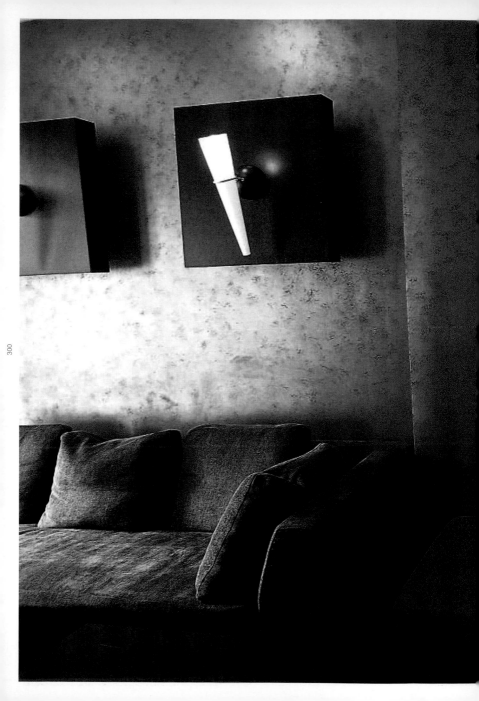

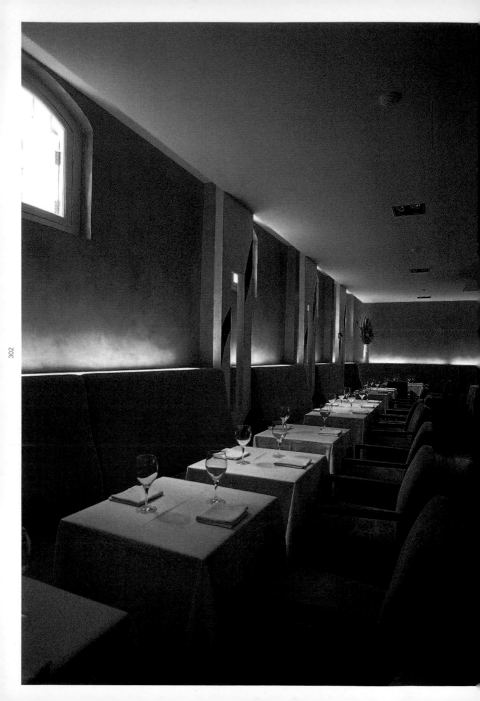

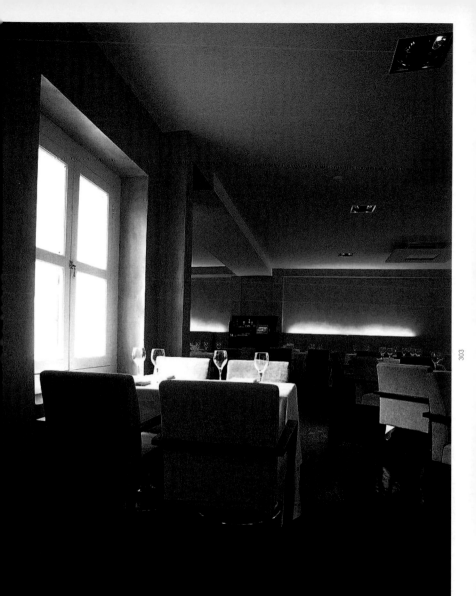

SHEER SIMPLICITY

shiro japanese
haute cuisine

"Shiro" means "white" in Japanese, but white is hardly a sensorially perceivable element here. Instead, it manifests itself as the sheer simplicity of concept and design.

NAME OF ESTABLISHMENT **SHIRO JAPANESE HAUTE CUISINE**
OWNER/CLIENT **SAM YEO/IMAGININGS PTE LTD**
ARCHITECT/DESIGNER **CECIL CHEE, ROBIN TAN, NG LAY ENG/WALLFLOWER PTE LTD**
PHOTOGRAPHER **KELLEY CHENG**
TEXT **ANG HWEE CHUIN**
LOCATION **24 GREENWOOD AVENUE, SINGAPORE**
TEL OF ESTABLISHMENT **(65) 6462 2774**

"Shiro", in Japanese, means "white". However, the colour is noticeably spared in the decor of this restaurant that specialises in Japanese haute cuisine. White is, instead, captured in the sensorial experience of utter simplicity that the design exhibits.

A restaurant by reservation only, Shiro is shrouded in as much mysteriousness as its discreet street entrance can suggest. Not wanting to be extraordinary, the appeal of Shiro lies in the design of its details; in fact, it is the absence of what is expected that is striking.

The entry into the main dining area is a ritualistic procession devised to give a deliberate sense of arrival. A generous thoroughfare cutting through the space depth-wise separates the quintessential chef's counter with the dining area. A row of columns clad in black pebblecrete defines the edge of the dining area, where thick draperies form fluid partitions between tables. An alternative interpretation to the Japanese *shoji*, these draperies appear to meld the walls into the timber flooring with their dense dark colour. Allowing a spatial reverence to be paid to the chef, the wide corridor between the dining area and the counter also elevates the latter element psychologically and visually, fully playing up the theatrics of culinary art.

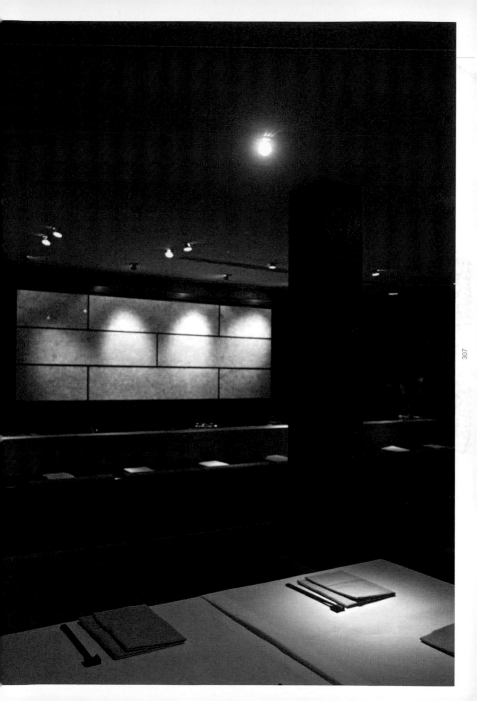

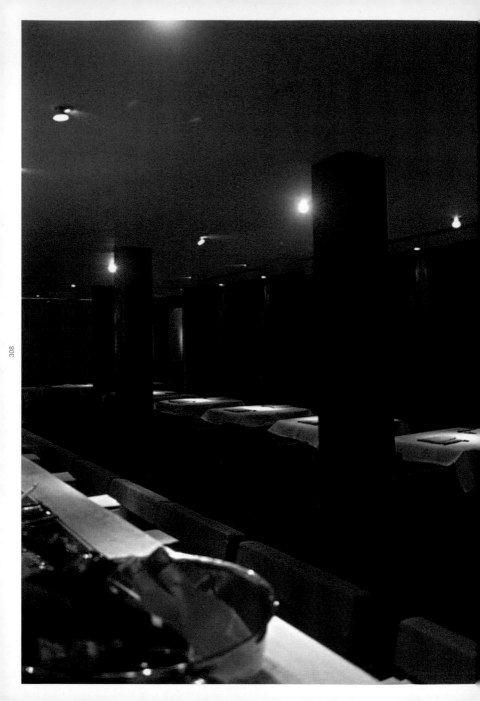

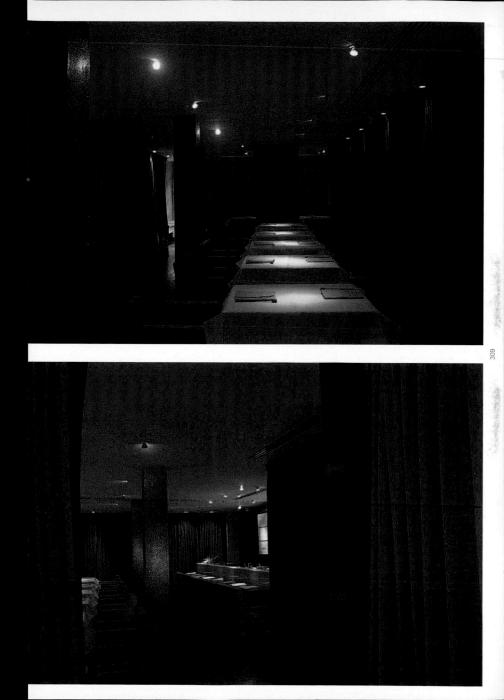

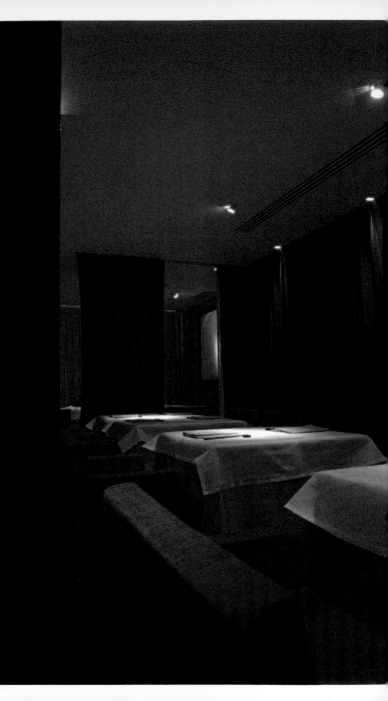

AFTER SIX

Visually stunning and yet quietly elegant, Six is that bar below the sleek Ally McBeal-esque office that we all dream about chilling out in after office hours.

NAME OF ESTABLISHMENT **SIX**
OWNER/CLIENT **CAPITALAND COMMERCIAL LTD**
ARCHITECT/DESIGNER **MGT ARCHITECTS (AUSTRALIA), RSP ARCHITECTS (SINGAPORE)**
PHOTOGRAPHER **KELLEY CHENG**
TEXT **JACINTA NEOH**
LOCATION **6 BATTERY ROAD, CAPITALAND BUILDING, SINGAPORE**
TEL OF ESTABLISHMENT **(65) 6534 1880**

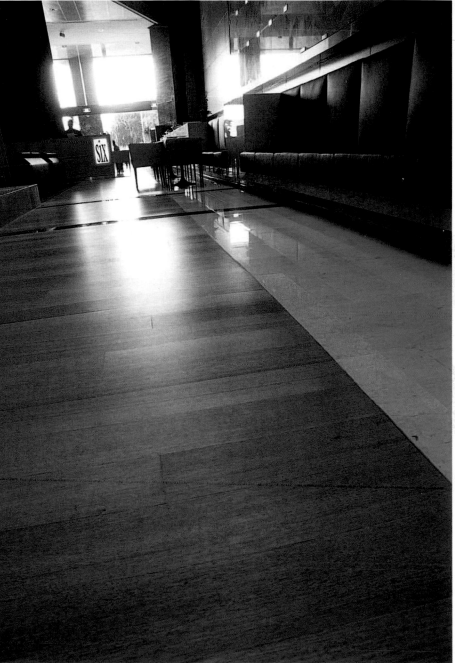

Imagine a sleek Ally McBeal-esque office with a bar below to chill out or unwind in after office hours - Six is this.

Sitting within the Baltic Brown granite envelope of an office tower, Six occupies a spacious double-volume section in the lobby to the building. Continuing the rich colour scheme and luxurious theme, the bar is furnished with fawn-coloured leather lounges and dark brown low tables. A seductive onyx back-lit screen wall spanning across one wall forms the feature of the space. Soft "water sculptures" and bamboo plants interposed through the bar inject a sense of quiet oriental elegance into the bar, carefully crafting a simple and yet visually stunning composition. A full-height clear glass façade affords breathtaking views of the Singapore River.

In order to not disrupt this sense of spatial continuity, the lounge seats and tables are kept low and simple, allowing the lines of sight to smoothly flow into the vista ahead. Designed as part of the building's refurbishment works, locating the bar here has created an activity node whereby people can weave through from the street level to the individual offices, or gather informally for discussions and meetings, rejecting the convention that lobby spaces are necessarily vast, characterless and transient.

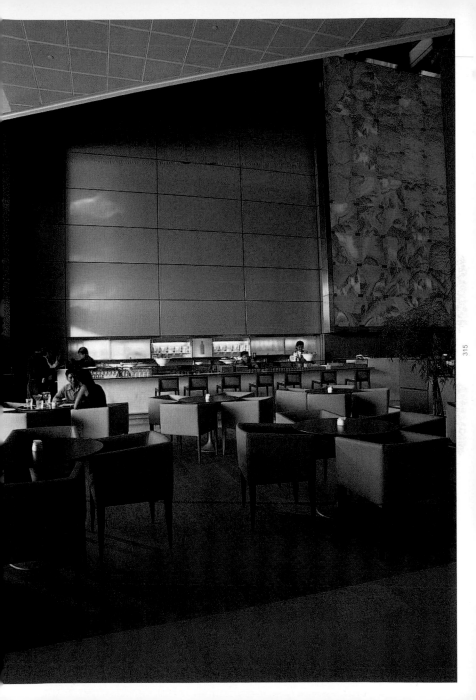

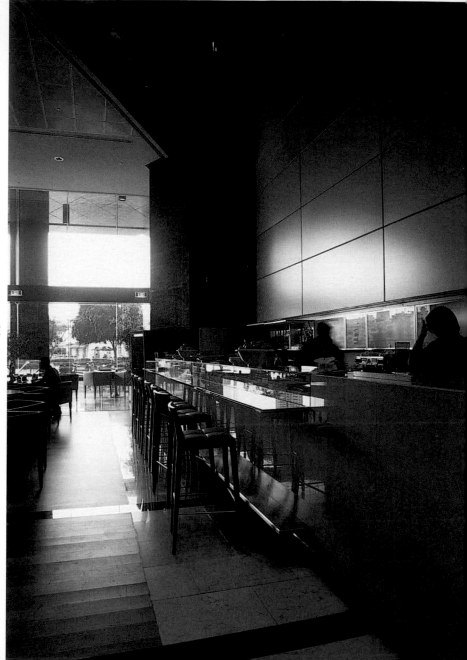

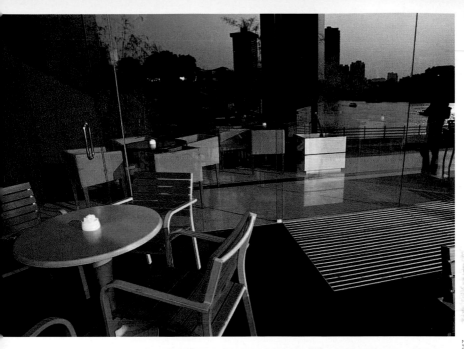

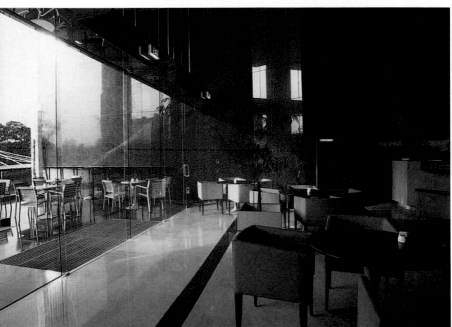

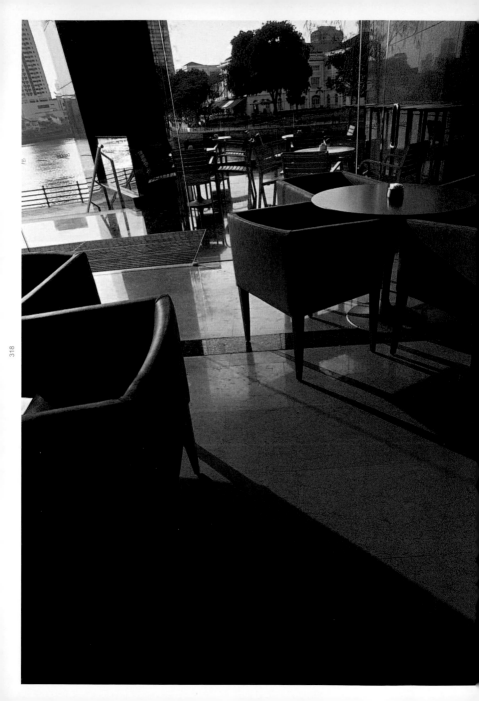

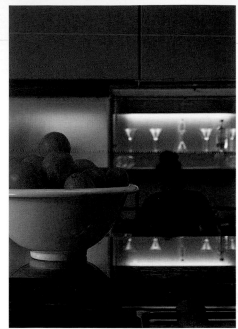

LAYERED SPACES

union bar

Unlike its flamboyantly plush neighbours down the road, Union Restaurant & Bar quietly fills an urban gap along Club Street.

NAME OF ESTABLISHMENT **UNION RESTAURANT & BAR**
OWNER/CLIENT **GASTRONOMICAL PTE LTD**
ARCHITECT/DESIGNER **GREG ELLIOTT/CLEAR CONSULTANTS**
PHOTOGRAPHER **KELLEY CHENG**
TEXT **ANG HWEE CHUIN**
LOCATION **81 CLUB STREET, SINGAPORE**
TEL OF ESTABLISHMENT **(65) 6327 4990**

Sauntering past the row of shophouses on Club Street, it is easy to miss the nondescript Union Restaurant & Bar, tucked away in one corner. Unlike its flamboyantly plush neighbours, Union Restaurant & Bar quietly fills an urban gap. Strangely, this tactic of silent insertion appears to work in its favour, subtly differentiating it from the other establishments.

Set within a conserved shophouse, the bar occupies the ground level, while the restaurant and private dining hall are located on the two upper levels. An underlying concept of "layers" governs the design of spaces. A schema of raw concrete planes warmed by occasional splashes of orange, red and timber tones characterise the bar. The airwell, converted into a skylight, floods daylight through the space. Louvred and casement windows invite fresh air, light and curious passers-by into the bar. Walls laid in old shophouse bricks are left exposed to set a contrast of texture with the concrete surfaces, while revealing the dualities of past and present. Blue steel cladding peels off the wall to further express the notion of "layers".

Connected to the bar by an external door, the restaurant upstairs employs a theme of royal blue, cream and timber tones to create a sophisticated atmosphere. French windows and chandeliers evoke a remotely European feel in the restaurant. Inspired by the signature dish of *moules*, the highlight of the space is a frame of arched timber slats, reminiscent of a ship's skeleton, affixed to one side of the passage space between the kitchen and the dining hall.

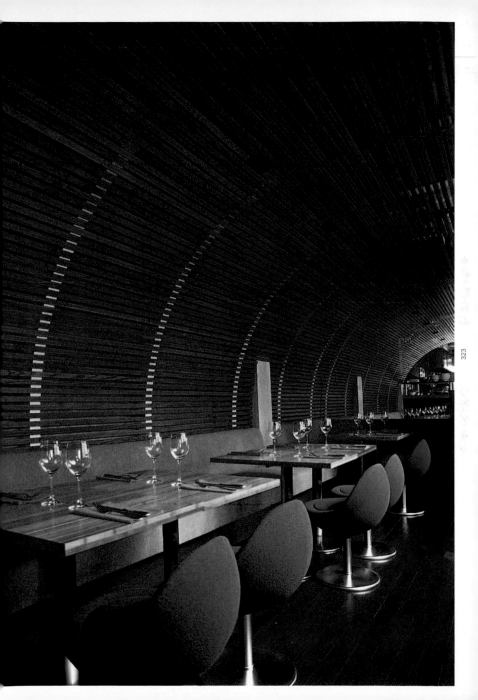

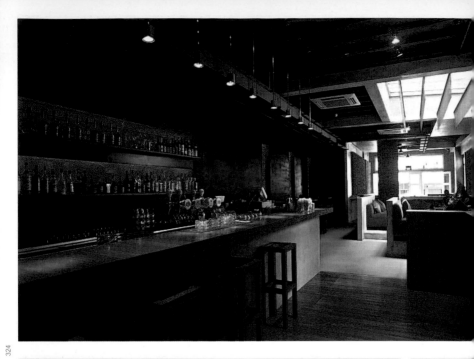

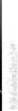

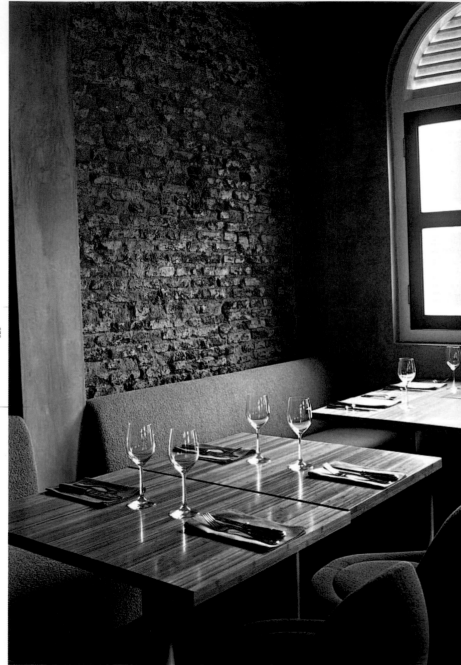

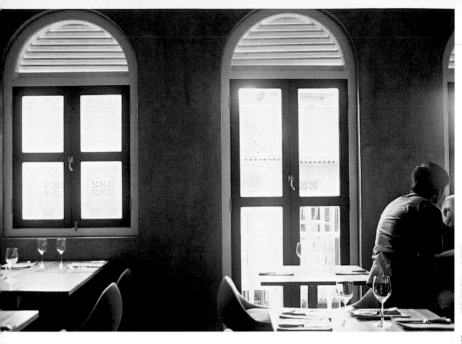

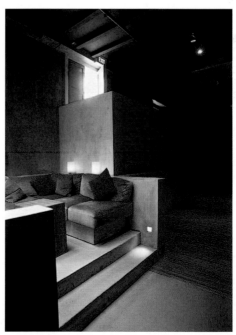

SPICE SEDUCTION

vansh

Realise your epicurean dreams in Vansh, as you immerse yourself in the sizzling chemistry between the restaurant's setting and its spicy Indian cuisine.

328

NAME OF ESTABLISHMENT **VANSH**
OWNER/CLIENT **R. M. CONCEPTS PTE LTD**
ARCHITECT/DESIGNER **WONG CHIU MAN, WARREN LIU, JOEY LIM/WARNERWONG PTE LTD**
PHOTOGRAPHER **KELLEY CHENG**
TEXT **ANG HWEE CHUIN**
LOCATION **2 STADIUM WALK, #01-04 SINGAPORE INDOOR STADIUM, SINGAPORE**
TEL OF ESTABLISHMENT **(65) 6345 4466**

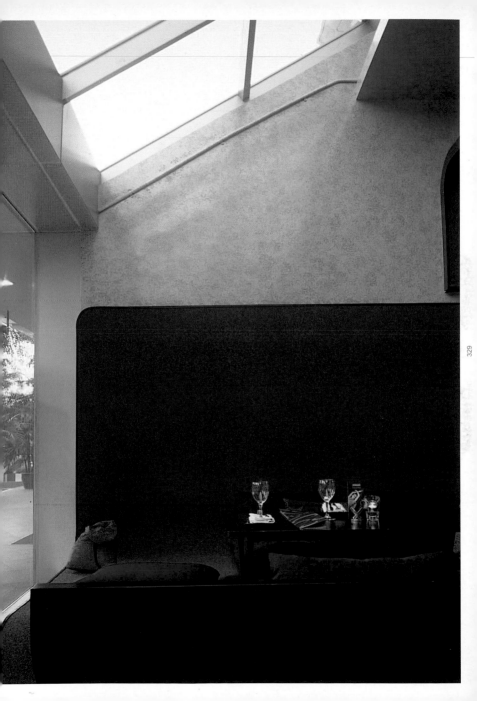

Vansh is a new-generation restaurant that features stylish contemporary Indian cuisine. Fronted by the Kallang River, the restaurant is at its best at the turn of dusk. As the last streaks of daylight filter through a skylight, flickering tea-lights and orchestrated lighting set the mood for an evening of relaxation. Draped indulgently in passionate purples and burgundies, Vansh spells the perfect after-office or pre-performance drinks-and-tapas venue.

The highlight of the restaurant is in a show kitchen - complete with an Indian tandoor and hot plate - that is brought to the front and encircled by dining areas offering booth, counter or cocktail seating. Clad in a skin of diachronic glass, and illuminated by designed lighting scenes that change through the day and night, the show kitchen captures the attention of diners and passers-by alike. The use of this unusual material does not come cheap, but the translucency and ephemerality that this material possesses prompted the designers to employ it in their depiction of the "passage of time".

All around, a lush sense of voluptuousness prevails in the restaurant. Idiosyncratic columns coated with epoxy paint and fashioned in organic forms mask the structural supports. Curved walls, sweeping floors and long stretches of floor and seating planes fold and merge against one another, creating a fluid visualscape. A bar counter backlit by red-hued light seduces one into the bar ahead through a small opening in the wall separating the bar and restaurant. Entering the bar, one transits into a high-ceilinged enclave of deep red fabric walls and complementary red upholstered seats.

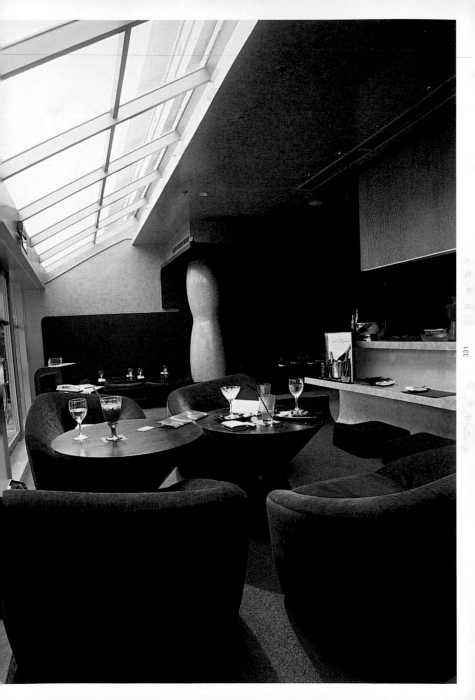

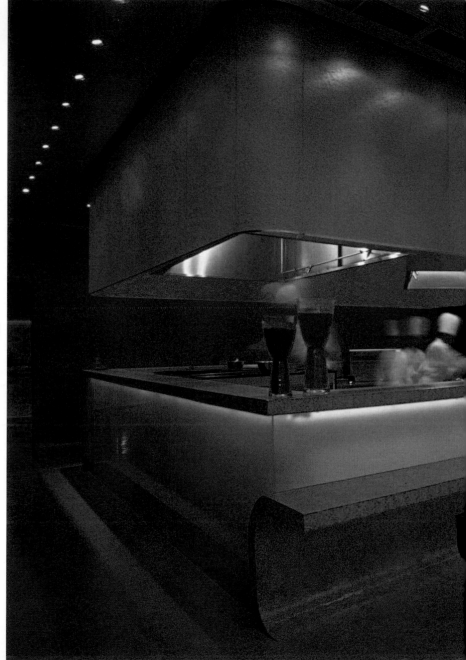

OLD-WORLD GRANDEUR

grand shanghai

As guests step into Grand Shanghai, they are seemingly transported into the middle of a grand banquet in Old Shanghai.

NAME OF ESTABLISHMENT **GRAND SHANGHAI**
OWNER/CLIENT **CITY DEVELOPMENTS LTD**
ARCHITECT/DESIGNER **ELITE CONCEPTS STUDIO (MANILA)**
PHOTOGRAPHER **KELLEY CHENG**
TEXT **ANG HWEE CHUIN**
LOCATION **LEVEL 1, KING'S CENTRE, 390 HAVELOCK ROAD, SINGAPORE**
TEL OF ESTABLISHMENT **(65) 6836 6866**

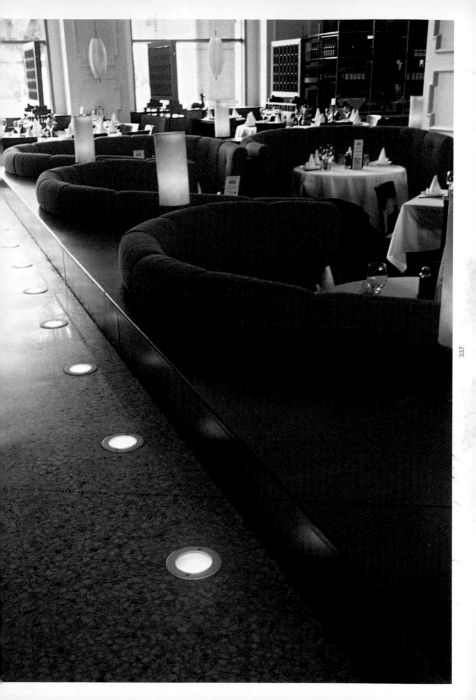

Touted as Singapore's first authentic Shanghainese restaurant, Grand Shanghai is literally yesteryear Shanghai recreated and transplanted into a modern restaurant setting.

Painted in a palette of olive green, red, yellow and mahogany, the atmosphere within the restaurant is intriguing and dramatic. Occupying a generous 10,000 square feet, the restaurant houses a main dining hall, 4 private dining rooms (which are each decorated in a different theme of the era), a wine bar and a section of booth seating that overlooks the riverfront on one façade of the restaurant.

The highlight of the restaurant is a proscenium stage that fronts the main dining hall, where live performances by musicians are put up nightly. Giant fabric pendant lamps cast yellow light upon rows of circular tables and booth seating arranged around the hall. One is seemingly transported into the middle of a grand banquet in Old Shanghai. The experience is made complete by the numerous small gestures of accessorising made within the restaurant - European wine glasses, Chinese tableware, images of Old Shanghai poster girls, trompe l'oeil murals, vintage photographs of Shanghai, antique fans, green terrazzo flooring. Each detail adds up to a rich conjuration of grand images of the enchanting city.

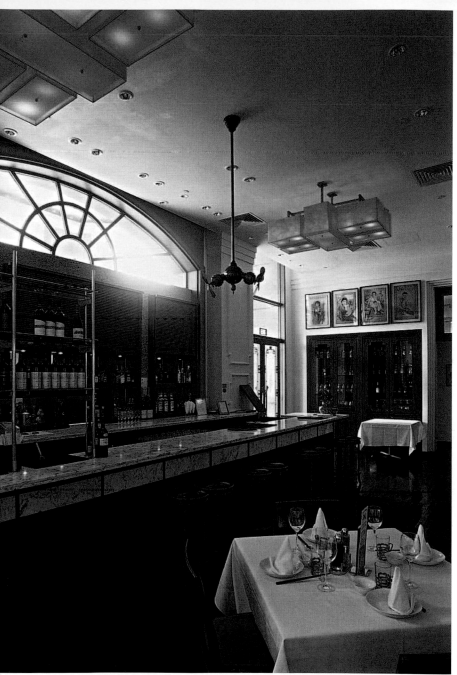

KITCHEN SECRETS

angelo kitchen revealed

Showcasing the elaborate processes, aromas, sounds and sights of Italian epicurism, owner Angelo del Ponte opens his kitchen to his guests.

NAME OF ESTABLISHMENT **ANGELO KITCHEN REVEALED**
OWNER/CLIENT **ANGELO DEL PONTE**
ARCHITECT/DESIGNER **CHAIRAT NA BANGCHANG**
PHOTOGRAPHER **KELLEY CHENG**
TEXT **SAVINEE BURANASILAPIN, THOMAS DANNECKER**
LOCATION **41/2 SUKHUMVIT SOI 16, BANGKOK, THAILAND**
TEL OF ESTABLISHMENT **(66) 2 258 1783**

ANGELO
KITCHEN
REVEALED

Exuding an easy charm, Angelo Kitchen Revealed is an open display of Italian hospitality at its most informal formality. This laid-back but nevertheless elegant restaurant, featuring an all-Italian menu, strikes one with its clean, bright and fresh modern interior that breaks away from tired replicates of the Italian *ristorante*.

The restaurant has a long rectangular footprint that has been divided into unequal quadrants. A vestibule leads into a waiting area raised upon a platform. At the rear, a screen allowing only a limited view of the dining room beyond plays upon the visitor's curiosity.

As suggested by the name of the restaurant, the kitchen is the greatest highlight within this restaurant. Designed with intricate cast-iron details, the kitchen showcases the elaborate processes that go on behind the counter. A chalkboard affixed to the kitchen wall displays the day's offerings in casual handwriting. Together with the aromas, sounds and buzz of all the food preparation activity, the kitchen forms a lively attraction for the diners.

The décor keeps to a minimal palette, chiefly favouring the colour white. An already huge but still-growing collection of white dinner plates, which have either been autographed or decorated personally by celebrity diners, decorate the wall surfaces, forming the most identifiable element of this restaurant's design. A strip of plastered timber board painted in white runs along the centre of the ceiling of the main dining hall, where lampshades with modern Byzantine-inspired motifs drop through circular cut-outs in the board. Coupled with generous windows on the long and front walls of the dining room that usher in a welcoming dose of daylight while screening off distraction from the street, the interior of the restaurant is washed in an uplifting luminosity.

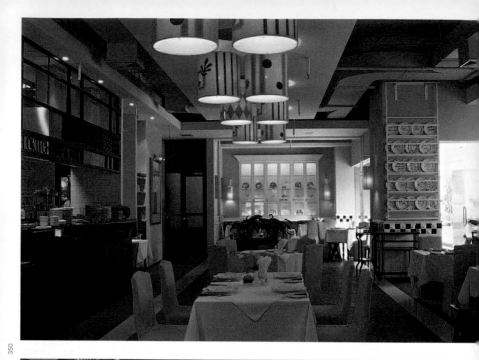

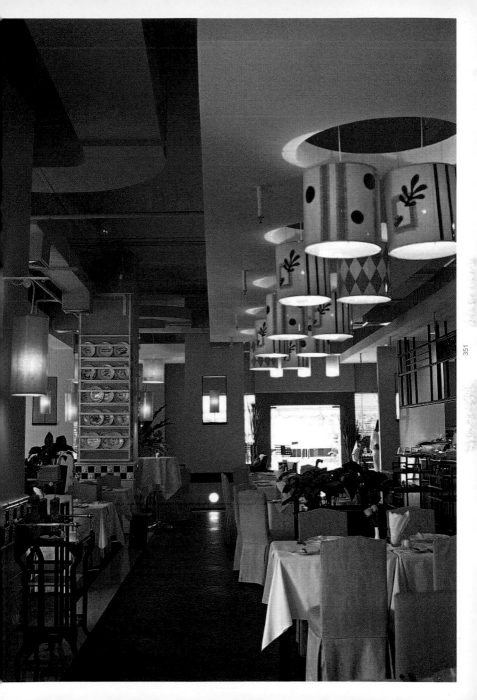

SLUMBER PARTY

bed
supperclub

Dinner is served in the "bedroom" at the Bed Supperclub, where strangers rub shoulders, relax and dine between beds, pillows and sheets.

NAME OF ESTABLISHMENT **BED SUPPERCLUB**
OWNER/CLIENT **PARIS BATRA, SOKOUN CHANPREDA**
ARCHITECT/DESIGNER **ORBIT DESIGN STUDIO**
PHOTOGRAPHER **MARCUS GORTZ**
TEXT **SAVINEE BURANASILAPIN, THOMAS DANNECKER**
LOCATION **26 SUKHUMVIT SOI 11, WATTANA, BANGKOK, THAILAND**
TEL OF ESTABLISHMENT **(66) 2 651 3537**

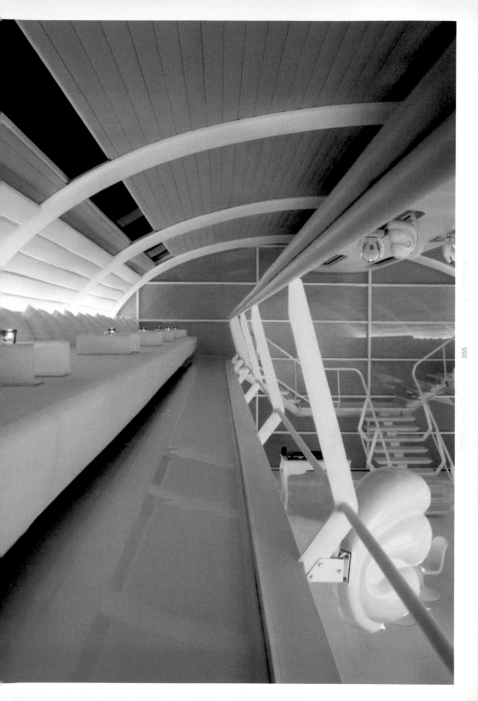

An elliptical tube of corrugated steel hovers above a gravel parking lot, barely touched by the mechanical fingers cradling it. Impossibly thin, a concrete ramp rises gently along one side to meet its centre. Reaching the top of the ramp, guests pass through a roll-up door to enter a vestibule upholstered entirely in white leather.

Welcome into the very unconventional Bed Supperclub - where dinner is served right in the "bedroom". Awareness pervades the *bed* experience: of other customers; of social norms; and above all, of the physical environment. Independent of the food, the art, and the crowd, it is *design* that has made the "bed" appear never as comfortable as this before.

Within the Bed Supperclub, beds, pillows and white sheets line the tube's sides. Boundaries between dining parties are left undefined by both architecture and furniture, leaving strangers free to mingle. A cavernous space in the middle of the tube is rarely left empty, as it is the stage for art installations and performances, calculated to entertain the dinner guests. A "grand" staircase set in white painted steel runs up the centre of this great tube, leading to a mezzanine level with more seats.

At the rear end of the tube is the bar area. Here, grey leather upholstery replaces the white sheets, and a full floor divides the elliptical section into horizontal halves. Vertigo-inducing clear glass sections that peer through the floor of the upper level fully defeat any suspicion that this is a conventional space.

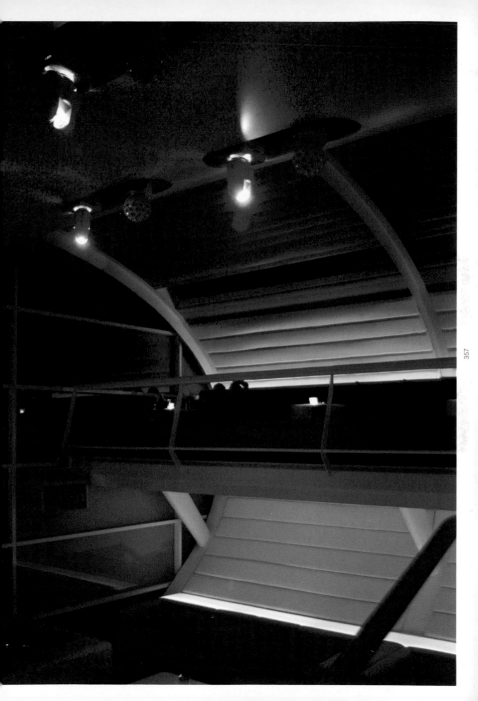

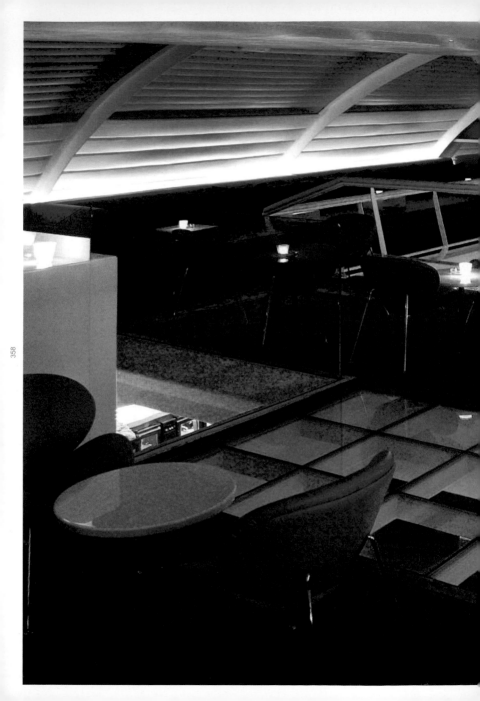

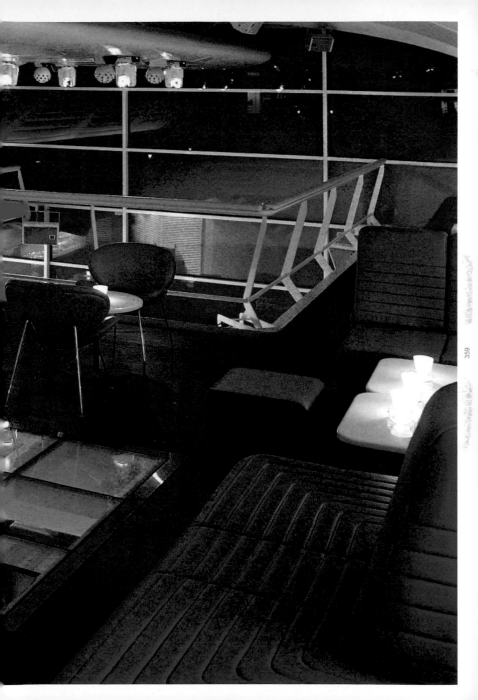

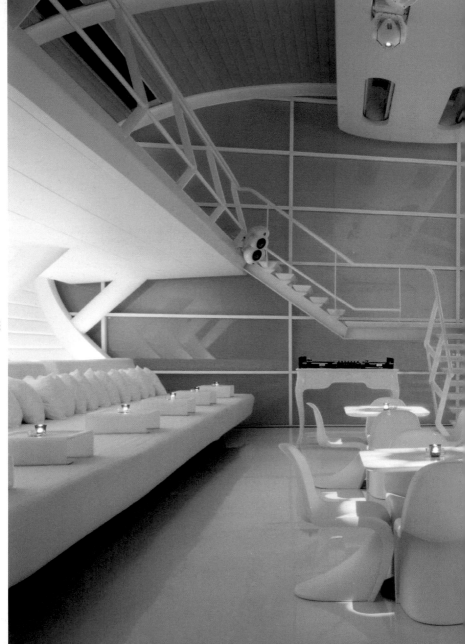

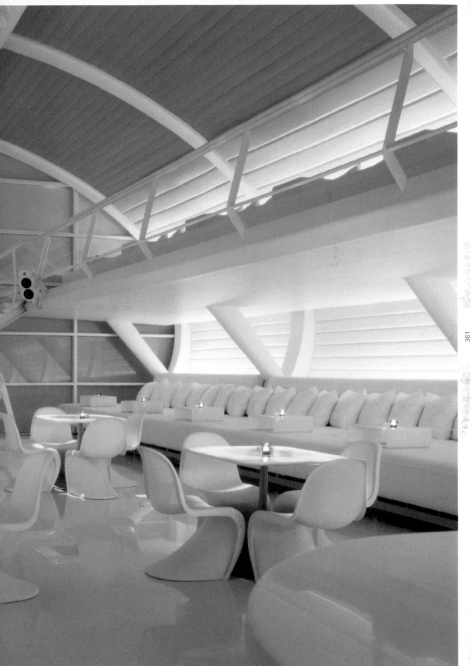

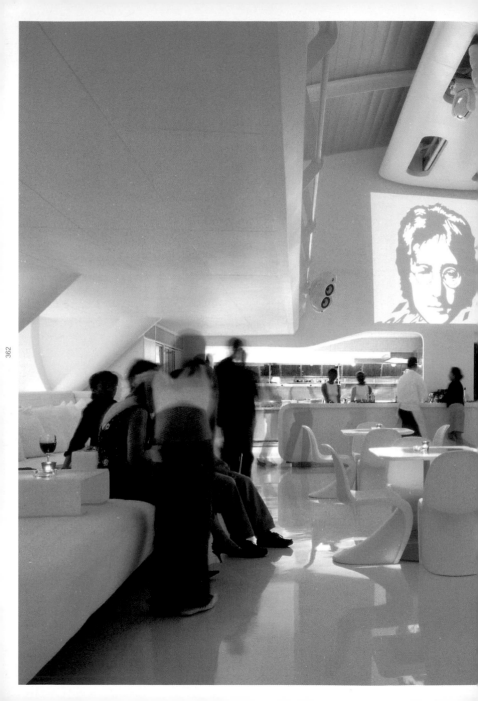

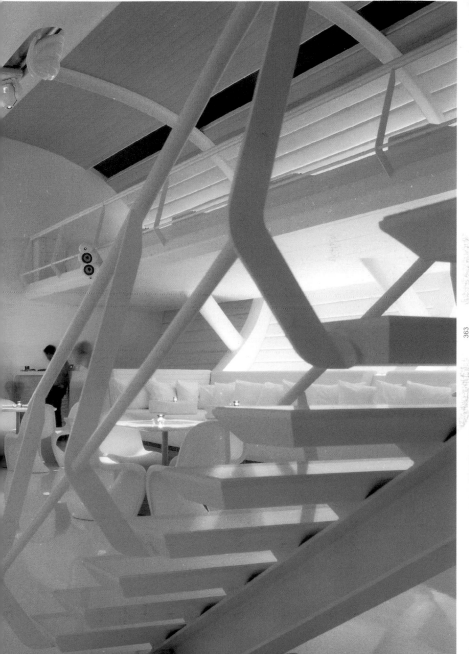

SPATIAL MANOEUVRES

by kalpapruek

Floorboards turn into ceilings in this second Kalpapruek restaurant, which is housed within a modern skyscraper complex.

NAME OF ESTABLISHMENT **BY KALPAPRUEK**
OWNER/CLIENT **RECIPES & FRIENDS CO LTD**
ARCHITECT/DESIGNER **BANGKOK MANIFESTO**
PHOTOGRAPHER **KELLEY CHENG**
TEXT **SAVINEE BURANASILAPIN, THOMAS DANNECKER**
LOCATION **CRC TOWER, ALL SEASONS PLACE, WIRELESS ROAD, BANGKOK, THAILAND**
TEL OF ESTABLISHMENT **(66) 2 685 3860**

The original Kalpapruek was founded in an old private home, but this restaurant now finds itself in a prominent location on the ground floor of a skyscraper complex. To signify this fresh beginning, the designers began by stripping the space to its barest elements (unconcealed ductwork and all), then cautiously adding new surfaces to suggest the restaurant's new functions.

A gently curving party wall that marks the entrance is upholstered in purple fabric, providing a politely inviting reception to the guest. Occasional openings in this wall reveal the contents on the shelves in an adjacent shop belonging to the same owner.

Borrowing views is exactly what the designers are adept at in the design of this restaurant. At the opposite end of the space, the restaurant exploits its other neighbour for a view, converting a part of the restaurant into an indoor verandah by "borrowing" the neighbour's fountain and plaza. The verandah floorboards continue up one wall, then make a ninety-degree fold to suggest a ceiling, which slowly exposes the web of equipment above. The floorboard-as-ceiling theme is repeated in the main restaurant, but this time, the boards establish only a suggested ceiling plane by gradually receding behind a neutralising layer of white paint.

A rusticity that draws upon the Asian locality of the restaurant while being interposed with touches of modernity defines the feel here. Timber and wicker furniture are set upon cement screed flooring, and custom textiles are used as screens between booths. At the same time, these textiles are employed as drapery across the bar, contributing a wonderful myriad of delicate textures and colours to the interior.

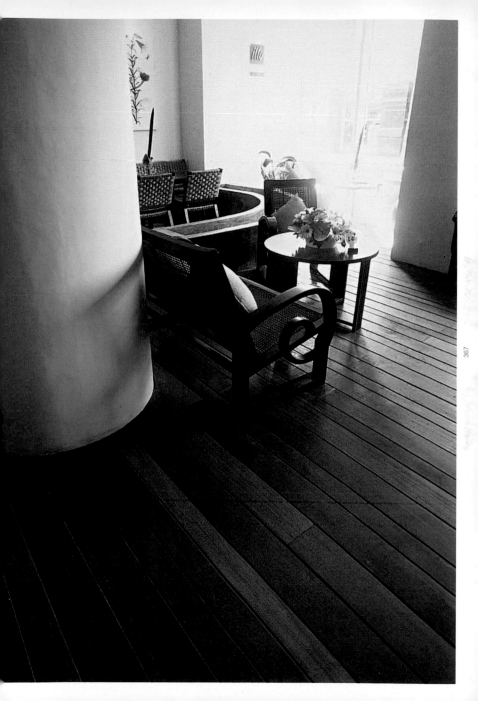

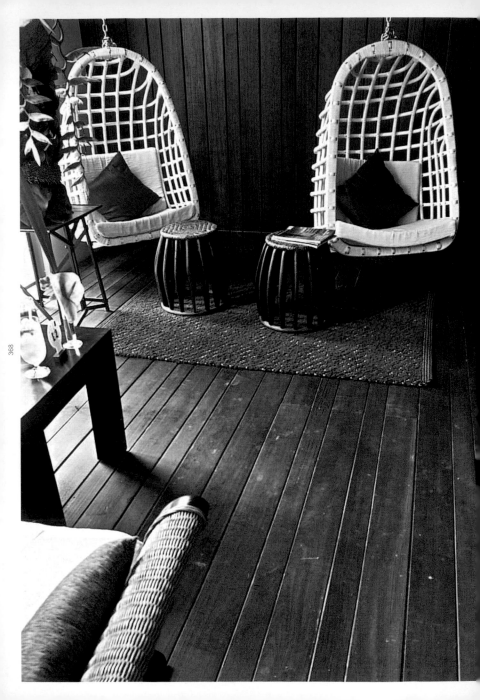

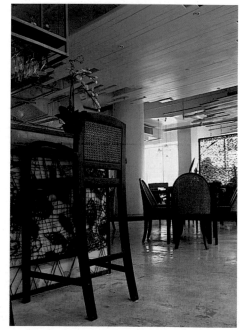

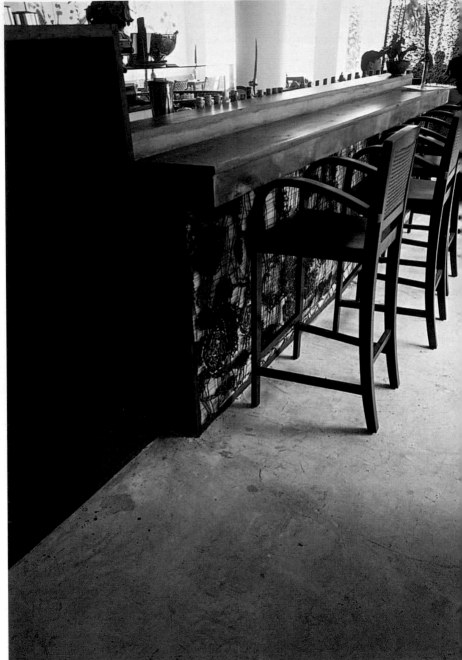

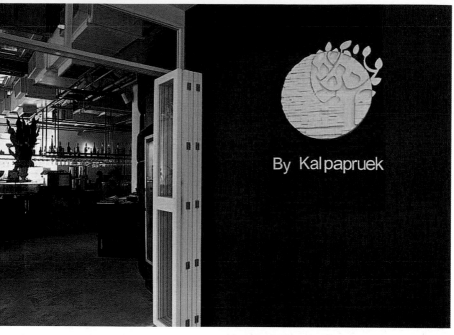

By Kalpapruek

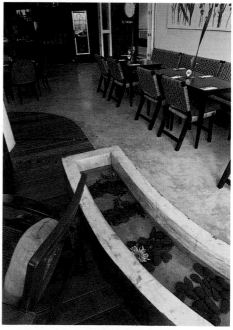

URBAN BEAT

greyhound café

A densely-seated cafe that is at once relaxed and stylish has proved to be immensely popular with the office lunch crowd since its opening.

NAME OF ESTABLISHMENT GREYHOUND CAFÉ
OWNER/CLIENT GREYHOUND
ARCHITECT/DESIGNER VITOON KUNALUNGKARN/INTERIOR ARCHITECTURE WORKSHOP
PHOTOGRAPHER CHANNI'S EYE CO LTD
TEXT SAVINEE BURANASILAPIN, THOMAS DANNECKER
LOCATION 1 ZONE B, U-CHULANG BUILDING, BANGKOK, THAILAND
TEL OF ESTABLISHMENT (66) 2 632 4466

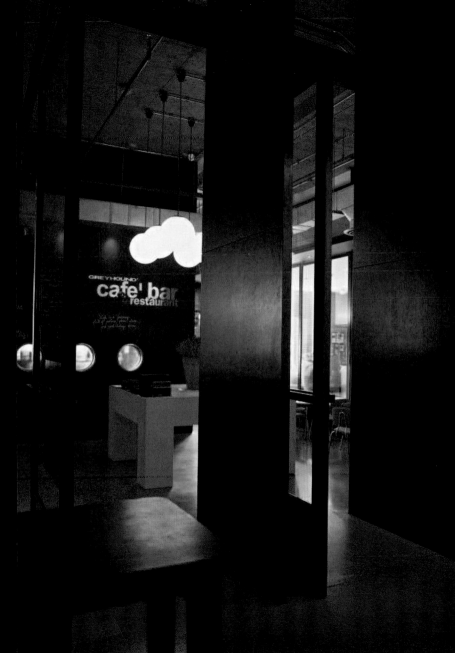

Originally a clothing retailer, Greyhound has since diversified into selling design in its totality - accessories, food and interiors. This new gastronomical venture by Greyhound is located on the street level of an office building in Bangkok's commercial district. Since its opening, it has succeeded in attracting crowds of lunching office workers everyday.

Despite the packed seating density here, the café manages to maintain a relaxed and stylish air that sets the perfect scene for an urbanite's break from work. An industrial palette of raw concrete and exposed ductwork meets stylish black leather and timber veneers to create a cross-style language that is uniquely in sync with Greyhound's brand identity.

One wall of the restaurant is finished with panels of slate-black chalkboard - a signature "Greyhound" feature that allows for convenient menu updates. More distinct are the circular, steel-rimmed translucent glass portals found in the restaurant, which allow diners to see the movement of restaurant staff on the other side of the wall.

Passing about the wall, patrons will find themselves entering a more intimate space, where they can seat themselves in leather couches in the space illuminated by a glowing, translucent bar. The bar glows yellow by day and blue by night. Rows of colourful liquids contained in clear bottles are placed on stainless steel shelves, acting as both a signifier of the bar and at the same time a playful and almost graphic element for the entire interior space. Separated from the tropical heat and bustle of Bangkok by a clean stretch of glass, the Greyhound Café provides a chic, informal urban stop in one's trek in concrete jungle.

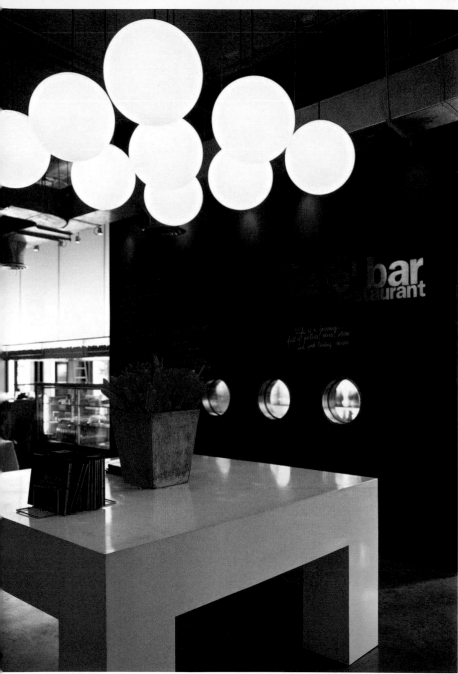

No Bullshitting
No Back Stabbing
No Gossiping
No Smoking
A R E A

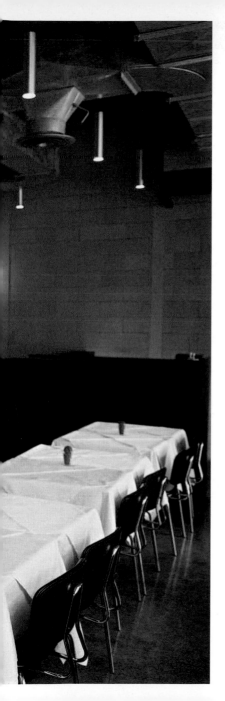

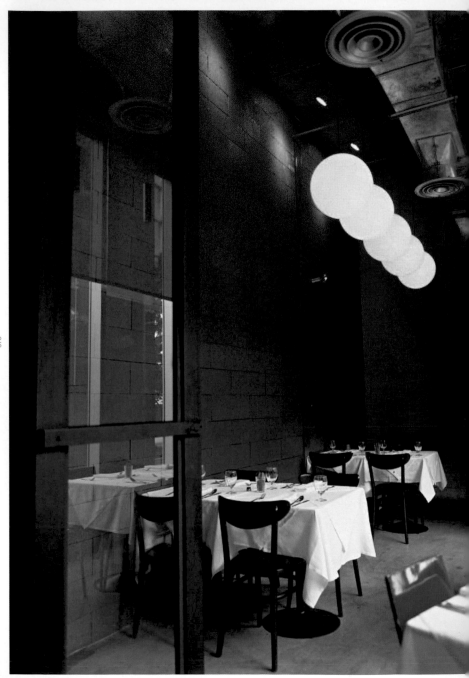

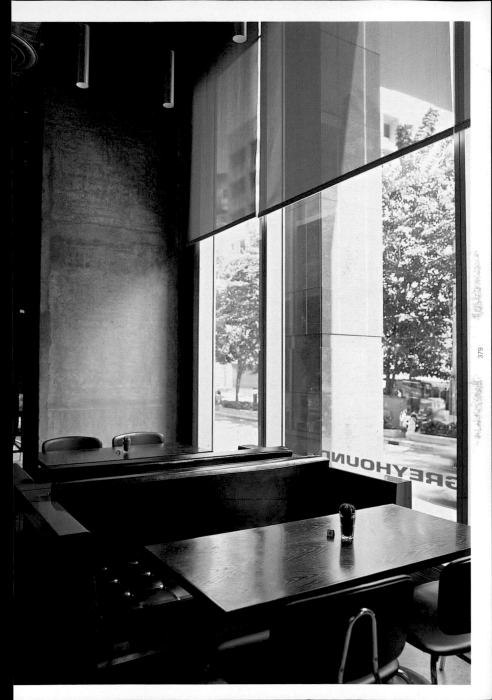

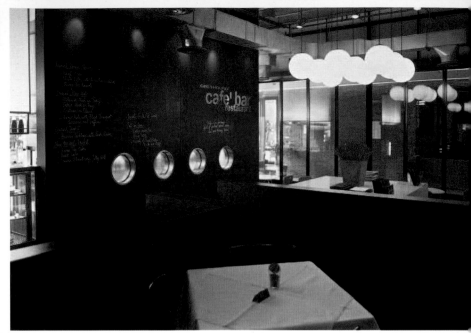

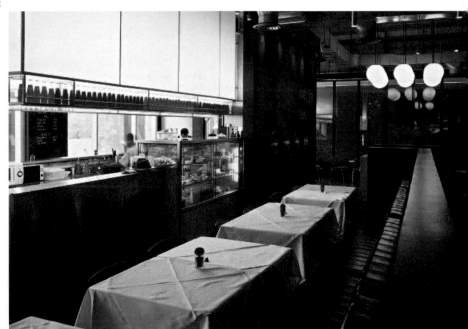

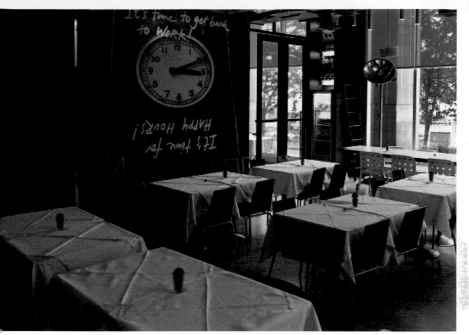

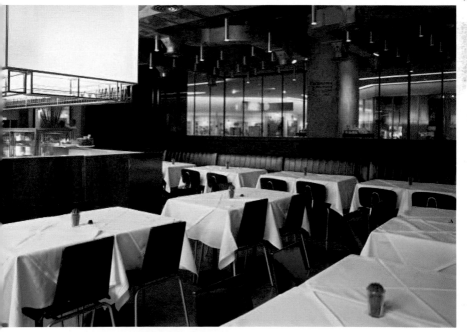

COSMOPOLITAN RECLUSE

madison
restaurant

Ringing with a Manhattan sophistication, Madison is a haven away from Bangkok's chaos.

NAME OF ESTABLISHMENT **MADISON RESTAURANT**
OWNER/CLIENT **THE REGENT BANGKOK**
ARCHITECT/DESIGNER **TONY CHI**
PHOTOGRAPHER **KELLEY CHENG**
TEXT **SAVINEE BURANASILAPIN, THOMAS DANNECKER**
LOCATION **THE REGENT HOTEL, RACHDAMRI, BANGKOK, THAILAND**
TEL OF ESTABLISHMENT **(66) 2 254 9999**

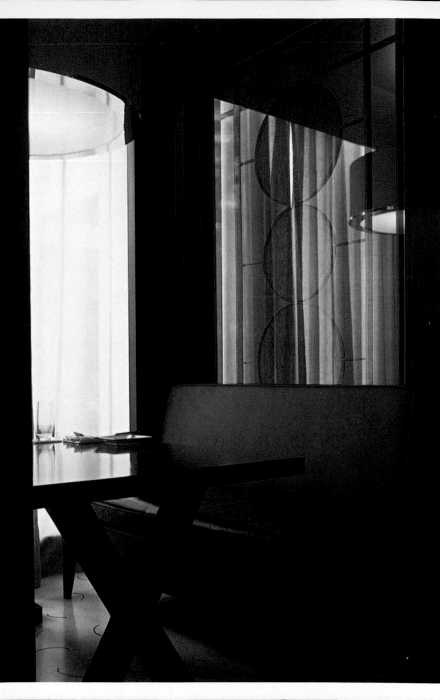

While waiting for a table, guests at Madison could easily be tempted into thinking that this is a gentleman's lounge: in a narrow slice of space that eases the transition from the Regent Hotel's cloistered courtyard into the restaurant, luxurious low leather chairs are arranged before a hearth against a wall of buff marble tiles. Generously-sized light fixtures are suspended from the ceiling, setting the tone for a splendid, luxurious space ahead.

The atmosphere in the restaurant is built from a carefully-considered combination of materials - each one a variation of the "natural" - copper, wood, leather and stone. Occasionally, stainless steel inserts an urbane dimension into the palette as well. Ringing with a Manhattan sophistication, Madison is truly a haven away from Bangkok's chaos.

The waiting area's inner boundary is defined by a screen formed by a translucent full-height wine cabinet. Beyond the screen lies the circulation spine, which joins the kitchen to the main dining room, between the waiting area and a private dining room. The private room is a glass box wrapped in delicately perforated wood and metal lattices, which form a screen that subtly allows for the activities within to be seen, but never heard. The kitchen beyond it, however, allows its noises and smells to drift down the corridor, tantalising the guests with the prospects of dining at Madison.

Lighting plays a role in defining various parts of the restaurant. The use of large circular lighting fixtures forms a recurrent theme that is applied throughout the restaurant, such as in the reception lounge, as well as in private booths that sit by the main dining hall. At the same time, natural lighting has helped to sculpt the interior atmosphere. The main dining room itself gains natural light, filtered through soft sheer curtains, from a small courtyard garden adjacent to it.

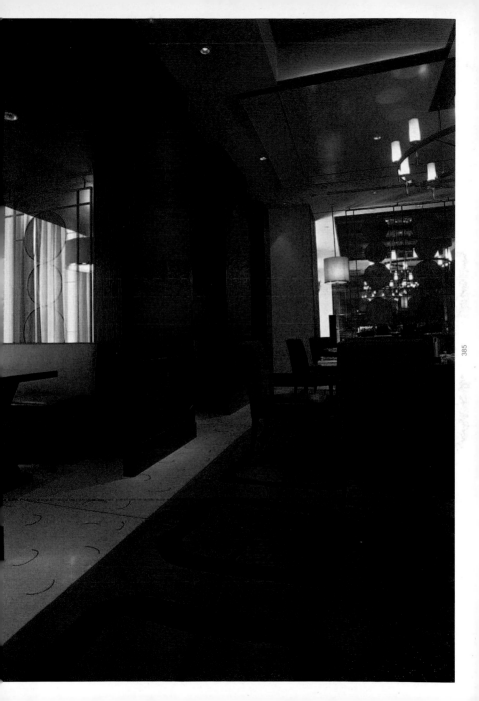

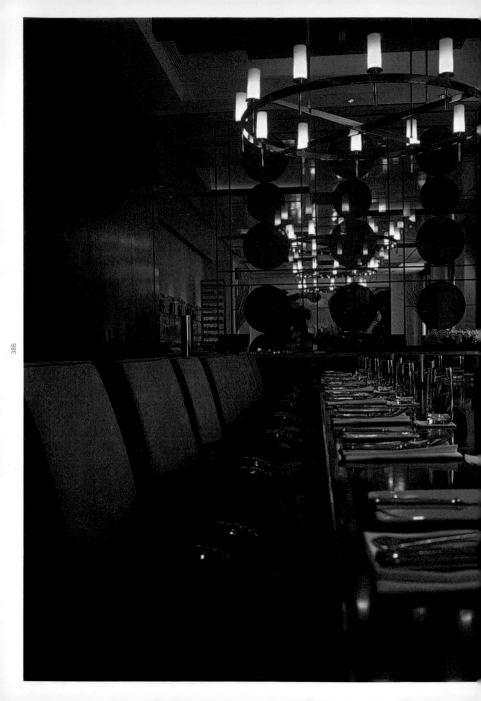

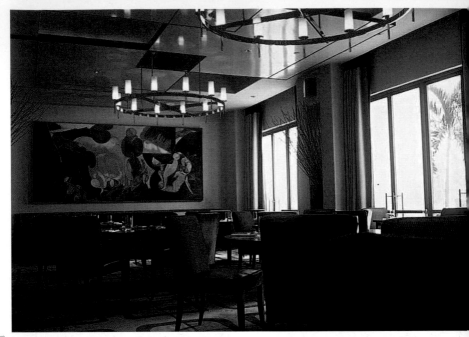

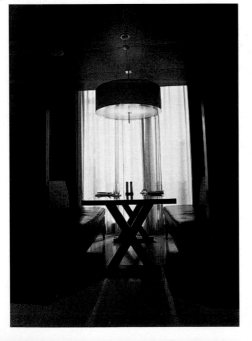

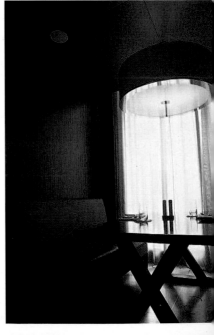

DESIGN RECYCLED

q bar bangkok

In a squat, turreted old house in Bangkok's Sukhumvit neighbourhood resides one of Bangkok's trendiest nightclubs.

NAME OF ESTABLISHMENT **Q BAR BANGKOK**
OWNER/CLIENT **ANDREW CLARK, DAVID JACOBSON**
ARCHITECT/DESIGNER **ORBIT DESIGN STUDIO**
PHOTOGRAPHER **MARCUS GORTZ**
TEXT **SAVINEE BURANASILAPIN, THOMAS DANNECKER**
LOCATION **34 SUKHUMVIT SOI 11, WATTANA, BANGKOK, THAILAND**
TEL OF ESTABLISHMENT **(66) 2 252 3274**

Unexpectedly, in a squat, turreted old house in Bangkok's Sukhumvit neighbourhood, resides one of Bangkok's trendiest nightclubs. The house has been radically renovated, but aspects of its domesticity are recycled into an atmosphere that - though exaggerated - preserves a certain homely cosiness.

Such a cosiness has in fact been exaggerated as a gesture of design. Leather upholstery grows beyond furniture and creeps up along walls, enveloping the entire space in a thick, soft blanket. Seams and buttons, usually intimate to the human hand, are now animatedly enlarged to supergraphics scale.

Chairs and stools are part of any home's furnishing. However, what fill the space here are not ordinary pieces, but thin, modern-styled public furniture extracted from external environments and transplanted indoors. Adding to the eclectic quotient, barstools and restaurant chairs fashioned in 60s European style transform the bar into a retro-chic one.

Illumination in the bar traces its sources to elements glowing mysteriously in different colours: walls, cabinets, stair risers. On the first floor, a bright yellow band of wall behind a sitting area complements the blue light emanating from an adjacent wall, onto which liquor bottles have been set.

Having ascended a staircase also illuminated by an ethereal glow, patrons find themselves entering a second bar. Here, the walls are padded in red, with head-sized concavities in section. Illuminated from some out-of-sight lighting cove, the walls become horizontal bands of red shadows. In one raised seating alcove, diagonal ellipses emboss each and every wall.

Indeed, Q Bar can be called an interior of surfaces, made up not only by intentionally exaggerated interior finishes, but also by the visually-driven culture of the night scene.

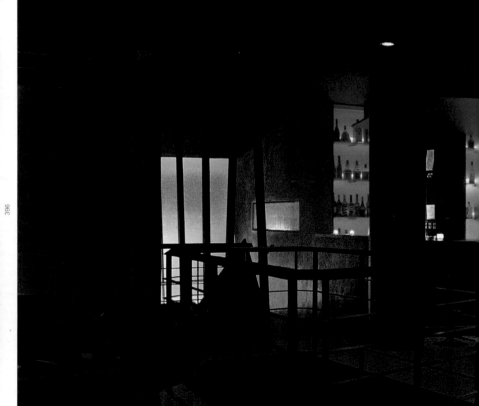

architects' email index

HONG KONG

AB Concept Ltd
info@abconcept.com.hk

Andre Fu/AFSO Design
afsodesign@aol.com

Dan Evans
dan@softroom.com

David Yeo
david@aqua.com.hk

Dialogue Ltd
info@dialogueltd.com

EC Studio
studio@elite-concepts.com

Head LTD
headltd@netvigator.com

Jason Caroline Design Ltd
jas_ca@hotmail.com

KplusK Associates
kplusk@netvigator.com

L & O Ltd
hzimmern@leighorange.com.hk

Darryl Goveas/Pure Creative Asia Ltd

Fred Lau/RYMD Industries
rymd@netvigator.com

Sunaqua Concepts Ltd
sunaqua@hkstar.com

Super Potato
spc@superpotato.po-jp.com

Tony Chi and Associates
t.chi@tonychi.com

Tracey Stoute
traceyhk@netvigator.com

Zanghellini Holt Architects
hz@zanghelliniholt.com

MALAYSIA

Allan Powell Pty Ltd
acpowell@vicnet.net.au

John Ding, Ken Wong, Ramesh Seshan, Yrk Swofinty/Unit One Design Consultancy
uodc@pd.jaring.my

ZDR Sdn. Bhd
zdr@po.jaring.my

SINGAPORE

Albano Daminato

Greg Elliot/Clear Consultants
greg@clear.com.sg

LG Interior Fitting & Contract Pte Ltd
lamine@singnet.com.sg

Harpajah Singh, Collin Wee/Mutiara International
info@mutiara-intl.com

Warren Bradley Chan/PT.ID Pte Ltd
ptarchitects@pacific.net.sg

Wallflower Pte Ltd
wallflower@pacific.net.sg

Wong Chiu Man/Warnerwong Pte Ltd
wcm@warnerwong.com

Mok Wei Wei/William Lim Associates Pte Ltd
wlap@pacific.net.sg

BANGKOK

Bangkok Manifesto
absolutes@samart.co.th

Orbit Design Studio
info@orbitdesignstudio.com

Vitoon Kunalungkarn/Interior Architecture Workshop
iawbkk@asiaaccess.net.th

Tony Chi/Tony Chi and Associates

acknowledgments

We would like to thank all the architects and designers for their kind permission to publish their works; all the photographers who have generously granted us permission to use their images; all our foreign co-ordinators – Anna Koor, Kwah Meng-Ching, Masataka Baba, Reiko Kasai, Richard Se, Savinee Buranasilapin, Thomas Dannecker for their hard work and invaluable help; and most of all, to all the bar and restaurant owners who have so graciously allowed us to photograph their establishments and to share them with readers the world over. Also, thank you to all those who have helped in one way or another in putting together this book.

Thank you all.